New Uses of Bourdieu in Film and Media Studies

NEW USES OF BOURDIEU IN FILM AND MEDIA STUDIES

Edited by
Guy Austin

berghahn
NEW YORK · OXFORD
www.berghahnbooks.com

Published in 2016 by
Berghahn Books
www.berghahnbooks.com

Library of Congress Cataloging-in-Publication Data

Names: Austin, Guy, editor.
Title: New uses of Bourdieu in film and media studies / edited by Guy
 Austin.
Description: New York: Berghahn Books, 2016. | Based on a symposium
 held at Newcastle University's Research Centre in Film and Digital Media
 in late 2012. | Includes bibliographical references and index.
Identifiers: LCCN 2015046388| ISBN 9781785331671 (hardback: alk.
 paper) |
ISBN 9781785331688 (ebook)
Subjects: LCSH: Motion pictures–Congresses. | Mass media–Congresses. |
Bourdieu, Pierre, 1930-2002–Influence–Congresses.
Classification: LCC PN1994 .N487 2016 | DDC 791.43015–dc23 LC record
 available at http://lccn.loc.gov/2015046388

British Library Cataloguing in Publication Data
A catalogue record for this book is available from the British Library

ISBN 978-1-78533-167-1 hardback
ISBN 978-1-78533-168-8 ebook

Contents

List of Tables and Figures vi

Introduction: Bourdieu on Media and Film 1

1. Bourdieu, Field of Cultural Production and Cinema:
 Illumination and Blind Spots 13
 Bridget Fowler

2. Bourdieu and Film Studies: Beyond the Taste Agenda 35
 Chris Cagle

3. Bourdieu and Images of Algerian Women's Emotional Habitus 51
 Sophie Bélot

4. The Taste Database: Taste Distinctions in Online Film
 Reviewing 70
 Eileen Culloty

5. Millennials Protest: Hipsters, Privilege and Homological
 Obstruction 89
 Anthony P. McIntyre

6. A Bourdieuian Approach to Internet Studies: Rethinking Digital
 Practice 107
 Richenda Herzig

7. Obtain and Deploy: Mobile Media Technologies as Tools for
 Distinction and Capital 124
 Justin Battin

8. Weak (Cultural) Field: A Bourdieuian Approach to Social Media 141
 Antonio Di Stefano

Index 163

Figures and Tables

Figure 8.1 Percentage of all articles (NM&S, JCMC) citing
 Bourdieu's work per year 144
Figure 8.2 Bourdieu's long tail within the field of Internet studies 147

Table 8.1 Different citation patterns regarding reception of
 Bourdieu's categories 145
Table 8.2 The reception of Bourdieu's key concepts 145
Table 8.3 The reception of Bourdieu's capital 146

Introduction

Bourdieu on Media and Film

Guy Austin

At the turn of the millennium, Pierre Bourdieu's sociology was memorably described as 'the most powerful social theorization currently available' (Fowler 2000: 2). In the intervening years, developments in cultural production, and above all in digital media, may lead us to revisit the value of Bourdieu's thought as applicable to such production. Moreover, given that film and media are fields to which Bourdieu devoted relatively little space in his work on culture as social practice (writing much more extensively on literature, theatre and painting, for example), what does Bourdieu offer film and media studies in a visually saturated culture? It is in order to answer that question that this book has been conceived. Based on a symposium held at Newcastle University's Research Centre in Film and Digital Media in late 2012, this collection brings together work by researchers from the United Kingdom, the United States and Europe. Our contributors come from diverse disciplines: from sociology, film studies, media studies and communication sciences. We are all however convinced that Bourdieu's work has valuable uses for current research in film and media, as our various case studies aim to show.

Of course, as many observers have noted, with the exception of the short book *On Television*, Bourdieu wrote very little on screen cultures. Indeed, as regards television, 'Bourdieu's lack of research on this topic was all the more puzzling in view of the "social centrality" of television worldwide' (Marlière 2000: 208). We can expand this observation to point out that Bourdieu's interventions on cinema were even rarer – and mainly

limited to comments on perceived threats to an auteurist conception of the medium, as an autonomous field in danger of losing its independence from the market (see below). To a degree this is no surprise, since 'The conflict of "pure" versus "market" can be seen in every field' (Bourdieu 1998a: 53). But given the current 'social centrality' of visual cultures ranging from film and television to new media, one might wish for a more in-depth analysis of the struggles and stakes in such fields, and a more nuanced view of the imbrications between art and commerce in their ongoing development. If Bourdieu failed to give such a thorough account, the present collection attempts to do so, with case studies including photography – Bourdieu's own – cinema, television, advertising, the Internet and social media. Our approach, while remaining aware of what Bridget Fowler calls the 'blind spots' of Bourdieu's theorisations of culture (see Chapter One), is to make use of the plentiful 'illumination' provided by his work, particularly what he tells us about the 'space of possibles' in diverse cultural fields.

One of the most fruitful extensions of Bourdieu's work on cultural fields concerns subcultures. Derived from Bourdieu's exploration of cultural capital, the term 'subcultural capital' was first coined by Sarah Thornton in her research on dance music and rave cultures (Thornton 1995). More recently it has been applied to cult films (Jancovich 2002), before being helpfully revisited in Bourdieuian terms (Jensen 2006), and again reformulated to investigate the diverse ways in which cult cinema is currently constructed (Hills 2015). Jensen in particular has critiqued Thornton for not being sufficiently aware of the hierarchical distinctions that inform and frame subcultures. He seeks to demonstrate 'the relative autonomy of subcultures' (in this case, Danish hip-hop cultures) 'without defocusing social structure' (Jensen 2006: 260). This he considers closer to Bourdieu's sociology by virtue of an emphasis on 'the unequal distribution of power to categorize and classify' (Jensen 2006: 264). Hills is more interested in how that power functions over time, noting that Thornton's work is mainly synchronic. Replacing this with a diachronic approach – as did Jancovich (2002) – Hills traces temporal changes in how cult cinema is constructed and renegotiated, suggesting that new media has a role to play in the generation of subcultural capital: 'new media might support new modes of subcultural distinction rather than merely challenging established taste hierarchies' (Hills 2015: 103). Online accessibility of previously rare material is, says Hills, often 'presumed to dilute cult's subcultural capital', but in fact 'technological change could give rise to new forms of cultish subcultural capital' such as 'mash-ups and re-enactments posted to YouTube' (Hills 2015: 104, 107; see also Klinger 2011).

Cultural capital remains perhaps the dominant Bourdieuian concept in use within cultural and media studies. Both cultural capital and the concept of

subcultural capital derived from it have been productive tools for recent film and media research. The concept of 'field' too has great value for research into any form of cultural production. A clear and resonant definition is given by Bourdieu in his study of television: 'A field is a structured social space, a field of forces, a force field. It contains people who dominate and others who are dominated. Constant, permanent relationships of inequality operate inside this space' (Bourdieu 1998a: 40). However, Jensen argues that subcultures are not quite fields, since they lack the stability that characterises the 'permanent relationships' that Bourdieu sees in a field. Jensen proposes the terms 'semi- or quasifields', or 'tentative fields, fields in the making' (Jensen 2006: 266). This compares with the concept of 'weak field' explored in our final chapter, by Antonio Di Stefano. But as Chris Cagle writes in this collection, generally 'the idea of the social field has had less impact than the notions of cultural capital, taste, and distinction'. He continues: 'film studies as a discipline has by now incorporated Bourdieu to address the matter of the consumption of media texts but it has been less concerned with using Bourdieu to understand the production of media' (see Chapter Two). Of course, questions of taste, consumption and reception are especially at stake in the way that online activity can function to establish differentials between users – see for example Eileen Culloty in this book (Chapter Four). Her research on different readings of the film *Hunger* posted to the imbd.com website persuasively illustrates Bourdieu's assertion that, in what he calls 'art perception', 'individuals have difficulty imagining differences other than those which the available system of classification allows them to imagine' (Bourdieu 1993: 223). As he says elsewhere about the media, 'whether you're talking about a speech, a book, or a message on television, the major question of communication is whether the conditions for reception have been fulfilled: Does the person who's listening have the tools to decode what I'm saying?' (Bourdieu 1998a: 29). Bourdieu's use here of the term 'decode' recalls Stuart Hall's influential 1970s essay, 'Encoding/decoding'. Hall points out that 'The codes of encoding and decoding may not be perfectly symmetrical' (Hall 1980: 131) and that the 'practices of coding' are concealed through an illusion of universality or naturalness associated with those codes imposed by the *'dominant cultural order'* (Hall, 1980: 132, 133, italics in original; see also Hall 2013). Bourdieu too reveals – in *Distinction* and elsewhere – the inequalities and universalising assumptions that inform cultural codes. The powerful essay 'Outline of a Sociological Theory of Art Perception' reveals how 'every work is, so to speak, made twice, by the originator and the beholder', and how one's mastery of a 'social code' determines the *'level of reception'* that one applies to cultural products (Bourdieu 1993: 224–25, italics in original). But reception or decoding is only part of the story.

In using Bourdieu to further our understanding of cultural production, an awareness of historical context and of what we might call the history of relationality is crucial. In Bourdieu's words, the 'entire history of production' is vital in order to understand contemporary production (Bourdieu 1993: 176). For a Bourdieu-inspired approach to film and media, then, the concepts 'history of production' and 'universe of the points under discussion' (Bourdieu 1993: 176) are just as valuable as more well-known keywords such as field, capital and habitus. Bourdieu's essay 'Principles for a Sociology of Cultural Works', reprinted in *The Field of Cultural Production*, adds to this list the phrase 'the space of possibles' or 'space of possibilities', shorthand for the choices available to agents in a given social, cultural and historical context; choices that thus become 'the instruments and stakes of the struggle' (Bourdieu 1993: 176). Each 'peculiar universe', then, is one of dominance, a space for the exercise of power, but it is also a place where struggle and improvisation can take place. Hence, contemporary literature, for instance, 'is the product of a long, partly repetitive, history, or, more precisely, a long struggle among theories and theoreticians, writings and writers, readings and readers' (Bourdieu 1993: 184). Such a history is shorter for the fields of film and media – even shorter still for new media – but as several of the chapters in this volume show, the struggle among producers and consumers in turn produces the field itself, from the field of film festivals to that of social media.

The question of time is significant. As Bridget Fowler puts it, each of the fields under analysis here possesses 'their own sense of time'. For his part, Bourdieu asserts that 'It is possible to distinguish, very roughly, *classical periods*', which see the perfection and even exhaustion of 'the possibilities provided by an inherited art of inventing', and '*periods of rupture*, in which a new art of inventing is invented' (Bourdieu 1993: 225, italics in original). To reiterate the importance of how production changes over time, and is only eventually caught up by its reception (via art competence), Bourdieu notes that 'the works produced by means of art production instruments of a new type are bound to be perceived, for a certain time, by means of old instruments of perception, precisely those against which they have been created' (Bourdieu 1993: 225–26). Exemplifying this process, we might note that the perception of early cinema was to a degree determined by conventions established by the theatre and even painting – a 'classical' connection that has been sought by film producers and exhibitors at various times since, via movements such as the film d'art in pre-World War One France. According to the film historian Richard Abel, the years between 1907 and 1911 saw 'Pathé's attempt to redefine the cinema and attract a white-collar and bourgeois audience. Critical support for this effort was needed from

French writers, especially dramatists' (Abel 1998: 40). As a result of such support, largely in the form of theatrical adaptations under the auspices of the tellingly named Société cinématographique des auteurs et des gens de lettres, 'art' cinema was consecrated as akin to theatre (see Abel 1998: 40). Moreover in France, cinema was – and still is – brought into the circle of 'classical' values by the means of the term 'the seventh art', thus ranking film alongside its artistic antecedents from previous epochs. In fact this consecration can be seen as part of the pre-World War One legitimisation of the field in France: the term 'seventh art' was initiated by the Italian film theorist Ricciotto Canudo in 1911. As well as writing the *Manifesto of the Seventh Art*, Canudo set up France's first cine club and founded a film art review. (The other six arts, by the way, are architecture, sculpture, painting, dance, music and poetry; television is known as the 'eighth art' in France and comic book art as the 'ninth'.)

In terms of the critical perception of new media no less than that of different schools of cinema, a Bourdieuian engagement with digital technologies implies an awareness of how these fields have developed, and a readiness to consider the power differentials within them. For Richenda Herzig (in Chapter Six), this means 'a reconceptualisation of digital inequality, and fresh methodological strategies for exploring it'. Justin Battin, meanwhile, illustrates how mobile media devices can operationalise digital technology and social networks to generate forms of capital and distinction 'within a cultural field that values such distinctions' (see Chapter Seven). Bourdieu's perceptive analysis of the way that art competences function can be illuminating for the study of new media, but has not always been viewed in this light. Indeed, as Richenda Herzig notes, researchers in Internet studies 'have sought to characterise Bourdieu's field theory as limited to an earlier form of modernity', and therefore as of little use when applied to newly developed cultural forms. However as she goes on to add, 'Bourdieu is not trying to advance a prescriptive theory, but rather a conceptual procedure. Contextual features combine with each component of the framework in order to form an entirely unique construction'. Simply put, for Bourdieu, 'the real is relational' (see Bourdieu and Wacquant 1992: 97). In a collection of essays on Bourdieu, language and culture, Christian Vermehren has asserted that media studies in general has been characterised too often by substantialist rather than relational thinking. This has led it to seek the location of reified meaning in a particular producer, text or context. In this regard, he writes, much could be learnt from Bourdieu's approach to the relationality of any given field:

> The belief that meaning can thus be found *somewhere* is, in my view, dubious insofar as it ignores the relational aspect of meaning. But even worse,

> the attempt to locate the *prime* location of meaning causes serious problems
> . . . in that it encourages a separation of media content and the context of its
> production or reception. (Vermehren 1999: 193, italics in original)

We share this concern, and have tried to avoid such a separation between
content and context in our case studies. From Bourdieu's own photographs
of Algeria during the anti-colonial war against French occupation (see
Chapter Three by Sophie Belot) to the news, television and advertising
texts circulating around the figure of the millennial hipster (Chapter Five
by Anthony McIntyre), we place media texts firmly in the context of their
production and reception.

Despite writing rarely on film, Bourdieu did, as is well known, make
several targeted interventions with regard to television, including the tele-
vised lectures on TV and journalism at the Collège de France in 1996 that
were subsequently published in book form as *Sur la télévision /On Television*.
Among his insights in this work is the observation that simply by agreeing to
appear on television, a scientist, author or other autonomous figure allows
external, commercial pressures to reduce the autonomy of their own field
(see Bourdieu 1998a: 60). As a result he urges autonomous fields 'to combat
these heteronomous individuals' in their midst. But this is not to keep art,
culture or 'universality' locked away for the elite. On the contrary, 'We must
struggle to . . . defend the conditions of production necessary for the prog-
ress of the universal, while working to generalize the conditions of access
to that universality' (Bourdieu 1998a: 63, 66). In his account of the adverse
reaction of the French media (and especially television journalists) to *On
Television*, Bourdieu states that they failed to understand he had approached
it as an object of scientific study; that is to say as a field. We would expect no
less. But at times his perception of television as a blanket threat to culture
may seem a little under-researched – more subjective rather than objective:
'I think that television poses a serious danger for all the various areas of cul-
tural production – for art, for literature, for science, for philosophy, and for
law' (1998a: 10). Surprisingly for a French commentator, Bourdieu does not
mention the cinema in his list of practices under threat from television. He
does however mention one of the many film-makers who have often made
this point in France: the renowned Swiss director Jean-Luc Godard. Hailing
the work of a truly autonomous artist, Bourdieu quotes some of Godard's
1972 interviews and declares that 'a true critique of images through images'
is to be found in 'some of Jean-Luc Godard's films'. Godard thus exemplifies
for Bourdieu autonomous film-makers' fight for 'the independence of their
communication code' (Bourdieu 1998a: 11–12). He adds: 'Indeed, I could
have taken Godard's agenda as my own: "This work was a beginning of a

political [I would say sociological] questioning of images and sounds, and of their *relations*'" (Bourdieu 1998a: 12, italics in original). While Bourdieu's appraisal of Godard is well founded, it is noteworthy that it should be Godard rather than any other director who is selected for such attention. Experimental throughout most of his career, and a maverick who is not however without great honour in his (adopted) country, Godard is the most stylistically challenging figure to come out of the French New Wave. Hence despite vast amounts of artistic capital, Godard –unlike the far less formally experimental François Truffaut or Claude Chabrol – has often struggled to find a sizable audience. His major film of 1972, *Tout va bien*, which featured two international stars at the height of their fame in Jane Fonda and Yves Montand, only attracted 30,000 spectators in France (against expectations of at least 100,000). Godard therefore epitomises the Bourdieuian figure of the artist working in a select, autonomous field, experimenting with the medium, and striving to stand outside the demands of the market. But this focus on Godard begs the question: for Bourdieu, can art ever be popular?

Bourdieu's dismissal of popular culture is no secret. As Bridget Fowler writes, 'Various critics have noted the clash between Bourdieu's sympathies with working-class people and his failure to accept that there is such a thing as popular art' (Fowler 2000: 14). More specifically, 'his thesis that popular art can become consecrated but *only when it is no longer popular*' is described by Fowler as oversimplifying 'the wider struggles over popular art' and ignoring 'the differentiated responses to popular culture' (Fowler 2000: 15, italics in original). Bourdieu can also seem overly schematic and insufficiently open to ambiguity when placing cultural production in one camp or the other. Take a notable example from pop music, The Beatles. Their success in both artistic and commercial terms (even with their most experimental work, such as the so-called White Album) would surely pose a problem for Bourdieu, even if we see popular music as an industry characterised as early as the 1960s by a form of globalisation. For The Beatles managed to combine art and commerce, autonomy and sales, tape loops and number one hits. As their most astute chronicler Ian MacDonald has noted, 'That The Beatles represented something transmitting at a higher creative frequency was clear even to many outside the pop audience', including, for example, autonomous literary figures such as Allen Ginsberg (MacDonald 2008: 1, 101). It is only if the field of pop music is considered a priori an economic rather than a cultural one that The Beatles' twin achievement is not registered.

Where cinema is concerned, Bourdieu again seems careful to maintain the polarity between art and commerce. In his late collection of essays, *Contre-feux 2*, we find a brief account of the development of the field of what

we would call art-house cinema (what he terms *cinéma de recherche*) in post-war France in the years leading up to the New Wave. Bourdieu is astute in emphasising the contribution to the production of symbolic capital made in the 1950s by new audiences (students) and new organs (film clubs, specialist reviews, cinémathèques), but he neglects the commercial imperatives behind even the New Wave, and posits the *'irruption du cinéma commercial'* [sudden emergence of commercial cinema] as a new phenomenon appearing at the turn of the millennium, rather than a presence that has been part of the film industry since its origins a century before (see Bourdieu 2001: 82). French cinema in the sixties, for example, embraced popular comedies, thrillers, war films, even spoofs of the successful Anglo-American James Bond series, alongside the 'consecrated' work of the New Wave directors. And even Godard had to raise money for his films, as the cheque-signing sequence from *Tout va bien* self-consciously acknowledges.

As Godard's New Wave colleague Chabrol had declared a few years earlier – before drifting into more 'middlebrow' if commercially viable projects – diminishing audiences for his own films taught him something terrible but important: *'le fait que le cinéma est obligatoirement un art de masse'* [the fact that cinema is by definition an art for mass consumption] (see Austin 1999: 34). To this we can add Bourdieu's observation that cinema is usually a collective enterprise, carried out within 'production units' that entail a 'transformation of the relationship between producers and their own work' (Bourdieu 1993: 130). Again Chabrol epitomises this, working with a regular team or 'family' of collaborators including technicians, actors and writers, and was happy to adapt scenarios written by others, even if this ran contrary to the auteurist values of the *Cahiers du cinéma* and the New Wave. Chabrol also moved from 'pure' New Wave film-making into genre pictures, including war films, spy spoofs and literary adaptations. The demarcation line between auteur cinema and genre cinema – close to the distinction between restricted production and large-scale cultural production that Bourdieu identifies in his essay 'The Market of Symbolic Goods' – remains operative in film discourse and practice today. Nonetheless, and perhaps surprisingly given his reluctance to engage at length with cinema, Bourdieu is perceptive on the tendency of film genres to change over time, and particularly to develop in the direction of self-conscious allusions, intertextuality, parody or pastiche: 'A genre containing ever more references to the history of that genre calls for a second degree reading, reserved for the initiate, who can only grasp the work's nuances and subtleties by relating it back to previous works'. Rarefied products such as '"Intellectual" Westerns' are according to Bourdieu 'the logical conclusion of these *pure cinematographic language games*' (Bourdieu 1993: 128, my italics). Thus a genre

can start off as 'middlebrow' but become increasingly 'pure' or autonomous. Similar points have subsequently been elaborated by key writers on film genre, such as Rick Altman (see Altman 1999, especially 77–82), but it is instructive to see Bourdieu making this case, especially acknowledging that genre cinema – still a dismissive term in much French discourse on film – can be as nuanced and subtle as so-called art cinema.

In the essay 'La Culture est en danger' from *Contre-feux 2*, Bourdieu suggests that globalisation is having a massive but insufficiently acknowledged impact on culture. Referring back to his work in *The Rules of Art*, he notes that the long and arduous formation of artistic fields as autonomous – the rules of art – positioned these fields in contradistinction from the rules that governed the surrounding social world, notably the economic rules (see Bourdieu 2001: 75–76). By contrast, contemporary patterns of globalisation in the developed world have resulted in the collapsing of differences between the cultural and economic fields (the submission of culture to market pressures) and hence a loss of cultural and artistic autonomy. In Bourdieu's words, the independence of cultural production and circulation *'se trouve menacée, dans son principe même, par l'intrusion de la logique commerciale'* [is threatened, in its very principles, by the intrusion of commercial logic] (Bourdieu 2001: 76, my translation). He gives as examples the marketing of television programmes, books, films and video games as merchandise, just like any other product (Bourdieu 2001: 77). More specifically, Bourdieu's view of culture in the new millennium included a fear that a kind of involution was taking place, whereby new technologies meant that the artist was being replaced by the technician: *'une régression, de l'oeuvre vers le produit, de l'auteur vers l'ingénieur ou le technicien, mettant en jeu des ressources techniques qu'ils n'ont pas eux-mêmes inventées, comme les fameux effets spéciaux'* [a regression from the work of art to the product, from the author to the engineer or the technician, putting to use technical resources that they have not invented themselves, as in the much talked-about case of special effects] (Bourdieu 2001: 82, my translation). Such a context replaces what Bourdieu calls the 'traditional cultural producer [as] a master of his means of production', investing not financial capital or technological resources but 'only his cultural capital, which was likely to be perceived as a gift of grace' (Bourdieu 1993: 131).

Bourdieu's thought is complex and passes through various phases. The militant, millennial urgency of his late writings against neo-liberal globalisation and the spread of *précarité* makes the interventions of *Contre-feux* and *Contre-feux 2* vital political commentary, but they do not always provide the most useful tools for research into contemporary cultural forms. As indicated above, such usefulness derives primarily from Bourdieu's earlier work from the seventies and eighties, such as the essays gathered

in *The Field of Cultural Production*. But even Bourdieu's late insights in the closing years of the century into the imbrication between fields and the power relations within them can be of great value. His writing on the interrelation of politics and journalism can be applied very effectively to current debates about the function of the media, such as that in the United Kingdom around the influence of press barons in the wake of the phone hacking scandal of recent years. The 1997 article 'La télévision, le journalisme et la politique' on French journalists' position in the political world predicts the relations between the Murdoch press and British politicians ten or fifteen years later: *'où ils sont des acteurs très influents sans être pour autant des membres à part entière et où ils sont en mesure d'offrir aux hommes politiques des services symboliques indispensables'* [they (journalists) play a very influential role without actually standing entirely apart; they are in a position to offer politicians symbolic services which are indispensable] (Bourdieu 1998b: 79, my translation). For Bourdieu, the field of journalism, insofar as it relates to politics through strategies such as structural amnesia, the obsession with scoops and novelties, cynicism, lack of continuity, and the promotion of combat rather than debate, creates an effect of depoliticisation, or more exactly generates a disenchantment with politics (Bourdieu 1998b: 80). The more general result is *'une représentation instantéiste et discontinuiste du monde'* and a vision that is *'déshistoricisée et déshistoricisante, atomisée et atomisante'* [a short-termist and discontinuous representation of the world, dehistoricised and dehistoricising, atomised and atomising] (Bourdieu 1998b: 82, my translation). And again, in a 1997 interview, Bourdieu declared that *'Les médias sont, dans l'ensemble, un facteur de dépoliticisation qui agit évidemment en priorité sur les fractions les plus dépolitisées du public'* [the media are, on the whole, a depoliticising factor which obviously works above all on the most depoliticised fractions of the public] (Bourdieu 1998b: 88, my translation).

We would do well to bear this in mind when we read that politics 'has become coterminous with popular culture' or that 'politics can be understood as a form of popular culture' (Street 2001: 217, 223). Bourdieu reminds us that it can be a depoliticised, depoliticising form of politics that is evident in 'the media' and in popular culture. The real workings of power may be elsewhere. As he notes in *On Television*, TV 'can hide by showing'. Inasmuch as he engaged with the role of the media in politics, therefore, Bourdieu saw television as 'a formidable instrument for maintaining the symbolic order' (Bourdieu 1998a: 19, 17). His position with regard to new digital media would no doubt have been what Barrie Axford terms the third position – neither 'techno-progressive' nor 'retro-nostalgic' but sceptical about the supposedly transformative power of new media,

seeing the latter as 'instrumentalities for the more or less efficient delivery of usual politics' (Axford 2001: 9). But speculating about what Bourdieu might have said about digital and screen cultures is not the point. It is time to use Bourdieu's sociological and cultural insights in order to develop our own ways of addressing, evaluating and interrogating such forms in an illuminating way. That is the hope of this collection.

REFERENCES

Abel, R. 1998. *The Ciné Goes to Town: French Cinema 1896-1914*. Berkeley, Los Angeles and London: University of California Press.

Altman, R. 1999. *Film/Genre*. London: BFI Publishing.

Austin, G. 1999. *Claude Chabrol*. Manchester: Manchester University Press.

Axford, B. 2001. 'The Transformation of Politics or Anti-Politics?', in B. Axford and R. Huggins (eds), *New Media and Politics*. London: Sage, pp. 1–29.

Bourdieu, P. 1993. *The Field of Cultural Production: Essays in Art and Literature*. Cambridge: Polity.

———. 1998a. *On Television and Journalism*. London: Pluto.

———. 1998b. *Contre-feux: Propos pour servir à la résistance contre l'invasion néo-libérale*. Paris: Raisons d'agir.

———. 2001. *Contre-feux 2: Pour un mouvement social européen*. Paris: Raisons d'agir.

Bourdieu, P. and L. Wacquant. 1992. *An Invitation to Reflexive Sociology*. Cambridge: Polity.

Fowler, B. 2000. 'Introduction', in B. Fowler (ed.), *Reading Bourdieu on Society and Culture*. Oxford: Blackwell/The Sociological Review, pp. 1–21.

Hall, S. 1980. 'Encoding/decoding', in S. Hall, D. Hobson, A. Lowe and P. Willis (eds), *Culture, Media, Language: Working Papers in Cultural Studies, 1972-79*. London and New York: Routledge, pp. 128–38.

———. 2013. 'The Work of Representation', in S. Hall, J. Evans and S. Nixon (eds), *Representation*. London: Sage, pp. 1–59.

Hills, M. 2015. 'Cult Cinema and the 'Mainstreaming' Discourse of Technological Change: Revisiting Subcultural Capital in Liquid Modernity', *New Review of Film and Television Studies* 13(1): 100–21.

Jancovich, M. 2002. 'Cult Fictions: Cult Movies, Subcultural Capital and the Production of Cultural Distinctions', *Cultural Studies* 16(2): 306–22.

Jensen, S.Q. 2006. 'Rethinking Subcultural Capital', *Young: Nordic Journal of Youth Research* 14(3): 257–76.

Klinger, B. 2011. 'Re-enactment: Fans Performing Movie Scenes from the Stage to YouTube', in P. Grainge (ed.), *Ephemeral Media: Transitory Screen Culture from Television to YouTube*. London: BFI/Palgrave Macmillan, pp. 195–213.

MacDonald, I. 2008. *Revolution in the Head: The Beatles Records and the Sixties*. London: Vintage.

Marlière, P. 2000. 'The Impact of Market Journalism: Pierre Bourdieu and the Media', in B. Fowler (ed.), *Reading Bourdieu on Society and Culture*. Oxford: Blackwell/The Sociological Review, pp. 199–211.

Street, J. 2001. 'The Transformation of Political Modernity?', in B. Axford and R. Huggins (eds), *New Media and Politics*. London: Sage, pp. 210–24.

Thornton, S. 1995. *Club Cultures: Music, Media and Subcultural Capital*. Cambridge: Polity.

Vermehren, C. 1999. 'Bourdieu and Media Studies', in M. Grenfell and M. Kelly (eds), *Pierre Bourdieu: Language, Culture and Education: Theory and Practice*. New York: Peter Lang, pp. 187–96.

Guy Austin is Professor of French Studies and Director of the Research Centre in Film & Digital Media at Newcastle University, UK. He is one of the editors of *Studies in French Cinema*, and the author of various articles and essays on French and Algerian cinema, as well as the monographs *Contemporary French Cinema* (1996/2008), *Claude Chabrol* (1999), *Stars in Modern French Film* (2003) and *Algerian National Cinema* (2012).

Bourdieu, Field of Cultural Production and Cinema

Illumination and Blind Spots

Bridget Fowler

This chapter discusses the logic of Bourdieu's theory of practice, moving from his initial discussion of the minor art of photography to the later analysis of the fields of cultural production. In his early works he states that the minor arts fail to undergo a consecration process because the necessary symbolic interests in doing so are absent. His second phase includes analysis of the genesis of the restricted cultural field and the distinctive author's point of view. This pivots on the accumulation of symbolic capital and the struggle for autonomy from the market and authoritarian state. I shall lay out some of the problems with this account, particularly those clustering around his views about popular art. Finally, I shall reflect positively on Bourdieu's value for the sociological and political dissection of the cinema.

In 1978, in France, Bourdieu's *Distinction* had the shock of the new:

> It is barbarism to ask what culture is for; to allow the hypothesis that . . . interest in culture is not a natural property - unequally distributed, as if to separate the barbarians from the elect - but is a simple social artefact, a particular form of fetishism . . . (Bourdieu 1984: 250)

In other words, Bourdieu invites us to explore the fetishised sacralisation of secular culture within modern capitalist societies. His research reveals

that amongst other uses, the arts contribute a symbolic armour to the dominant classes, testifying to their spiritual values and seemingly innate good taste. This demystifying analysis permeates Bourdieu's first phase, offering an unrelenting disenchantment of the world. It reveals how much our taste is determined by habitus, formed by a family's trajectory over several generations.

Habitus differentiates actors' modes of perception, judgement and evaluation of the world and drives the embodied practices that are improvised in relation to these. Felt like a second nature, it is crucially shaped by positions of power or powerlessness, including exposure to immediate material urgencies. In advanced capitalist societies, this positioning in social space depends not just on the volume of economic capital but crucially on educational qualifications – cultural capital – which is in part pursued instrumentally as a labour market investment, entailing material rewards. Specifically, agents' diverse capitals, classifications of the world and social practices need to be understood within different fields, or specialised occupational areas.

In particular Bourdieu focuses on the genesis within Europe of the restricted field of cultural production, including the Romantic invention of the cursed or Christ-like artist. Crucially, in France by the mid nineteenth century the artist had come to occupy a second bohemia, a space for autonomous cultural production, free not only from the control of the State and the Church but also from the 'Hidden God' of the cultural industry, who demands market success or high audience ratings (1998a: 25).

Bourdieu's sociology possesses the greatest potential for discovering the underlying structures or 'mechanisms' governing contemporary social reality. The study of cinema throws up both fertile and problematic areas in his general logic of cultural practice. We will benefit from being neither too pious nor too iconoclastic towards him, but from developing his social theory.

THE MINOR ARTS – PHOTOGRAPHY AND CINEMA

Cinema appears fleetingly in an early text, *Photography – A Middlebrow Art* (Bourdieu with Boltanski et al. 1990). Published in France in 1965, this book claims that it is the technology of photography together with its everyday family use that have so far proved insuperable obstacles to classifying it as an art form. Hence the absence of any sanctified tradition of consecrated practitioners. Like photography, cinema (and jazz) are both potentially 'legitimisable arts' but are doomed never to become major arts.

Why should Bourdieu possess such a tragic view? In order to grasp this we need to see that he approaches photography as Durkheim did religion. Across classes, he contends, photography has become part of the sacred cult of the family. Taking wedding or honeymoon photographs testifies to the importance of the occasion; to use a phrase he had deployed earlier, these stereotyped images contribute to collective memory (Sorlin 1977: 98). Of course, those with the highest cultural and economic capital realise photography could be an aesthetic practice but, given the necessary economies of time, they choose to dedicate their energies to more 'noble arts' – opera, theatre or literature. Consequently, the more exploratory uses of the camera are restricted to the subordinate classes, notably the petty bourgeoisie and skilled workers. It is from these classes that people come together in camera clubs around a different practice. Yet even then experimentation is rare; either they take classical academic conventions of painting as their aesthetic model or their interests are mainly technical. Bourdieu himself adopts a critical subtext, emphasising the subtle perspectivism and juxtaposition of contrasts that the camera can allow, and citing Proust to claim that photography permits the destruction of the '"cocoon of habit"' (Bourdieu with Boltanski et al. 1990: 75–76). Dependence on a mechanical process does not remove the potential for defamiliarisation, a destabilising gaze.

Photography could in principle deploy images to undermine the usual frames of perception, thus unsettling the habitus and with it the stable processes for the social reproduction of power. Bourdieu refers throughout his works to Bakhtin and the Russian avant-gardists: in other words, he possesses an overlooked constructivist aesthetic that he shares with photographers like Rodchenko (Gray 1986; Tupitsyn 2009).

Yet since the early '60s, Bourdieu has been in part disproved by events. Photography has been recognised as one of the major arts. Further, an orthodox history of the art has been disseminated, to which his co-author Chamboredon alluded – Stieglitz, Brassai, Clergue, Moholy-Nagy and Cartier Bresson (Bourdieu with Boltanski et al. 1990: 146–47, 209). Has the same fate occurred in the case of Bourdieu's other 'legitimizeable arts' – such as cinema? Indeed: the cinema is now preserved via multiple forms of canonisation including higher education curricula. Bourdieu implicitly acknowledges this consecration in *Distinction* where he identifies a surrogate high/low division between the educated who classify films via directors and the uneducated who classify them via actors (1984: 26–28, 564; cf. Orr 1993: 182). Further, just before his death, he alerts us to the renewed dangers that the cinema of the 'auteur' is collapsing, following neo-liberalism (Bourdieu 2002).

BOURDIEU'S SECOND PHASE (FROM THE 1980S ONWARDS): A MOVE FROM THE ETHIC OF SUSPICION TOWARDS THE ANALYSIS OF CRITICAL 'HETERODOXIES'

Bourdieu's early phase – including *Photography* – was underpinned by an ethic of suspicion, provoking the critical unmasking of privilege and power. It revealed how claims of a universalistic stance are offered that act as a front for class or other concealed interests. He never ceased to think this important, yet he also possesses a second, later phase. This represents a defence of what he called the 'corporation of intellectuals', in particular an appeal to universalistic ideas and an elucidation of the resources conducive to an end to domination, a reasoned utopia (1989, 1998b). This second phase was in part his response to certain misuses of social theory that he classified as 'narcissistic relativism' and 'chic radicalism'; in part, to the rolling back of the welfare state with the financialisation of capitalism (1998c: 50, 94–105).

In these later works, he emphasises how within the fields of professional existence in modernity such as the law, specific universalistic rules are codified, rules that should be seen as necessary and 'disinterested' (Guibentif 2010: 277–78). These advance a wider 'corporation of reason' and autonomy, free from domination by market logic or political power (Bourdieu 1996: 343–48). The consecrated arts, although often given a final State imprimatur, form part of these activities (Bourdieu 2014: 157–58 and 188). Heretical visions and divisions of the world are associated intimately with the artistic or experimental subfield – cinema has its place here alongside the other arts.

CLOSE-UP: THE AUTONOMOUS OR RESTRICTED (SUB)FIELD

Bourdieu famously describes the restricted cultural field (or the Republic of Letters) in terms of the historical battle for the conquest of autonomy in post-1848 France. He elucidates this through the work of modernist writers (such as Baudelaire or Flaubert) and artists (Manet particularly, but also the later avant-gardes). His analysis breaks with the usual hagiography and the 'biographical illusion'. Granted, 'Bourdieu's modernists' act with an improvisational flair and a 'feel for the game', but also in accordance with their class and the concerns derived from their artistic habitus. Front stage, they may be valued for their 'natural' distinction but they may also exhibit – backstage – strategic interests in the field, interests of which they themselves are not always fully aware. But what are the key elements of the restricted subfield?

First, an ethical rupture is the fundamental dimension of all aesthetic ruptures (1996: 60–61), which is noteworthy since Bourdieu's critics claim that none of his actors are capable of reflexive thought except the sociologist (Alexander 1995). For Bourdieu, cultural producers are capable of at least some critical reflexivity about the social world. In Flaubert's case, for example, he paints a sociological image of Frederick in *Sentimental Education* engaging in 'social flying', interacting with all or 'flying' above every social circle and thus understanding the point of honour in each.

Second, new art has to make its own public, and at first is appreciated only by fellow producers working in the same field (Bourdieu 1996: 82). Here he writes of the contemporary arts having to create their own demand (cf. Marx 1973: 92–93) – indeed, an individual artist's failure may be conveniently masked due to this. The heroic modernists of the first generation made an artistic rupture via 'formalist realism' with safe academic forms; they paid a heavy price – exile or impoverishment – after criminal prosecutions.

Third, by the early twentieth century, a period of permanent revolution had been instituted within the restricted avant-garde field via successive symbolic revolutions (Bourdieu 1996: 239). For Bourdieu, this has multiple consequences, prompting, not least, a degree of strategic position-taking on the part of artists. This is most evident from the art-world insiders: 'naturally distinguished' figures – such as Duchamp or Picasso – learnt a feel for the game from their artistic families and are thus like 'fish in water' (1996: 246–47, 276–77).

Fourthly and lastly, Bourdieu challenges the portrayal of the artist in Western Romanticism in which the doomed creator not only possesses innate gifts but reveals the charismatic Christ-like mystique of the cursed artist. 'God is dead but the uncreated creator takes his place' (1996: 189), he remarks, in unmasking mode. Yet in Bourdieu's thought, this challenge does not entail the death of the author. Instead, he wants to substitute for this earlier individualistic view a more social or relational account of how the artist in the autonomous subfield manages to acquire her 'author's point of view'. At root, the 'illusio' or group ethos within the cultural field operates as a professional ethic for artists or writers. The artistic illusio entices them to sacrifice (at least short-run) worldly status and material wealth for the sake of art. In particular, it establishes a duality of hierarchies – the position of the art form within the hierarchy of arts (for example, poetry above the novel) and 'secondarily, to the hierarchy of the ways of using them which, as is seen clearly in the case of the theatre and especially the novel, varies with the position of the audiences reached in the specifically cultural hierarchy' (1993a: 47). Artistic legitimacy is inversely related to other forms

of legitimacy, notably to 'the economic and political profits secured by success'; either 'high society successes and bourgeois consecration' [. . . or] 'so-called "popular" success – the authors of rural novels, music-hall artists, *chansonniers*, etc' (1993a: 46; see also 46–52).

The making of the autonomous field is rather like the making of the working class – it involves continuous struggle and is perpetually endangered. In literature, the political blacklisting and exile of the African-American writer Richard Wright offers post-World War II evidence (Dickstein 2009: 174–97). In cinema, the forced departure of Patricio Guzmán and Raul Ruiz from Chile after the 1973 coup, the banning from film production the Iranian Jafar Panahi (see *This is Not a Film,* 2011) and the permanent exclusion from Algeria of the director Nadir Moknèche all indicate how hard this has been to establish and maintain. In Bourdieu's terms, artists in the restricted field break with commercial interests, elite patronage – their very security – to found an alternative bank of symbolic values: part of a wider 'Internationale of intellectuals' (1996: 344).

CRITIQUE

Bourdieu has been variously criticised; for example by Born (2010), Hennion (2007) and Prior (2011) in the sociology of music for not explaining the 'affective and sensual qualities of musical encounters', or how actors actively deploy music to 'craft their ongoing emotional and biographical selves' (Prior 2011: 132). This is certainly a valid critique of Bourdieu's approach to music. But nobody who has read him on Baudelaire or Flaubert could fail to note his sensitivity both to new ways of seeing and to those stylistic innovations that created the symbolic revolutions in poetry and the novel. Here it is worth recalling his view that sociology is not intended to dismiss the reality of the aesthetic sense. Rather it is to provide a strong sauce for it, so that by these means it 'intensif[ies] the literary experience' (1996: xvii).

There are, however, two more profoundly intractable problems with Bourdieu: first the question of artists' material needs, which I have discussed elsewhere (Fowler 2012); second, the problem of popular art. Bourdieu viewed the notion of popular art as a dangerous illusion and another form of 'radical chic' condescension that naively neglects the educational prerequisites for artistic participation (1990a: 152–53, 1993a: 70, 129). The subordinate classes lack access to the necessary educational prerequisites, so they are automatically excluded from the area of autonomous art. Moreover a realist account has to acknowledge that '[p]opularization devalues'. As

works become more available – for example, Mozart and Beethoven today – they lose their rarity: 'Déclassé goods no longer give class' (1993b: 114).

Certain exceptions exist. First:

> When [rarity] is threatened on one side it can be brought back from another angle [as in] the games of some composers who, like Mahler or Stravinsky, enjoy playing with fire, by using, at the second degree, elements of the popular or even "vulgar" music borrowed from the music hall or the dance hall. (1993b: 114–15)

Secondly, and infrequently, a writer of popular novels may be consecrated. This was the case when Zola – hitherto discredited as a commercial naturalist – famously intervened with his newspaper article 'J'accuse!' on behalf of the falsely imprisoned Jewish officer Dreyfus (Bourdieu 1993a: 54 and 1996: 131, 258, 341–42). But other claims for 'popular art' merely represent intellectuals' wish-fulfilling imposition onto the subordinate classes of an alien discourse, such as the designation of Georges Brassens and Jacques Brel as poets. This 'betrays their [intellectuals'] recognition of academic legitimacy in the very discourse attempting to challenge it' (Bourdieu 1993a: 292, footnote 26).

Is this not a half-truth? Yes, their discourse may indeed 'betray' this, but this does not remove the possibility that working people themselves may find these singers' lyrics poetic. Bourdieu is certainly right that most workers lack the educational prerequisites necessary for artistic production, especially those works deploying modernist styles (see, on this, Grignon and Passeron 1989; Rose, 2002). But – in the case of cinema – this still allows for some artistically powerful films to gain a popular audience. This includes, if more rarely, those examples of film art made by directors who have themselves originated from the subordinate classes (James 1993; Dickstein 2009). Of these, Almodovar is a contemporary example (Arroyo 1992), as is the British director Steve McQueen, now hailed in Hollywood.

Bourdieu's uncompromising disavowal of any popular art in modernity is, in my view, a distinctive blind spot, especially given his awareness of popular oral poetry amongst the Kabylian Algerians. He regards these poets as sages, possessing a vocation that made them not just the bearers of the experience and collective memory of the group, but also improvisers who use double-coded verses – popular and more esoteric forms – to say the unsayable and respond innovatively to crises (Bourdieu and Mammeri 1978; Bourdieu 1990a: 97; Bourdieu 2008; Bourdieu 2014: 58–61). For him, this richness is what is lost in a class society when the cultural heritage becomes annexed by the few. Yet whilst he never developed this aspect

himself, Bourdieu's study of Kabylia might serve as the seed corn for a
theory of the popular arts in capitalism.

CINEMA: THE GENESIS OF AN AUTONOMOUS RESTRICTED FIELD

Like the novel, the entire cinematic field originated as a popular form,
branching off from theatrical melodrama in the early years of the twentieth
entury (Levine 1988; Taylor 1999; Baumann 2007). Yet a key point that
Bourdieu's sociology of culture might obscure is that cinema has consis-
tently yielded consecrated films whose artistic power has been appreciated
at both a popular and more esoteric level. This is true of many of the early
Soviet directors whose work was shown in Workers' Film and Photo clubs
internationally from the 1920s onwards (Bordwell 1997: 100; Heise and
Tudor 2007). Williams, noting this, emphasises that early cinema was both
modernist and questioning, and also an undoubtedly popular culture:

> What has been lost, in the whole process [with tendencies to monopolisation]
> is not so much the consciously modernist work, which can find a not uncon-
> genial place at the margins, but the fully autonomous development of native
> popular cultures which keep showing their strength whenever there is even half
> a chance . . . (1989: 145)

Williams is right. Nevertheless, at the heart of this popular cinema as well as
on its margins we can detect the uneven development of an autonomous or
'restricted field' (cf. Hesmondhalgh 2006: 217). Indeed, as early as the 1920s
in France some popular films were undergoing an initial consecration, trig-
gered by their recognition from 'authorised' viewers, such as Man Ray and
Pirandello (Duval and Mary 2006).

The emergence of a distinctive 'art-house cinema' occurred first in
France and then at different times within different societies – Europe before
America (Wilinsky 2001; Baumann 2007; Heise and Tudor 2007). By the
late 1950s, the French avant-garde had embarked on the 'symbolic revolu-
tion', which was to produce a restricted subfield similar to that of litera-
ture, prized more by intellectuals than as a popular taste. Familiar as the
Nouvelle Vague (New Wave) – that is, Godard, Truffaut, Rohmer, Chabrol,
Rivette and Doniol-Valcroze and on the Left Bank, Marker, Resnais, Varda
and Demy – this included many directors who had previously been writ-
ers for *Cahiers du Cinéma* (Lovell 1972). As Lovell has argued so powerfully,
this movement was the equivalent of a new Kuhnian paradigm (1972: 342).

Yet surprisingly, the Young Turks of the New Wave segregated themselves not from the makers of Hollywood B movies but from the currently popular French mainstream cinema or the 'cinéma de papa': detective films featuring Maigret, etc. (Vincendeau 1992: 57, 71).

The tension now typically perceived between an 'artistic' and an 'industrial' logic is addressed very clearly in Darré's historical sociology of the cinematic field (2006). On the one hand, France after World War II had witnessed the decline of the 'artisanal' production of the popular community cinemas and cine clubs in the face of competition from the American studio system, with its assembly line 'detail division of labour'. Yet on the other hand, cinema started to acquire the legitimacy that Bourdieu had thought might never be achieved. Agencies of consecration emerged, especially via the 'gatekeepers' of the *Cahiers du Cinéma* and the new Grandes Ecoles film schools, the Ecoles Louis Lumière and FEMIS.[1] A theory of auteurism emerged, attributing extraordinary creative qualities to iconic film directors, despite awareness that cinema is collective and dependent on a complex division of labour (Bordwell and Thompson 1979; Becker 1982: 83–85; Taylor 1999). Hence the accolades for the distinctive points of view within the New Wave authors (Lovell 1972; Vest 2003). Godard himself famously celebrated the film director as a solitary auteur making films 'as though in front of a blank sheet' (cited in Darré 2006: 134). Models of creativity such as this produce inherent friction and even open conflict. Nevertheless similar individualistic theories of the artists' innate charisma are frequently resurrected within new fields.

Despite Godard's charismatic 'individual as director', we need to know more about the artisanal cinema of the Nouvelle Vague. In Paris, it is the artisanal mode of film production that has produced so many canonised films within the restricted subfield. Here, as both Darré and Allan Scott (2000: 25–26) have pointed out, we can also turn to Bourdieu's wider 'logic of practice' and 'sense of the game' (1990b). For such practical skills, gained from on-the-job work, allow us to grasp the often tacit knowledge about how visual and sound techniques can be used to translate empathy and expressivity into film. Rather than see these as linked individualistically to the uncreated auteur, we should see them as aspects of groups made up of skilled directors and technicians, over many decades, especially in Paris in the 8th arrondissement. Scott comments on these skills, used both in the artisanal and major prestigious films such as the state-subsidised *Germinal* (Berri 1993):

> The workers' sensibilities (forms of empathy, feeling, awareness, imagination, expressiveness and so on) . . . are of course partly a reflection of their formal

and informal training. They also grow, however, out of processes of acculturation in different realms of daily life, together with the habituation and socialization that tend to occur on the job, and that helps to endow workers such as actors, directors or set designers with instinct-like capacities to proceed with the tasks of cultural performance and improvisation, much as in the notion of practice outlined by Bourdieu. (Scott 2000: 25–26)

However, there are several forms for autonomy that can be seen in play, not just that which is evident in French artisanal modernism. I want to argue that Bourdieu in this respect, too, had a curious blind spot, blinkering him to the variety of what goes on in the popular culture industries, as Hesmondhalgh (2006) has also claimed. I shall do so by means of two exemplary cases within the film world, Italian neorealism and Hollywood.

THE CASE OF ITALIAN 1940S AND '50S NEOREALISM

Profoundly disillusioned by fascism, Italian film-makers had to accommodate in the '40s and '50s to the so-called miracle of the Italian economy, founded on American aid and heavy taxes on agriculture (Sorlin 1977, 1991 (chapter 2)). Whilst this heralded a massive increase in the professions – petty bourgeois sales staff and service workers – such transitions had a darker face: underemployment, poverty and – particularly in the pre-industrial rural south – begging and vagrancy. A film such as the now classic *Bicycle Thieves* (de Sica, 1948) responds to these divided fortunes, tracing the vicissitudes of the central protagonist, Ricci, as he seeks secure employment (Orr 1993). Although the industrial working class rarely appear at the point of production, the neorealist film directors – de Sica (*Shoeshine,* 1947) , Rosselini (*Roma, città aperta,* 1945), Visconti (*Ossessione*), Antonioni (*Il Grido*), Fellini (*La Strada*) – place the poor and marginalised petty bourgeoisie, casual workers and ex-peasants at the centre of their films (Sorlin 1977: 261; Orr 1993).

Pierre Sorlin's *Sociologie du cinéma* (1977), to which we are indebted for this example, has also developed many parallels to Bourdieuian ideas. This first work by Sorlin deserves to be much better known in Britain, not just for its pivotal theoretical advances but also for its brilliant application of these developments to Italian neorealism. Like Bourdieu, Sorlin emphasises the importance of cinema as a field, stressing the ensemble of cooperative producers and of their strategies to gain symbolic goods (1977: 99–100). Like Bourdieu, he castigates the theory of charismatic individualism or innate genius (the very basis on which the auteurist approach was advanced). And like Bourdieu on the 'author's point of view', he also advances an alternative:

that the collective artisanal cinema nevertheless permits the autonomy (even individual vision) of the film-maker, with his/her distinctive 'point of view' (Sorlin 1977: 287; cf. Bourdieu on the author's point of view 1996: 85–94).

It is one of Sorlin's great merits, however, to address with more precision the economic pressures of the large-scale field, especially the ramifying effects of globalisation and movements of capital in film production in the wake of World War II. Critical, like Bourdieu, of formalist interpretations, which remain internal to the literary system (Bourdieu 1996: 197–205), Sorlin's study of Italian neorealism charts in detail the box-office imperatives linked to financing and mode of production. More specifically, it assesses post-war film directors' hope for making the profit required of them, and their producers' recruitment of scriptwriters and management of distribution outlets so as to try to achieve this goal (1977: 85). Yet despite continued state subsidies to Italian cinema, the onward march of Hollywood from the 1940s–1960s emerged as a threat to the independent national industry (1977: 91–93).

It has been argued intriguingly that the deep pessimism of these particular films should not simply be understood as derived from an impetus to counter current hegemonic ideas (Sorlin 1977: 280). Instead, we need to address the field of Italian film production itself, within the wider cultural field. Italian neorealist films were certainly popular – some returned four times the cost of financing them – but the even greater popularity of imported Hollywood films (and television) threatened their homegrown production. In this respect, Sorlin's innovativeness is in understanding the neorealism of Rosselini, de Sica, et al. not just as a response to the great Italian divide between the agricultural stagnation in the south and the economic buoyancy and trade union autonomy within the north, but to the fact that the directors and their co-workers within Italian film production had also been precarised. There was thus a homology between their own experiences and those of the underemployed workers they represented, despite their own more privileged social origins and material position.[2]

THE CASE OF HOLLYWOOD

Three directors – Chaplin, Hitchcock and Welles, whose careers were made well before Bourdieu died – are everywhere acknowledged as crucial components of the tradition of consecrated film. The first figure is Charlie Chaplin, whose early life was shaped by a British workhouse, yet who on coming to America made and acted in extraordinarily popular films, including *Modern Times* and *The Great Dictator* (Taylor 1996). His was not an unproblematic

presence. Coerced into leaving by the U.S. State in the McCarthy period, he was as reviled then as Van Gogh was at his death (Heinich 1997). Yet he has now been securely canonised (Sand 2004: 180).

Chaplin's representation in *Modern Times* of the assembly line labour process, terrorising with its relentless speed, is both comical and threatening; his nostalgic delineation of the rural utopia of the couple within the suburbs is tinged with pathos; his hero's uncertainties about demonstrating workers and fear of authority figures captures the naivety of the newly arrived factory worker. Indeed, C.L.R. James aptly saw Chaplin's contrast between his protagonist's ideals and his disillusioned discovery of social reality as that of a modern Don Quixote. James – whilst noting that many popular films and novels are only of sociological interest – said of Chaplin in the late '40s:

> The early producers, actors, directors, etc., worked on their own for the simple public despised by intellectuals, critics and all the educated members of society. Yet by themselves, pioneers and commonplace public between them, they produced the greatest artist of modern times, Charles Chaplin, and in him they produced something that was *new*. (James 1993: 132)

The second figure – Alfred Hitchcock – is much better known. Championed as early as 1950 by French 'auteur' theorists and film-makers, he was taken up not just within the *Cahiers du Cinema* journal, but with a first book-length study, by Rohmer and Chabrol, as early as 1957 (Vest 2003: 163). Truffaut and Godard saw him as a metaphysical director, subtly framing his films through a Jansenist world vision. His case is particularly disputed because of his combination of unusual psychological realism (Zizek 2008), coupled with a distinctive cinematic language, using montage and visual analogies. Whilst he saw himself as the maker of innocent melodrama, others emphasised religious or existentialist interests, sometimes even lionising him as an idealised intellectual figure (Vest 2003: 173). His detractors argued that he was weakened over the years by an increasingly formulaic approach (Vest 2003: 20, 39, 82). The crucial point for me, however, is that he attracted and held a mass audience, and not just a minority audience for esoteric works (Vest 2003: 2–3, 49).

Orson Welles is the third 1940s' and '50s' figure who produced works of genuine popularity. One such, of course, was *Citizen Kane*, which had extraordinary cinematic originality (flashbacks, long takes, deep focus shots) as well as critiques of the endless pursuit of accumulation. Rooted in Freud and New Deal progressivism, Welles's *Kane* savaged the democratic pretensions of the paternalistic robber-barons of the culture industry. It remains as apt now as a critique of the political economy of the mass

media as it was in 1941. Its risk-taking portrayal of Kane as the combined figures of William Randolph Hearst – Rupert Murdoch's predecessor – and Henry Luce nearly earned it the fate of having the negatives burnt before distribution (Bogdanovich 2004: 19–20).

If *Citizen Kane* was widely accessible – middlebrow, fleetingly even part of popular culture – this should not detract from its break with conventions. Welles's formalist critics admired especially his 'symbolic revolution' (Bourdieu 1996: 75–76) – his break with the shot-reverse shot or découpage, pervasive in film after the silent era, and his preference instead for the more aesthetically unusual 'profondeur du champs' (Bordwell 1997: 59). Indeed, on Hitchcock's and Welles's rupture with formulaic melodrama, John Orr remarked that they were 'foreshadowing the coming of the modernist movement to Hollywood' (1993: 18). Welles's *Touch of Evil* (1958), in particular, represents the height of American noir, combining American mystery stories with Brechtian alienation effects. This was a questioning, morally complex yet popular film (Orr 1993: 171; Sand 2004: 48).

Furthermore, before McCarthyism covered Hollywood with a blanket of fear, we also see the emergence in the 1940s and '50s of what Cagle has called the second prestige model or a 'serious artistic feature film' (2007: 292). Unlike earlier melodrama or the prestigious literary adaptations of the big studio productions, these films had modest budgets and minimal sets, foregrounding instead a penetrating realist depiction of social relations. Such popular films challenged to some degree the dominant doxa and orthodoxy. Ford's *Grapes of Wrath* (1940), Cagle argues, is a good example of this critical genre, as are *Gentlemen's Agreement* (Kazan, 1947), about anti-Semitism; *The Snake-Pit* (Litvak, 1948) about mental illness and its treatment; and *Pinky* (also Kazan, 1948) about racism (Cagle 2007: 293). Even Kazan's *On the Waterfront* (1954) could be included, despite the disillusioned vision at its end of the dockers' union, which succumbs, to use Sand's words, to 'the iron law of oligarchy' (2004: 196). Cagle makes a plausible case that it was this series of films – under the banner of contemporary realism – that legitimated or consecrated cinema in America. Leaning partly on Bourdieu, he illuminatingly dissects the underlying structural conditions (or 'steering mechanisms') that facilitated this (Cagle 2007: 311 and Cagle, 2009).

We need to chart further this emergent consensus on the genesis of the U.S. restricted field, as derived from the study of Cagle and other film theorists. Of the greatest significance here were the 1940s' legal challenges, culminating in the new Hollywood Antitrust Law (1948), which produced a major reorganisation in American cinema. This severed the production studios from the distribution cinemas, stopped the enforced blind booking en bloc of films. In turn this made independent films more attractive, first

to little art-house cinemas, then later to multiplexes (Wilinsky 2001: 44–45, 67). Initially, within the competing production spaces, a key studio at RKO (1928–1947) pioneering more unpredictable, politically progressive films had risen to prominence from the late '30s and into the '40s, in tune with Popular Front culture of the New Deal (Cagle 2009: 31; see also Denning 2004; Dickstein 2009).

After World War II, a different public was emerging, formed from the greatly extended professional and managerial class, as well as a new petty bourgeoisie (Cagle 2007: 311; Baumann 2007: 32–46). As Cagle has shown, it was these class fractions that also provided the 'virtuoso' critics – Bourdieu's 'lectors' or 'cultural intermediaries' – who offered interpretations of such films for this growing audience. This more inventive and realist cultural production appealed to their quest for understanding the main social issues of the time – discrimination, industrial disputes and women's work (Cagle 2007: 301, 311). Cagle's argument is persuasive, especially in the light of the unusual cross-class alliances formed as a consequence of the renewed racialisation of black Americans during the late 1930s' political crisis (Goldberg 2013: 241).

The comparatively late start in Hollywood of a restricted field has been elaborated by recent film scholars, influenced theoretically by Bourdieu, Becker (1982) and Levine (1988). Baumann (2007), particularly, has both imaginatively and rigorously investigated the material 'opportunity structures' for the restricted cinematic field, concurring with Cagle about the growing middle and petty bourgeois classes, whilst emphasising also the expansion of education and hence a 'legitimate disposition' (2007: 47) amongst adult cinemagoers, as well as the shift of working-class audiences from cinema to watching television at home. However, it should also be added that this period (1945–1973) was the 'golden age of the American worker' with higher wages and job security due to low unemployment (Brenner 2006). A section of these manual workers, especially from second-generation immigrant families, may also have gravitated to the restricted subfield.

These structural features – changes in the class structure, demographic shifts (the baby boom) and the diffusion of television, 'historical accidents' in Baumann's impressive study (2007: 20) – can be linked to key legal transformations in the art world for films. I have already mentioned the antitrust legislation (1948), which undermined the all-powerful studio-system producer in favour of the director (Wilinsky 2001: 44). Further, as Baumann notes, the removal of the harsh censorship regulation by 1966, including the 1930 Hays production code, irrevocably altered films' imagery, political and social ideas and once hegemonic ethics (2007: 44, 101–4, 190–1). This had a profound effect on the conventions of Hollywood film, with the

appearance in the late 1960s of new independents and films such as *Bonnie and Clyde* (1967) and *Midnight Cowboy* (1969) (Taylor 1999; Wilinsky 2001; Baumann 2007: 105). Yet research is also now needed on whether 1950s' McCarthyism – especially the blacklisting of the 'Hollywood 10' and the placing of over 100 staff on leave of absence at RKO – obstructed the full-blown development earlier of an autonomous film world ('The Hollywood Ten' 2015).

'Little' cinemas or art houses had already been built or converted by the late 1940s, using modernist architecture and catering for a public rich in cultural capital (Wilinsky 2001: 49–53). Initially showing, and thus consecrating, imported British, French and Italian films (still 80 % of the total in 1958), once popular Hollywood films were then reissued as 'film classics'. Alongside these went new American films like *Lost Boundaries* (1949, de Rochmont), which introduced a greater realism about race (Wilinsky 2001, chapter 1).

These more educated audiences were receptive to Sarris's importation into America of auteur theory (Taylor 1999: 85–94). Earlier post-war film critics had celebrated specific cult aspects of Hollywood films (Manny Farber) or developed an early 'camp' aesthetic within film (Parker Tylor) (Taylor 1999). Together with Pauline Kael, such pioneers transformed film reviews – a key aspect within the institutionalisation of 'film as an artistic genre' (Becker 1982; Baumann 2007: 97) – for film reviews in turn 'created a "feedback effect"' with directors making films for the newly emergent art world (Wilinsky 2001: 92–93; Baumann 2007: 117–37). From the 1960s onwards, film newspaper/billboard advertisements featured reviews, typically comparing both directors and films, and developing the language of film as an art form similar to other consecrated arts (Baumann 2007: 126–27). Alongside this, festivals and Academy Awards aided the recognition of field-specific success, provoking a new distinction between popular and serious Hollywood (Baumann 2007: 125). A film such as Renoir's *Rules of the Game* (1939) – dismissed in the *New Yorker* (1950) – was canonised as a great work in the *Village Voice* (1961) (Bauman 2007: 132–33).

The key stakes in the new restricted field were the relative position of director and producer and the struggles between them. The rationalised Taylorist 'assembly line' production, organised for maximum exchange value, had been controlled by the studio producer: the director – often in his own self-image – was a craftsman or master technician. The last vestiges of producer dominance hung on even up to 1951 with John Huston's direction of *The African Queen*, for Huston's preferred ending was substituted belatedly for another while he was a continent away and unable to counter

the blow (Becker 1982). But eventually, the 1960s crisis of profitability meant that the old mode of film production, with its conventions organised around linear narratives, clear-cut causal relations and minimal realism was placed in abeyance. If profit was still a tacit constraint, the rise of Hollywood independents – amongst them, Robert Altman, John Cassavetes and Martin Scorsese, and companies such as Miramax – meant a much reduced resort to earlier rules (Wilinsky 2001: 18, 133). Alongside this, the retrospective consecration of earlier popular Hollywood classics gathered apace (Baumann 2007: 31).

This powerful 1960s challenge from the extended autonomous field was one that was not to last: as the 1980s developed, Miramax was bought by Disney (from the expanded field) whilst other independent companies were also taken over (Wilinsky 2001: 4). The rise of neo-liberalism and finance capital dominance has been translated in the American film world into the rise of the blockbuster for globalised consumption. With this return to a predictable product – as in the case of books – there is less and less room for subsidy of risqué, innovative films by more formulaic genre products: every film must satisfy the bankers.

In assessing this history, it would surely be unduly fatalistic to claim that film critics' views of aesthetic appeal can never coincide with mass appeal, especially given the examples of Chaplin, Welles, Hitchcock and Rossellini. Popular audiences may appreciate certain films not just for their ethical/political messages but also for their power of aesthetic imagery, just as audiences value certain lyrically innovative artistic protests in rap (Shusterman 1992: 169, 302–4). In certain contexts – brilliantly described by Cagle – audiences may defer the pursuit of symbolic goods or distinc-tion in favour of films that resonate more with collective memory and clarify wider social conflicts (cf. Shusterman 1992, chapters 7, 8, especially 177).[3]

WHAT IS AT STAKE WITH THE BUILDING OF AN AUTONOMOUS FIELD?

We should remember that where such autonomy is missing it makes it much easier for the state to maintain oppressive regimes as well as the beliefs on which they are founded. The example of South Africa is telling here. Until the fall of the racist regime in 1994, South African 'cinema [had] historically played an important role in presenting apartheid as a natural way of life' (Tomaselli 1989: 11). Indeed, as late as 1963 it was impossible for a feature film to be on general release portraying a cross –'racial' love; this

was so even if the film had a script by an internationally renowned author, such as Nadine Gordimer (Tomaselli 1989: 17, 207). No critical film-makers were permitted to show their works publicly through the whole apartheid period, from 1948 onwards (Tomaselli 1989: 9–28, 89–92).

Bourdieu, following Husserl, has a category of 'doxa' – or beliefs that become part of the 'natural attitude' – thus, for example, rendering differences between the classes or races as essences and eternal. What is at stake is whether cultural producers, like so many treacherous 'Trojan horses', will comply out of self-interest with the demands from 'external economic and political power' associated with such doxa. Bourdieu writes:

> The symbolic power acquired in the observance of the rules of the functioning of the [restricted] field is opposed to all forms of heteronomous power which certain artists and writers . . . may find themselves granted as a counterpart to the . . . symbolic services they render to the dominants[,] notably in *the reproduction of the established symbolic order*. This heteronomous power may be present at the very heart of the field, and producers who are the most devoted to internal truths and values are considerably weakened by that sort of "Trojan horse" represented by writers and artists who accept and bend to external demand. (1996: 221, my emphasis)

It is largely 'independent' or artisanal cinema that has played the role of estranging the filmgoer from such doxa, providing the shock that defamiliarises the field of vision. But as with 1940s' and '50s' second prestige film, even the Hollywood studios, in certain contexts, have produced such films.

CONCLUSION

Pierre Bourdieu offers us an excoriatingly critical analysis of the social reproduction of domination. He wrote in the second half of the twentieth century when income inequality was legitimated by reference to the differential possession of rare talents and capabilities. His innovation was to show precisely how the social reproduction of classes continued in a subterranean manner, even with the removal of some material barriers to entry. The family transmission of linguistic and cultural capital allowed only a small minority to appropriate or monopolise the educational, certified cultural capital necessary for positions with high material rewards. Only radical pedagogy as part of wider social change could alter this.

Since the late 1970s, throughout the neo-liberal West, the inequalities generated by capital ownership, as opposed to income, have gone back to

the levels of 1890–1914 (Piketty 2014). Yet Bourdieu's analytical insights into the bourgeois family's distinctive 'inheritance' of skills and knowledge are still important. For only when that has changed will educational opportunities really become open to all. Further, only when social conditions are changed – necessary prerequisites for educational access to cultural capital – will consecrated works both become universally accessible and the spur to fresh productive inventiveness.

As we have seen, Bourdieu never ceased to hold that popular art is an illusion. The general lines of his argument need to be endorsed for the reasons just given. But that does not mean that all works made for the 'large-scale public' are doomed to be artistically impoverished. Revivified genres within the popular tradition can sometimes be appreciated without education (Born 2010). Moreover, on occasion, the uneducated can create new, aesthetically powerful works, just like the craftsmen-bards of Kabylia with their double-coded poems. In this chapter I have argued that the case of cinema is of sociological interest partly because it has witnessed the same genesis of a restricted subfield as did the novel and visual arts many years earlier. In the face of this, we do have to reluctantly agree that there is an elective affinity between those with a high volume of capitals, especially cultural capital, and the actors in this cinematic restricted field (Heise and Tudor 2007). Nevertheless we should not forget that certain notable consecrated films initially gained a popular reception; even more surprisingly, a small minority of their directors – Chaplin, Hitchcock, de Sica, Almodovar – without early cultural capital came from working-class, petty bourgeois or poor peasant origins.

If popular art in this sense informs our critique of Bourdieu, it does not do so to enter a theoretical wedge that destabilises the whole foundation of his first period. On the contrary. In endorsing his second period reiteration of the importance of artistic autonomy in interrogating power, we want to extend this argument to film production. Ultimately, we see both economic crises and legitimation crises as creating struggles within the various fields, including cinema; each possessing their own sense of time. When these come together ('synchronisation'), they culminate in 'historical events' (Sapiro 2013: 267). It is then that the social transformation of the wider field of power opens up as a possibility. In brief, for us, and for Bourdieu, hegemony is not cast in stone, heterodoxies do emerge and the habitus in certain circumstances empowers practices conducive to transformation (Bourdieu 1988, 1990b: 40–41, 1991; Gorski 2013: 2, 14–15).

NOTES

I am grateful to Roy Enfield, Megan Morrissey, Guy Austin and two anonymous readers for advice on the political economy of cinema for this chapter, although it goes without saying that the final responsibility is my own.

1. FEMIS is a grande école training students for cinema.
2. De Sica was an exception, coming from poor peasant farmers.
3. Shusterman's Dewey-influenced 'meliorist' stance regarding popular art is a promising alternative to Bourdieu's lingering enchantment 'by the myth he demystifies' (1992: 172). As Shusterman argues, 'popular art can be improved because it can and often does achieve real aesthetic merit and serve worthy social goals [. . . it] deserves serious aesthetic attention since to dismiss it as beneath aesthetic consideration is to consign its evaluation and future to the most mercenary pressures of the marketplace' (1992: 177).

REFERENCES

Alexander, J.C. 1995. *Fin de Siècle Social Theory*. London: Verso.

Arroyo, J. 1992. 'La Ley del Deseo', in R. Dyer and G. Vincendeau (eds), *Popular European Cinema*. London: Routledge, pp. 31–46.

Baumann, S. 2007. *Hollywood Highbrow: From Entertainment to Art*. Princeton: Princeton University Press.

Becker, H. 1982. *Art Worlds*. Berkeley, CA: University of California Press.

Bogdanovich, P. 2004. 'Interview with Orson Welles', in J. Naremore (ed.), *Orson Welles's Citizen Kane: A Casebook*. Oxford: Oxford University Press, pp. 19–70.

Bordwell, D. and K. Thompson. 1979. *Film Art: An Introduction*. Reading, MA: Addison-Wesley.

Bordwell, D. 1997. *On the History of Film Style*. Cambridge, MA: Harvard University Press.

Born, G. 2010. 'The Social and the Aesthetic: For a Post-Bourdieuian Theory of Cultural Production', *Cultural Sociology* 4: 171–208.

Bourdieu, P. 1984. *Distinction*. London: RKP.

——. 1988. *Homo Academicus*. Cambridge: Polity.

——. 1989. 'The Corporatism of the Universal', *Telos* Fall: 99–110.

——. 1990a. *In Other Words*. Cambridge: Polity.

——. 1990b. *The Logic of Practice*. Cambridge: Polity.

——. 1991. 'Genesis and Structure of the Religious Field', *Comparative Social Research* 13: 1–44.

——. 1993a. *The Field of Cultural Production*. Cambridge: Polity.

——. 1993b. *Sociology in Question*. London: Sage.

——. 1996. *The Rules of Art*. Cambridge: Polity.

——. 1998a. *On Television and Journalism*. London: Pluto.

——. 1998b. 'A Reasoned Utopia and Economic Fatalism', *New Left Review* 227: 125–30.

——. 1998c. *Acts of Resistance*. Cambridge: Polity.

——. 2002. *Les Chances de la Survie de la Culture* in Hyper-Bourdieu, 2002A fra8. (Originally published in *Tages-Anzeiger*, 8 December 1999, in German.)

——

——. 2008. *Esquisses Algériennes*, T. Yacine (ed.). Paris: Le Seuil.

——. 2014. *On the State*. Cambridge: Polity.

Bourdieu, P. with L. Boltanski et al. 1990. *Photography: A Middlebrow Art*. Cambridge: Polity.

Bourdieu, P. and M. Mammeri. 1978. 'Dialogue sur La Poésie Orale en Kabylie', *Actes de la Recherche en Sciences Sociales* 23: 51–66.

Brenner, R. 2006. *The Economics of Global Turbulence*. London: Verso.

Cagle, C. 2007. 'Two Modes of Prestige Film', *Screen* 4(3): 291–311.

——. 2009. 'When Pierre Bourdieu Meets the Political Economists', in J. Staiger and S. Hake (eds), *Convergence Media History*. London and NY: Routledge, pp. 24–33.

Darré, Y. 2006. 'Esquisse d'une Sociologie du Cinéma', *Actes de la Recherche en Sciences Sociales* 1–2(161–62): 122–36.

Denning, M. 2004. 'The Politics of Magic: Orson Welles's Allegories of Anti-Fascism', in J. Naremore (ed.), *Orson Welles's Citizen Kane: A Casebook*. Oxford: Oxford University Press, pp. 185–216.

Dickstein, M. 2009. *Dancing in the Dark: A Cultural History of the Great Depression*. New York: W.W. Norton.

Duval, J. and P. Mary. 2006. 'Retour sur un Investissement Intellectuel', *Actes de la Recherche en Sciences Sociales* 1–2(161–62): 4–9.

Fowler, B. 2012. 'Pierre Bourdieu, Social Transformation and 1960s' British Drama', *Theory, Culture and Society* 29(3): 3–24.

Goldberg, C. 2013. 'T. H. Marshall Meets Pierre Bourdieu: Citizens and Paupers in the Development of the U.S. Welfare State', in P.S. Gorski (ed.), *Bourdieu and Historical Analysis*. Durham and London: Duke University Press, pp. 215–41.

Gorski, P.S. 2013. 'Introduction: Bourdieu as a Theorist of Change', in P.S. Gorski (ed.), *Bourdieu and Historical Analysis*. Durham and London: Duke University Press, pp. 1–15.

Gray, C. 1986. *The Russian Experiment in Art*. London: Thames and Hudson.

Grignon, C. and J.-C Passeron. 1989. *Le Savant et Le Populaire*. Paris: Le Seuil.

Guibentif, P. 2010. *Foucault, Luhmann, Habermas, Bourdieu: Une Génération Repense le Droit*. Paris: Fondation Maison des Sciences de l'Homme.

Heinich, N. 1997. *The Glory of Van Gogh*. Princeton: Princeton University Press.

Heise, T. and A. Tudor. 2007. '(Film) Art: Bourdieu's Field Model in Comparative Context', *Cultural Sociology* 1(2): 165–87.

Hennion, A. 2007. 'Those Things that Hold Us Together: Taste and Sociology', *Cultural Sociology* 1(1): 97–114.

Hesmondhalgh, D. 2006. 'Bourdieu, the Media and Cultural Production', *Media, Culture and Society* 28: 211–31.

James, C.L.R. 1993. *American Civilization*. Oxford: Blackwell.

Levine, L. 1988. *Highbrow/Lowbrow*. Cambridge, MA: Harvard University Press.

Lovell, T. 1972. 'The Sociology of Aesthetic Structures and Contextualism', in D. McQuail (ed.), *The Sociology of Mass Communication*. Harmondsworth, Middlesex: Penguin, pp. 329–49.

Marx, K. 1973. *Grundrisse*. Harmondsworth: Penguin.

Orr, J. 1993. *Cinema and Modernity*. Cambridge: Polity.

Piketty, T. 2014. *Capital in the Twenty-first Century*. Cambridge, MA: Belknap.

Prior, N. 2011. 'Critique and Renewal in the Sociology of Music: Bourdieu and Beyond', *Cultural Sociology* 5(1): 121–38.

Rose, J. 2002. *The Intellectual Life of the British Working Classes*. New Haven, CT: Yale University Press.

Sand, S. 2004. *Le XXe Siècle au Cinema*. Paris: Seuil.

Sapiro, G. 2013. 'Structural History and Crisis Analysis: The Literary Field in France during the Second World War', in P. Gorski (ed.), *Bourdieu and Historical Analysis*. Durham and London: Duke University Press.

Scott, A.J. 2000. 'French Cinema: Economy, Policy and Place in the Making of a Cultural Products Industry', *Theory, Culture and Society* 17(1): 1–38.

Shusterman, R. 1992. *Pragmatist Aesthetics*. Oxford: Blackwell.

Sorlin, P. 1977. *Sociologie du Cinéma*. Paris: Aubier-Montaigne.

———. 1991. *European Cinemas, European Societies, 1939-90*. London: Routledge.

Taylor, G. 1999. *Artists in the Audience: Cults, Camp and American Film Criticism*. Princeton and Oxford: Princeton University Press.

Taylor, N. 1996. 'Re-presenting the Field of Restricted Cultural Production: The Nude at the Interface', *Screen* 37(1): 16–29.

'The Hollywood Ten'. 2015. Wikipedia. Retrieved 6 June 2015 from http://en.wikipedia.org/wiki/The_Hollywood_Ten

Tomaselli, K. 1989. *The Cinema of Apartheid: Race and Class in South African Film*. London and New York: Routledge.

Tupitsyn, M. 2009. *Rodchenko and Popova: Redefining Constructivism*. London: Tate Modern.

Vest, J.M. 2003. *Hitchcock and France: The Forging of an Auteur*. Westport, CT: Praeger.

Vincendeau, G. 1992. *Popular European Cinema*. London: Routledge.

Wilinsky, B. 2001. *Sure Seaters: The Emergence of Art House Cinema*. Minneapolis, MN: Minnesota University Press.

Williams, R. 1989. *What I Came to Say*. London: Hutchinson Radius.

Zizek, S. 2008. *The Plague of Fantasies*. London: Verso.

Bridget Fowler is an Emeritus Professor of Sociology at the University of Glasgow. She specialises in social theory, the sociology of culture and

Marxist-feminism, with particular reference to contemporary social class and inequality. She has long had an interest in the thought of Pierre Bourdieu, whose ideas she has taken up in her own books including *The Alienated Reader* (Harvester Wheatsheaf, 1991); *Pierre Bourdieu and Cultural Theory: Critical Investigations* (Sage, 1997); *The Obituary as Collective Memory* (Routledge, 2007); and her two edited volumes, *Reading Bourdieu on Society and Culture* (Blackwell, 2000) and (with Matt Dawson, David Miller and Andrew Smith) *Extending the Sociological Imagination: Essays in Honour of John Eldridge* (Palgrave, 2015). In recent years she has contributed various journal articles and chapters on Bourdieu's theory of social transformation, and has sought to elaborate on his analysis in the cultural field.

Bourdieu and Film Studies

Beyond the Taste Agenda

Chris Cagle

Film studies scholars who find Bourdieu useful in their work do so less out of direct inspiration from what Bourdieu writes on the cinema than out of an affinity with his concept of cultural capital. As Bridget Fowler (2012) has noted, Bourdieu often had surprisingly little to say about cinema. His limited discussion of cinema in *Distinction* analyses cinephilia, a class-inflected activity (Bourdieu 1984: 270–72). While his sociological method by nature differs from the interpretive methods of humanities scholars of culture, Bourdieu nonetheless does at times deal with the specificity of narrative arts as the cornerstone of analysis, particularly the novel. 'There are, of course, significant differences between sociology and literature, but we should be careful not to turn them into an irreconcilable antagonism', he states, adding that writers like Gustave Flaubert and Virginia Woolf perform a type of valuable social analysis through literary form (Bourdieu and Wacquant 1992: 206). While this suggestion of art as a type of analysis opens up potentially fruitful areas of inquiry, in practice it also provides a central role only for a few canonical artists. Moreover, Bourdieu's emphasis on consecration and auteur perception in cinema tends to reinforce canonical understandings of cinema as much as it challenges them.

Despite initial difficulties, though, Bourdieu's work has found a welcome reception among many film scholars. The study of cinema in the humanities has taken up the idea of cultural capital to pursue a sociology-of-taste agenda: analysing film preferences and consumption through the lens of class stratification. The examples are numerous but, broadly speaking,

coalesce around a few critical agendas. Reception scholars have used the notion of cultural capital and taste distinction to identify specific reading formations; for example of classical Hollywood (Jacobs 1992; Jancovich 2010). *Distinction*, and its discussion of cinephilia, has been a natural fit for those reading art cinema or independent cinema as a social practice as much as an aesthetic form (Tudor 2005; Newman 2009). Conversely, the champions of 'paracinema' argue that fans of exploitation and trash cinema possess a kind of cultural knowledge and sophistication that more conse-crated cultural capital cannot sufficiently recognise (Sconce 1995; Schaefer 1999; Hawkins 2000). Accordingly, Bourdieu is often cited to buttress a populist desire to resist elite, hegemonic or bourgeois taste in cinema (Klein 2013). In these critical moves, many have been in dialogue with what James English calls the 'reflexive sociological turn within English departments' in the 1990s,'resulting in studies about canon formation, literary value, and the relation of English to other disciplines, to the broader cultural field, and to the field of power itself' (English 1999: 139). Media studies and televi-sion studies have also been fertile and influential grounds for Bourdieuian scholarship, even in their humanities-centric iterations; the case of prestige television has been particularly ripe for taste readings (Levine and Newman 2013).

As instructive and productive as this sociology-of-taste agenda has been, though, it has had the effect of relegating Bourdieu to a theoretical variant of reception studies. It is clear why reception studies have found such value in sociology of taste as heuristic; Bourdieu's work has helped film scholars bridge the empirically oriented reception study and larger theoretical agen-das in the field. Bourdieu's writings on art, however, go beyond the work in *Distinction*. His books *Rules of Art* and *The Field of Cultural Production* in particular present a model of art as a social field, in which artists' placement in social space shapes their aesthetic struggles in productive as well as con-stricting ways (Bourdieu 1996 and 1993). While film studies as a discipline is undoubtedly aware of his studies on the field of cultural production and has produced some scholarship in this vein,[1] the idea of the social field has had less impact than the notions of cultural capital, taste and distinc-tion. Another way to phrase the problem is that film studies as a discipline has by now incorporated Bourdieu to address the matter of the consump-tion of media texts but it has been less concerned with using Bourdieu to understand the production of media. Bourdieuian analysis has therefore remained removed from areas of film studies inquiry with which it could be in productive dialogue.

Three cases can suggest how the concept of the social field productively reframes existing areas of inquiry and debates within film studies. First,

the instance of middlebrow in classical Hollywood cinema would seem to corroborate a sociology-of-taste approach but at closer examination is characterised by a more complex dynamic. Second, documentary ethics is a subfield often removed from reception study, yet Bourdieu's work gives a valuable perspective on the normative claims of ethics. Third, the social field helps reconcile some of the methodological positions in film festival studies. These case studies are not exhaustive, but they do show possibilities of Bourdieuian study beyond a purely reception approach. Richard Jenkins (1992) remarks that Bourdieu is a good thinker for thinking, by which he means that the thinker's impact may be less in his particular insights than in modelling a kind of reflexive sociological practice. This claim is certainly debatable, but some version of it is appropriate for film studies. The predominance of sociology of taste springs from a clear methodology for analysing movies, but the concept of the social field means something less instrumental: the social field is not a methodology for study of cinema per se but rather an imperative to think relationally between social agents, cultural creators and the cultural object (cinema) itself. The value of the model is that it straddles complexity and simplification.

Bourdieu's definition of the social field is economical enough. 'In analytical terms', he writes, 'a field may be defined as a network, or a configuration of objective relations between positions. These positions are objectively defined, in their existence and in the determinations they impose upon their occupants, agents or institutions, by their present and potential situation . . .' (Bourdieu and Wacquant 1992: 97). The analogy is clearly the physical sciences, wherein a field is defined by the differentiated force and impact on matter. Similarly, Bourdieu delineates fields by their impact: 'so that what happens to any object that traverses this space cannot be explained solely by the object in question' (Bourdieu and Wacquant 1992: 100). Fields are larger than individuals, companies and institutions; examples include the art market, the higher educational system and journalism.

What implications does field theory hold for film and media studies? First, it means treating cultural production as a social practice. Cinema, television or other media by no means automatically act as a singular field, but certain social practices of audiovisual production and consumption feasibly qualify: industrially made entertainment cinema, television news, state propaganda and experimental film-making, among others. Others, such as video art, might better be construed as a subfield of a larger visual arts field. In defining these, we can look for the likelihood that professional attitudes, aesthetic sensibility and strategic behaviour will depend on the objective relation to others in the field.

MIDDLEBROW AND HOLLYWOOD'S PRODUCTION CULTURE

Hollywood in the studio era is at first glance an unusual example of a social field. Largely associated with the practices of a single industry and identified with a commodity-oriented cultural product, cinema of the studio years in the United States nonetheless included both the industry and a broader cultural context that included audiences, critics and even elite institutions (Decherney 2005; Polan 2007). Not only did audience reception of Hollywood films vary by taste, but the studios and their artists were keenly aware of the taste classifications of cinema and built this awareness into the films themselves. Certain bodies of film theory, such as on the melodrama, have pointed out films that privilege social class in their narratives, but a wider view of Hollywood's products shows a self-consciousness about taste and status in nearly every corner. For example, MGM's 1943 film *Presenting Lily Mars* (Norman Taurog) is instructive because it shows how much taste distinction was central to classical Hollywood. In one early scene, Lily Mars (Judy Garland) reveals her aspirations to escape her small town by becoming an actress. She has stolen a play from a successful theatre producer, John Thornway (Van Heflin). Thornway confronts Lily and recovers his play, in the process discovering that Lily has a pamphlet titled 'Lessons in Acting' by a 'Professor Eggleston'. The scene itself is rife with reflexivity, starting with Thornway's impromptu performance-within-the-film, relayed through Lily and her siblings as surrogate spectators. The film inserts the acting-lesson pamphlet, clearly the object of comedy, in close-up as Thornway flips the pages. The spectator knows that Lily has committed the greatest of middlebrow sins in trying to read instruction in what should ideally be, in Bourdieu's phrasing, 'legitimate autodidacticism' (1984: 24). As instruction, the mail order pamphlet underscores the city-provinces cultural gap and Lily's own lack of cultural capital. Allodoxically, she loves the theatre unconditionally but ultimately knows nothing of it.

In *Presenting Lily Mars*, there are therefore at least three vectors of taste formation. Within the text, the narration establishes the spectator's relation to the characters, since the film is a social satire that lovingly mocks Lily Mars' naivety in trying to become a great actress. With the spectator's relation to the text, realist visual style asks the spectator to see this as a better type of movie. With the text's relation to the source material, the film adaptation draws upon Booth Tarkington's novel and adapts the social critique of the realist novel to new ends. In short, *Presenting Lily Mars* suggests the usefulness of a sociology-of-taste agenda – that is, an approach to cultural critique that understands aesthetic judgements as emerging from social overdeterminants and in turn affecting the lives of social agents. Bourdieu

was hardly the first sociologist to be interested in the class dimension of taste. Herbert Gans (1964), for instance, gave such a reading of Hollywood's social problem films. However, Bourdieu's notion of cultural capital has provided an economical heuristic for understanding taste differentiation in these texts and their reception.

However, to read *Presenting Lily Mars* as a middlebrow text does not fully do justice to it. From a Bourdieuian perspective, cultural producers are social agents, likely themselves to categorise culture. Matthew Tinkcom (1996) has argued that MGM's Freed Unit had a subcultural disposition towards camp derived from gay labour; based on the films, it seems likely that other MGM units, like the Pasternak unit, had a similar production culture. If so, the double-edged satire in *Presenting Lily Mars* works according to the habitus of its producers: a sense of otherness in face of Middle America, an incentive to sublimate this otherness into a tongue-in-cheek celebration of Americana, and an identification with the pathos of cultural misrecognition. At the same time, these MGM artists were not in a vacuum, since external cultural fields influenced their aesthetic dispositions. There are a number of fields with which cinema interacted in the 1940s, but the literary field was one powerful influence, and one can point to the class self-consciousness of the middle-class novel, such as John P. Marquand's books (1942), in fostering the class critique in Hollywood comedies. Literary historian Gordon Hutner (2011) has furthermore argued that these novels engaged the middle-class readership's class self-understanding in sometimes surprisingly critical ways. In short, understanding cinema as a field posits cultural producers as equally cultural consumers. Hollywood was in dialogue with the literary field of the time (published literature and legitimate theatre), even though it occupied a different space in the social field.

Finally, we should note that media consumers have a different stake in various fields. In experimental cinema or documentary fields, there is some version of the avant-garde dynamic Bourdieu describes in *Rules of Art*; other artists make up a significant portion of their audience. Entertainment commodity media in contrast tends to have a disparate audience of consumers, but even here the bounds of the social field can cohere by the ability of producers to act as consumers for each other's work. There has been a recent agenda of production culture studies, spearheaded by John Caldwell (2008), which argues that artists and producers working in the film industry share common cultures not reducible to professional instrumentalism. To propose production cultures as a social field helps connect them to larger social determinants. The cinematographers at MGM in the 1940s, for instance, were in dialogue with a broader discussion among cinematographers about the desirability of realism. *Presenting Lily Mars* (director

of photography Joseph Ruttenberg) makes some gestures towards the new realist style, with a considerable amount of downcast, medium-key lighting and unusual setups that do not disguise the lighting source, but it does so in ultimate adherence to the brighter look of MGM's comedies. The visual style of the film therefore involved a dual differentiation. *Lily Mars* differentiated itself against the starkly modernist cinematography (off-kilter framing, high-contrast, highly formalist) associated with European cinema and occasionally visible in Hollywood, as in Rudolph Maté's work. Alternately, the film refuses at moments the high-key, slightly overexposed house style MGM was famous for. The cinematographer's habitus in fact corresponded to the class contradictions of the film: seeking sophistication but wedded to the industrial demands of MGM as a studio.

DOCUMENTARY ETHICS AND FIELD ENFORCEMENT

A field theory research agenda can assess field effects and field autonomy. Fields often influence proximate fields, while social agents in a field may militate to assert their separation from neighbouring fields. Documentary cinema is produced within a fairly autonomous field and thereby provides an excellent case study. The discussion of documentary ethics, for instance, very often proceeds on the basis of normative claims for what individual agents should do. To take one example, *Daughter from Danang* (2004) is a documentary about a Vietnamese-American adoptee trying to connect with her birth mother; during one scene, she realises that her birth family sees her in more material terms than she would like. The scene's decoupage cuts between her biological brother proposing that Heidi take her birth mother to the States and otherwise support her financially, Heidi's measured but distraught refusal of the request, and the mother's silent expression in reaction shot. A long shot frames the three facing forward off-screen (presumably towards the interpreter), then zooms in on Heidi's emotionally torn reaction. In a follow-up shot, she looks up in the other direction at one of the directors and says, 'I can't'. The film-makers, Gail Dolgin and Vicente Franco (2004) have spoken of the ethical dimensions of this scene:

> Of course, the "breakdown" moment was without a doubt the biggest test of our ability to control our personal emotions while at the same time continuing our work as documentary filmmakers . . . Suddenly we had to find a balance between the respect we owed to Heidi and her family, the compassion we felt for everyone in the room, and our own emotions and reactions to the pain everyone was feeling – all this had to be balanced with our commitment as documentary filmmakers to capture the moment without intruding, affecting

it as little as possible with our presence. If anyone had asked us to stop, we would have immediately turned off the camera. But our work was to document the raw truth as it revealed itself to us – it was life in the making . . . As film-makers we often find ourselves in situations in which we need to decide what's more important: to get the shot, or to preserve the privacy of our protagonist's intimacy. And we have to decide as we go, often without time to deliberate. We hope that in moments in which there is no time to make rational decisions, we can trust our intuitive integrity . . .

Dolgin and Franco's response is disingenuous in the sense that ethical decisions take place in the editing stage as much as the shooting stage – having intruded on an emotionally intimate moment they could just as easily leave it on the cutting room floor, but they articulate the competing needs of documentarist and social actor and capture the way in which larger ethical concerns take place on the level of internalised habitus – 'intuitive integrity' as the film-makers so succinctly put it.

Unstated but implicit in Dolgin's and Franco's discussion is the pre-sumption that there is a semi-formalised and collective backdrop to indi-vidual ethical decisions. Documentary ethics discourse posits a social field staked out in relation to two putative alternates: entertainment cinema, with its relative lack of ethical considerations, and journalism, in which profes-sional ethical standards generally take on more formalised enforcement mechanisms. In its classical formation, documentary ethics show a strong affinity with journalistic ethics, which tend to have a stronger effect on the documentary field than vice versa, and a strong autonomy from entertain-ment cinema, which relies on different funding structures and production models. In relation to both of these 'others', the place of the American docu-mentary field has changed over recent years. In fact, the study of documen-tary ethics could productively shift from a collection of normative claims to a more analytical study of the documentary field's conditions – one that assesses both the field's autonomy and its relation to other fields.

Fields are not static entities. Not every agent in the field shares the same attitudes and values, and even the most stable fields change over time. A social field model therefore examines internal field dynamics in addition to the relationship between fields; each can change a field's nature and disposition. More recently, social theorists have extended Bourdieu's work by theorising these dynamics. For Neil Fligstein and Doug McAdam (2012), social fields are comparable to social movements in that their dynamics are variable: newly emerging or dissolving fields are especially susceptible to external shock, whereas established or stable fields are inclined towards incremental, internal change. This insight is vital for considering cinema and moving image media, since their various fields have been in changing

states of stability and instability. To take the example of documentary in advanced industrial societies, the field was relatively stable and cohesive for the latter decades of the twentieth century, but external factors have eroded this coherence and opened the space for challengers and heterodox voices. For instance, *Capturing the Friedmans* (Andrew Jarecki, 2003), an example of what Stella Bruzzi (2006) has branded the 'new documentary', departs significantly from a classical documentary-ethics stance of *Daughter from Danang*. The documentary about a family convicted of paedophilia charges in the 1980s relishes in the voyeurism of the Friedmans' private home-video moments as much as *Daughter* feels anxiety about Heidi's inability to keep her family drama private. One expert knowledgeable with the Friedman case has charged that Jarecki has embraced ambiguity as a marketing strategy (Nathan 2003). The ethical considerations have not exactly disappeared; after all, the problem of what the documentarist does with the social actor's images and testimony remains. What has changed is the enforcement mechanism by which funding bodies or critics might restrict entry into the field. *Friedmans* has arguably found theatrical success because of and not despite its ethical issues, and the film largely circulates in popular venues where documentary ethics is not a formalised discourse. Institutionally, two major trends weakened the prior documentary field in the United States: broadcast television funding has retrenched since 1980 (Bullert 1997: 17) and lower entry costs to film-making have opened the field to makers from other cinematic and professional backgrounds.

THE FILM FESTIVAL CIRCUIT AS A FIELD EFFECT

The example of documentary ethics is one in which the changes to a social field dissolve previously stable mores, but the trajectory can go the opposite direction. The growth of documentary film circuits has changed the circulation and even production of documentaries and, especially in the European context, has given an underlying stability to a diffuse range of non-fiction production across national contexts. Film festival scholars have presented a supple account of how festivals work as social institutions. Unlike with the industrial mode of production, festival circuits rely on loose networks rather than strictly economic arrangements of production, distribution and exhibition. Festival studies has blossomed as a subfield because of the desire for scholars to address the in-between nature of this slice of contemporary global film culture: relatively uncoordinated yet collectively conforming to both aesthetic and institutional norms. As Marijne de Valck (2014: 76–77) notes, 'Bourdieu features as one of the theoretical "founding fathers" for

film festival scholarship; studies turn to his work, in particular to the concept of symbolic capital, to explain how festivals function as sites of cultural legitimization'. Key studies of festivals have used Bourdieu extensively for his observations about taste (de Valck 2007; Wong 2011).[2] However, festivals function in many ways as a social field: a collection of social dispositions rooted in the material but not deterministically economic in nature. The social field model makes sense of how various actors – film-makers, programmers, distributors, film journalists, tourism boards and cinephile audiences – may have different stakes in festivals but collectively shape the ultimate contours of the social enterprise in a manner that is stable despite the etherealness of their networks. Dina Iordanova (2009: 33) has used the analogy of the treadmill – social networks powered simply by its users – to describe the festival circuit, noting, 'If these men [attendees] stop returning, there will be no more festival circuit any more. It is through the incessant movement of these sole traders between festivals that the appearance of a "networked nature" is created'. Iordanova's point is that festivals abstract and reify the lived social connections between the various agents. The social field, however, can extend beyond the lived connections that field members create, in publications, awards prestige and general professional habitus. The idea of the social field helps make sense of the nebulous but powerful effect of the festival circuit, but the field is not the same as the circuit itself.

To use the example of European documentary film festivals, a progression of documentary film festivals transpires each Autumn, including DocLisboa, Jilhava Documentary Film Festival, DOK Leipzig and CPH:DOX in Copenhagen, and culminating in the largest and possibly most prestigious, the International Documentary Festival Amsterdam (IDFA). Other first- and second-tier festivals are important for their regional, national or thematic specialisation: DocPoint (Helsinki), ZagrebDox, Thessaloniki, Visions du Réel (Nyon) and Marseille FID. Each of these festivals has its own emphasis and identity – for instance, CPH:DOX has been known for curating hybrid doc-fiction work, whereas Marseille FID includes documentary from North Africa. Despite, or even because of their specialisation, the festivals are networked in a number of ways. Smaller and earlier festivals can serve as a vetting ground, as larger festivals will pick up films, either for competition or for a 'best of festivals' programme. Documentary-specific film festivals maintain a close relationship with general film festivals, whose documentary juries often come from the documentary field (makers, producers and critics). Finally, festivals actively cultivate the production of documentaries with labs, workshops and other industry events. To give an example, *Sofia's Last Ambulance* (Ilian Metev, 2012) had its genesis in the IDFA Forum (2010) and Trieste Film Festival's When East

Meets West forum (2011), screened in a rough cut workshop at the Sarajevo Film Festival (2011), and ultimately won a number of film festival awards, including DOK Leipzig and Karlovy Vary before screening in IDFA's 'best of fests' programme. Although it serves a distinctly supranational role in contemporary Europe (Hongisto 2014), the European circuit parallels a global documentary circuit and various Anglophone circuits.

The function of the circuit is hardly new to film festival scholars or indeed any cinephile familiar with festivals. What Bourdieu's model provides is a way of correlating the aesthetic struggles for self-differentiation to the objective constraints of the festival circuit as a social practice. Film festival studies have employed Bourdieu to give a theoretical model for struggles over the consecration of cinema and for the uneasy relation between art and commerce in festival-oriented art cinema (Burgess 2014; De Valck 2014). Burgess, for instance, notes how the 'junket journalism' of the festivals raises questions of the disinterestedness of film critical discourse in the festivals (2014: 101). De Valck and Burgess are right that Bourdieu's models do have more to offer than the distinction of consumption. While audiences are important to festivals, festivals disproportionately comprise an audience of producers – film-makers, critics and programmers. Perhaps nowhere is the mutual imbrication of cultural consumer and producer more apparent.

The field effects of the festival circuit have implications for the aesthetics of documentary. Much as documentary ethics is structured by a twin field differentiation (documentary vs. entertainment; documentary cinema vs. journalism), the European festival documentary (the 'author's documentary' as it is sometimes labelled) defines itself against both straight-issue or broadcast documentary and its more experimental alternatives (the new documentary or experimental non-fiction). De Valck (2010) traces the history of IDFA, which, she argues, has been torn by three tensions: between 'political' and 'artistic' documentary, between 'television' and 'cinematic' documentary, and between 'straight' and 'hybrid' documentary forms. Each of these is a typically Bourdieuian struggle that cuts across levels of production and consumption, since they emerge from the aesthetic definitions of programmers, jurors, film-makers, critics, scholars and audiences. Moreover, each acts on a conscious and non-conscious level, since various players in the festival circuit may have conscious normative visions for documentary while they unwittingly reflect larger social positions and vested stakes.

The struggles that de Valck describes have not been resolved, but recent European festival documentary has managed them with a structural ambiguity between 'politics' and 'art'. So, while different festivals may emphasise one vision or another, one overall development across festivals has been

the importation of experimental film-making into documentary. This trend is most evident in the prolific amount of poetic documentary screening in European festivals. These films have a much looser narration than a traditional documentary and in fact often seem minimalist, without voice-over, explanatory titles or social actor testimony to guide the spectator to a clear theme or meaning. Formally, the editing pace is slow, and compositions are often static; the tableau compositions of art cinema are frequent. Take for instance, the Latvian short *Snow Crazy* (Laila Pakalniņa, 2008), in which a series of static shots depict a man-made ski slope in Latvia. Pakalniņa uses off-centred framing, rack focus and source sound to abstract the imagery from the normal non-fiction meaning. Adopting the strategy of defamiliarisation, the film asks the spectator to look at the images anew and to make the familiar strange. In both its formal strategies and aesthetic aim, *Snow Crazy* is like many other poetic documentaries, from across national contexts.

At the same time, by most standards *Snow Crazy* is a documentary and not an experimental film. It and films like it circulate in documentary festivals and are often made by those trained in documentary rather than those coming to non-fiction from experimental or art cinema backgrounds (although there is increasing convergence here). More importantly, the festival poetic documentary retains an underlying Griersonian or public sphere dimension. *Snow Crazy* is part of a process of national self-definition as the film asks what Latvian identity means. If the answer the film gives to the question is offbeat and ironic, the proliferation of poetic documentaries on the festival circuit serves a dually transformative effect. Poeticism pushes issue documentary away from more straightforward narration and reinvigorates the popular observational format.

Similarly, contemporary festival documentaries selectively import structural film-making into the feature documentary. An approach largely associated with experimental cinema of the 1960s and '70s, structural film relies on an arbitrary formal device – a shot length camera movement or framing approach – that forces a break with ingrained cinematic perception (Sitney 1970). Although the structural experimental films were not narrative (or even non-fiction for that matter), they could invoke the spectatorial experience of narrative but with an emphasis on what David Bordwell (1985) calls parametric narration, in which the narrating system itself takes precedence. The sensibility has been taken up in other movements, including video art and the gallery film. Catherine Russell (1999) has argued that makers like Chantal Akerman have a structural approach to documentary. However, there has been a recent and fairly self-conscious application of structural film aesthetics to non-fiction. *Landscape* (Sergei Loznitsa, 2003) consists of a single long take pan across the landscape of a small Russian town in winter.

As townspeople gather and wait for a bus, the soundtrack captures and edits snippets of their conversations. As the panoramic space unfurls, the limited framing and sound montage destabilise the profilmic. The film is indeed a portrait of a moment in Russian working-class daily life, but the film's meaning lies in the spectator's confrontation with the space of contemporary Russia rather than in a traditional type of documentary theme.

Such a cinematic exercise could be written off as a marginal work in the more experimental wing of the documentary field were it not for the extent that documentary features share formal strategies with *Landscape*. *The Autobiography of Nicolae Ceaușescu* (Andrei Ujică, 2011), for instance, uses similar sound design techniques, compiling a montage of ambient sound and often inaudible speaking. The structural approach to sound resignifies the archival footage format as a kind of meta-history. Vitaly Manksy's *Pipeline* (2014) goes further in absorbing the structural device in an accessible feature documentary synthesising observational, poetic and experimental documentary. The film follows the Trans-Siberian gas pipeline from its start in Siberia and across Russia, Ukraine, the Czech Republic and Germany. Rather than an issue film on the pipeline, however, the film obliquely invokes the economic connections and national tensions of contemporary Europe by giving an observational snapshot of towns and spaces along the pipeline's route. One key scene of the film depicts a memorial service for Ukrainian veterans. There are a series of takes that provide a minimal exposition of the event – chairs being set up, wreaths laid and a ceremonial fire lit as veterans arrive. The film then offers a long take circular pan, similar to *Landscape*. Only now, the device is integrated in the observational narrational approach driving the wry commentary on the uneasy place of Soviet national memory in contemporary Ukraine and Russia. The pan inverts the utopian aspiration of the structural film, since rather than hoping to break ingrained perception as the 1970s structural makers sought, Mansky's critique lies within the limitation of ideological perspective.

In the instance of both poetic and structural documentary, the ultimate field transformation is the situation of a festival voice in between the exigencies of U.S. documentary, with its premium on a narrative, character-driven format, and European television broadcast. Any discussion of a documentary field, furthermore, must grapple with the tendency for the stakes to be different in the United States (and, arguably, other Anglophone countries) and those European countries with a more robust film policy. This, despite the fact that public broadcast distribution and non-profit and foundation funding for many documentaries in the United States comes closest to what Thomas Elsaesser (1989) calls a 'cultural mode of production' in a national context heavily oriented to an industrial mode of production.

BEYOND THE CONSUMER/PRODUCER DIVIDE IN FILM STUDIES

The sociology of taste approach is certainly applicable to the examples above. For instance, a research agenda could assess how different documentary approaches speak to different taste and class fractions. Nonetheless, a static hierarchy of low/middle/high does not adequately capture the aesthetic transformation of documentary in either the U.S. or European setting. The documentary field and film festival circuit both are primarily the province of bourgeois constituencies, even if other classes are at times important secondary audiences. While the placement of documentary in the larger cultural field is a relevant matter, the conflict between fractions of the same social class takes precedence over the divisions between high-, middle- and lowbrow positions. At least at a glance, observational documentary and experimental documentary are both 'difficult' genres that require some cultural capital to appreciate, but the observational documentary speaks to a different constituency (produced for elites, closer to the field of power) than the experimental documentary (produced for other artists, more invested in cultural capital). In short, Bourdieu's model in *The Rules of Art* has as much to tell as that in *Distinction*.

John Guillory (1997) has argued that the selective misunderstanding of Bourdieu in the American academy speaks to an ideology of voluntarism. The stakes have been different in film studies than in literary theory and different still in other Anglophone academic contexts, but it is possible that the success of Bourdieu for reception studies springs from an underlying (and limiting) model of media consumer agency. In any case, a Bourdieuian agenda in film studies can examine phenomena of cinema other than the taste preference of audiences. Bourdieuian film studies can offer new ways to understand the aesthetic, even as the aesthetic itself is subject to social analysis. It can take into account the work in sociology and social theory to refine and extend Bourdieu's work. Finally, taking the cinema into account as a social practice, it can assess the strength, autonomy and internal dynamics of cinematic fields. Bourdieu's writing frequently aims to synthesise and overcome conceptual antinomies like subjectivism and objectivism. It would be too cavalier to expect a Bourdieuian approach to overcome opposing camps in film studies. And despite its insights into aesthetic categories, it remains primarily a sociological rather than an aesthetic approach. Nonetheless, major divisions between film theory and film history, or between cultural studies and political economy, have structured the discipline. Field theory will not necessarily reconcile these, but it can help us reframe our research agendas productively.

NOTES

1. For an example of film historical scholarship using the concept of social field, see Edwards 2006.
2. Although she does not use this particular strain of Bourdieu, de Valck's account (2007: 126–27) in particular focuses on taste hierarchy enforcement as a kind of symbolic violence (Bourdieu 1991).

REFERENCES

Bordwell, D. 1985. *Narration in the Fiction Film.* Madison: University of Wisconsin Press.

Bourdieu, P. 1984. *Distinction: A Social Critique of the Judgment of Taste*, trans. R. Nice. Cambridge, MA: Harvard University Press.

———. 1991. 'On Symbolic Power', in J.P. Thompson (ed.), trans. G. Raymond and M. Adamson, *Language and Symbolic Power.* Cambridge, MA: Harvard University Press, pp. 165–70.

———. 1993. *The Field of Cultural Production: Essays on Art and Literature*, R. Johnson (ed.). New York: Columbia University Press.

———. 1996. *The Rules of Art: Genesis and Structure of the Literary Field*, trans. S. Emanuel. Stanford: Stanford University Press.

Bourdieu, P. and L. Wacquant. 1992. *An Invitation to Reflexive Sociology.* Chicago: University of Chicago Press.

Bruzzi, S. 2006. *New Documentary.* London: Routledge.

Bullert, B.J. 1997. *Public Television: Politics and the Battle over Documentary Film.* New Brunswick: Rutgers University Press.

Burgess, D. 2014. 'Why Whistler Will Never Be Sundance, and What This Tells About the Field of Cultural Production', *Canadian Journal of Film Studies* 23(1): 90–108.

Caldwell, J. 2008. *Production Culture: Industrial Reflexivity and Critical Practice in Film and Television.* Durham, NC: Duke University Press.

Decherney, P. 2005. *Hollywood and the Culture Elite: How the Movies Became American.* New York: Columbia University Press.

de Valck, M. 2007. *Film Festivals: From European Geopolitics to Global Cinephilia.* Amsterdam: Amsterdam University Press.

———. 2014. 'Film Festivals, Bourdieu, and the Economization of Culture', *Canadian Journal of Film Studies* 23(1): 74–89.

de Valck, M. and M. Soeteman. 2010. '"And the winner is . . .": What happens behind the Scenes of film festival competitions', *International Journal of Cultural Studies* 13(3): 290–307.

Dolgin, G. and V. Franco. 2004. 'Filmmaker Q&A', *Daughter from Danang.* Retrieved 27 July 2010 from http://www.daughterfromdanang.com/about/qa.html

Edwards, K.D. 2006. 'Brand-Name Literature: Film Adaptation and Selznick International Pictures, *Rebecca* (1940)', *Cinema Journal* 45(3): 32–58.

Elsaesser, T. 1989. *New German Cinema: A History*. London: British Film Institute.

English, J.F. 1999. 'Radway's "Feelings" and the Reflexive Sociology of American Literature', *Modernism/Modernity* 6(3): 139–49.

Fligstein, N. and D. McAdam. 2012. *A Theory of Fields*. Oxford: Oxford University Press.

Fowler, B. 2012. Insights and Blind-spots in Bourdieu's Reconstruction of the "Author's Point of View", *New Uses of Bourdieu in Film & Media Studies, 16 November 2012*. Newcastle University: Culture Lab.

Gans, H. 1964. 'The Rise of the Problem Film: An Analysis of Changes in Hollywood Films and the American Audience', *Social Problems* 11(4): 327–36.

Guillory, J. 1997. 'Bourdieu's Refusal', *Modern Language Quarterly* 58(4): 367–98.

Hawkins, J. 2000. *Cutting Edge: Art-Horror and the Horrific Avant-Garde*. Minneapolis: University of Minnesota Press.

Hongisto, I. 2014. 'Differentiating Nations, Imagining the People: Post-Soviet North Eastern European Documentaries at the Festival Circuit', *Society for Cinema Studies, Seattle 19–23 March 2014*.

Hutner, G. 2011. *What America Read: Taste, Class, and the Novel, 1920-1960*. Chapel Hill: University of North Carolina Press.

International Documentary Festival Amsterdam. 2012. '16 October: Selection for IDFA Forum 2012 Announced'. Retrieved 1 June 2014 from https://www.idfa.nl/industry/latest-news/selection-for-idfa-forum-2012-announced.aspx

Iordanova, D. 2009. 'The Film Festival Circuit', in D. Iordanova and R. Rhyne (eds), *Film Festival Yearbook 1: The Festival Circuit*. St. Andrews: St. Andrews Film Studies, pp. 23–39.

Jacobs, L. 1992. 'The B Film and Problem of Cultural Distinction', *Screen* 33(1): 1–13.

Jancovich, M. 2010. 'Two Ways of Looking: The Critical Reception of 1940s Horror', *Cinema Journal* 49(3): 45–66.

Jenkins, R. 1992. *Pierre Bourdieu*. London: Routledge.

Klein, A.A. 2013. *American Film Cycles*. Austin: University of Texas Press.

Levine, E. and M.Z. Newman. 2013. *Legitimating Television*. London: Routledge.

Nathan, D. 2003. 'Complex Persecution', *The Village Voice*. Retrieved 1 June 2014 from http://www.villagevoice.com/2003-05-20/news/complex-persecution/full/

Newman, M.Z. 2009. 'Indie Culture: In Pursuit of the Authentic Autonomous Alternative', *Cinema Journal* 48(3): 16–34.

Polan, D. 2007. *Scenes of Instruction: The Beginnings of the U.S. Study of Film*. Berkeley: University of California Press.

Russell, C. 1999. 'Framing People: Structural Film Revisited', in *Experimental Ethnography: The Work of Film in the Age of Video*. Durham: Duke University Press.

Schaefer, E. 1999. *'Bold! Daring! Shocking! True!': A History of Exploitation Films, 1919-1959*. Durham: Duke University Press.

Sconce, J.1995. 'Trashing the Academy: Taste, Excess, and an Emerging Politics of Cinematic Style', *Screen* 36(4): 371–93.

Sitney, P.A. 1970. 'Structural Film', in *Film Culture Reader*. New York: Praeger Publishers, pp. 326–49.

Tinkcom, M. 1996. 'Working like a Homosexual: Camp Visual Codes and the Labor of Gay Subjects in the MGM Freed Unit', *Cinema Journal* 35(2): 24–42.

Tudor, A. 2005. 'The Rise and Fall of the Art House Movie', in D. Inglis and J. Hughson (eds), *The Sociology of Art: Ways of Seeing*. Basingstoke: Palgrave Macmillan, pp. 125–38.

Wong, Cindy Hing-Yuk. 2011. *Film Festivals: Culture, People, and Power on the Global Screen*. New Brunswick, NJ: Rutgers University Press.

Chris Cagle is an assistant professor of Film and Media Arts at Temple University, Philadelphia. His research interests include classical Hollywood, cinematography, documentary and social theory. He has completed a book on the Hollywood social problem film, titled *Inventing the Social*.

Chapter 3

Bourdieu and Images of Algerian Women's Emotional Habitus

Sophie Bélot

INTRODUCTION

This chapter explores and reinstates Bourdieu's philosophical ideas (especially the notion of habitus) to their original Algerian (troubled) social and political life. As a scholar of Algerian culture, Bourdieu has not yet had a great impact on scholarly work concerning Algeria. Only a few studies can be mentioned: *Bourdieu in Algeria: Colonial Politics, Ethnographic Practices, Theoretical Developments* (Goodman and Silverstein 2009); *Algerian National Cinema* (Austin 2012); *Picturing Algeria: Pierre Bourdieu* (Schultheis and Frisinghelli 2012); and *Pierre Bourdieu: Algerian Sketches* (Yacine 2013). Until recently, critics have been reluctant to refer to Bourdieu's analysis of Algerian society, as well as his conceptualisation of gender relations informed by his early research in Algeria. The present chapter will attempt to address this by offering a Bourdieuian reading of representations of women in contemporary Algerian cinema.

Throughout his career, Pierre Bourdieu established a strong link with Algeria. His experience of the country informed the development of his influential theoretical thinking, as Tassadit Yacine observes: 'Algeria occupies a pivotal place in Bourdieu's thought and work, such that it is impossible for a serious analyst to ignore it when seeking to understand his distinctive intellectual approach' (2004: 488). Bourdieu's approach mostly focuses on the relationship between individual social beings (or agents) and the social world – an aspect that will be relevant for this study and will be

further developed regarding Algerian women during the social upheavals of the 1990s and early 2000s, also referred to as the second Algerian war or the civil Algerian conflict.[1]

Bourdieu's research testifies to a deep political commitment and personal engagement with Algeria. Indeed, Bourdieu's experience of the country and its society began with immersion into an Algeria in conflict (during the 1954–1962 war of independence against the French). He was sent to Algeria in 1955 to complete his national service; as a soldier he was posted in the Chéliff Valley, near Algiers, before obtaining an administrative post in Algiers in early 1956. In 1957 he was offered a lectureship post in philosophy and sociology at the University of Algeria where he stayed until 1960. It is during this time as a soldier and a civilian that Bourdieu started researching and publishing about Algeria, as well as taking photographs. His strong (personal) involvement can explain the fact that it is difficult to give an exhaustive list of the work that emanates from his time in Algeria, for all of his writing has been influenced by his early relationship with the country and its people. As David Tresilien remarks: 'Algeria subsequently became the subject of Bourdieu's first sociological works, reappearing throughout his career as a source of examples and a frequent reference' (2003). These first works include *The Sociology of Algeria* (1958); *Work and Workers in Algeria* (1963); *The Uprooting* (1964); *An Outline of a Theory of Practice* (1977); *Algeria 1960* (1979); and *The Logic of Practice* (1990). The importance of his Algerian studies can be extended to their formative influence on his own life, and most specifically their relationship with his own social background in France.

Bourdieu's French rural origins made him particularly susceptible to the social suffering he observed in colonial Algeria, especially in the Berber region of Kabylia. I believe that Bourdieu's deep personal relationship with Algeria can be referred to as an emotional tie infusing his theoretical position. This particular relationship might be rather difficult to grasp in his scholarly work, but it is evident in the many photographs he took of his time in the country. Among his thousands of photographs, only a few hundred were saved and made available to the public at exhibitions in 2003 (Austria and Paris), 2004, 2006 (Algeria) and 2007 (London). Some were published in *Picturing Algeria: Pierre Bourdieu* (Schultheis and Frisinghelli 2012), while others were used for his book covers. Referring to some of these photographs, my intention is to show that they form an important aspect of his thinking around emotional habitus, as mentioned in *Masculine Domination* (1998). Indeed, this chapter will aim to explore Bourdieu's unacknowledged, but influential, photographic work, which will be useful to cast light on Algerian women's lived (emotional) experience of conflict and instability

as represented in recent domestic cinema. In this sense, Bourdieu's photographs will be valuable in establishing a link with contemporary (social) film-makers whose objective – reminiscent of Bourdieu's – is also to make visible the individual (female) experience in an Algeria at a time of conflict.

Following a feminist reading of Bourdieu's ideas, this study will concentrate on the connection between habitus and emotion as challenging a dominant perspective. In other words, this study will tease out the concept of emotion in habitus to allow a strengthening of the relationship between social agent (Algerian women) and their actual social environment, that is to say an Algeria in conflict, as depicted in recent films made by Djamila Sahraoui (*Barakat!*, 2006), Belkacem Hadjaj (*El Manara*, 2005), and Yamina Bachir-Chouikh (*Rachida*, 2002). A Bourdieuian feminist perspective will focus on the idea of change in the above films, noticeable in Algerian women's bodily habitus inflected by shifting social structures, which their emotional dispositions betray.

In some ways, this study has another underlying objective, which is to emphasise the unrecognised influence of Bourdieu's work on contemporary Algerian and North African film-makers by highlighting their concern with women's bodily behaviours.

MASCULINE DOMINATION, HABITUS AND EMOTION

Sahraoui's, Hadjaj's and Bachir-Chouikh's cinematographic works mostly evoke the social and humanitarian crisis the country experienced in the 1990s and early 2000s. They also concentrate on specific gender issues by tackling Algerian women's position in contemporary society. The 1990s and early 2000s civil conflicts emanating from the rise of a militant branch of Islam, led initially by the FIS (Front islamique du salut) and subsequently by the ultra-violent GIA (Groupe islamique armé) – and the beleaguered government's equally violent attempts to curb this – had a considerable impact on Algerian women as well as intellectuals, artists, professionals and the civil population at large. Works by now well-known Algerian directors, such as Sahraoui and Bachir-Chouikh look at the situation and position of women during the civil conflict that followed the suspension of elections in late 1991. A link is often suggested between women in this current context and women who fought during the war of independence (1954–1962) only to be marginalised by a patriarchal independent Algerian state. Several key films, as we shall explore, seem to show the unchanged situation of Algerian women, which could, therefore, be explained by Bourdieu's notion of habitus, as developed in *Masculine Domination*.

As already noted, Bourdieu experienced Algeria during the war of inde-
pendence of which his early writings provide an account. He focused his
ethnological and anthropological work on the peasant population, the sub-
proletariat and the proletariat in villages and towns across the country, but
mainly from the region of Kabylia. Within these groups of people, Bourdieu
conducted incisive research on issues of employment/unemployment, the
separation of space, the division of time, and education, which he also
considered from a gender point of view. Although this gender perspective
permeates most of his writings on Algeria, *Masculine Domination* (originally
published in French in 1998) is totally devoted to relations between the
sexes. The substantial Algerian-related material in *Masculine Domination*
focuses on the sexual division of labour in Kabylia regulating the structures
of space, time and activities, thus creating what Bourdieu calls a gendered
cosmology. Bourdieu refers to the gendered division at work here as 'the
logic of the relationship of domination' (Bourdieu 2001: 31) imposed imper-
ceptibly on the body through a process of socialisation inscribed in 'the
dispositions of the body' (Bourdieu 2001: 27). Bourdieu illustrates this point
by describing how,

> women, . . . being on the side of things that are internal, damp, low, curved
> and continuous, are assigned all domestic labour, in other words the tasks
> that are private and hidden, even invisible or shameful, such as the care of the
> children or the animals, as well as the external tasks that are attributed to them
> by mythic reason, that is to say, those that involve water, grass and other green
> vegetation (such as hoeing and gardening), milk and wood, and especially the
> dirtiest, most monstrous and menial tasks. (Bourdieu 2001: 30)

As will be highlighted in a subsequent section, some of Bourdieu's
photographs of Algerian women do not entirely correspond to such a domi-
nant description, and are, in some ways, more aligned with an ambiguous
portrayal of women during the war(s). Indeed, the significant and contested
role Algerian women played in the Algerian war of independence comes to
destabilise and challenge this division of labour and the dispositions of their
bodies. This idea of destabilisation of the sexual order can already be seen
in the ambiguity conveyed by the notions of permanence and change in the
cultural and social division between the sexes running through *Masculine
Domination.* I will show that these notions of permanence and change also
inflect Bourdieu's photographic work, which will be fundamental in appre-
ciating the contemporary position and condition of Algerian women. Due
to Bourdieu's perspective on a seeming persistence of patriarchal rules in
contemporary Algeria, only a few feminists have turned to his work, but
those who have done, such as Lisa Adkins and Beverley Skeggs (2005),

Terry Lovell (2000), Veronique Mottier (2002), Toril Moi (1991) and Clare Chambers (2005) have brought to the fore the pertinence and contribution of Bourdieu's embodied subject (as made apparent in his photographs) for reconsidering female subjectivity. Pertinent to this study, these feminists have explored the relation between habitus and embodied subjectivity in the light of reconsidering the female body in Bourdieu. My feminist-based reading of representations of feminine expression and bodily postures – or dispositions of habitus – will emphasise variations in women's condition and their involvement in the civil uprisings, as depicted in the films.

In *Masculine Domination*, Bourdieu addresses the question of permanence or change in the sexual order. Notwithstanding, his conclusion tends towards the persistence of patriarchal domination in Algerian society. For Bourdieu, patriarchy has become naturalised due to its deep roots in the society. Hence, Bourdieu does not dismiss the sexual differences in the production of male and female bodies, but his position is nevertheless better conveyed in the idea of a 'biologicization of the social', or 'a naturalized social construction' (2001: 3). For Bourdieu the physical and social body are intertwined to become the main site of legitimisation for the patriarchal order. In this sense, the Bourdieuian (female) body becomes a site where masculine domination is imposed and suffering experienced. Acts of suffering are the effects of 'symbolic violence', by which Bourdieu means 'a gentle violence, imperceptible and invisible even to its victims, exerted for the most part through the purely symbolic channels of communication and cognition (more precisely, misrecognition), recognition, or even feeling' (Bourdieu 2001: 1–2). At first sight, Bourdieu's position towards masculine domination and the female body does not seem innovative in relation to developments in feminist philosophy informed by a Foucauldian perspective. But as far as this study is concerned, the idea of suffering, and therefore emotion, carries a particular theoretical innovation in relation to (Algerian) women. This is an aspect not fully developed within Bourdieu's work, but which is recurrent in his notion of habitus and, I will show, can be uncovered in his photographic work. Studies led by Deborah Reed-Danahay, *Locating Bourdieu* (2005) and by Margaret Wetherell, *Affect and Emotion: A New Social Science Understanding* (2012), have teased out the notion of emotion in habitus, which will be helpful for this study. I will subsequently show the relevance of Bourdieu's photographic work when examining the notion of habitus in relation to the depiction of contemporary Algerian women's (lived) bodies inflected by change (or improvisation).

For feminists, the importance of *Masculine Domination* undoubtedly lies in its concern with the (female) body in relation to issues of permanence and change. Bourdieu claims that the invisible symbolic force or violence

inculcated on female bodies is unremitting and concerns stances, gaits, postures as well as thoughts, tastes and emotions. The constant and deep effects of the relation of domination on (female) bodies are what Bourdieu refers to as dispositions. Some feminists, such as Mottier, have interpreted Bourdieu's dispositions as so deeply ingrained beyond the conscious that it is impossible to transform or correct them. For these feminists the notion of habitus coined by Bourdieu offers a fitting terminology for the persistent domination imposed on women. Feminists have therefore often accused Bourdieu of offering a gloomy picture of gender relations. Mottier argues that '[A]s a consequence of the overemphasis on the structural constraints of the habitus, he gives us few theoretical tools for conceptualising active practices of self-fashioning and resistance to the structures of power' (2002: 354). For Bourdieu, the deep embedding of habitus in dispositional and perceptual bodies also relates to emotion, which further enhances the symbolic force exerted on (female) bodies:

> These emotions are all the more powerful when they are betrayed in visible manifestations such as blushing, stuttering, clumsiness, trembling, anger or impotent rage, so many ways of submitting, even despite oneself and "against the grain" [*à son corps défendant*], to the dominant judgement, sometimes in internal conflict and division of the self, of experiencing the insidious complicity that a body slipping from the control of consciousness and will maintain with the censures inherent in the social structures. (Bourdieu 2001: 38–39)

Bourdieu's few direct statements on emotion in the perpetuation of relations of domination have attracted the attention of feminists in recent publications. Several chapters from Adkins and Skeggs' edited volume, *Feminism After Bourdieu: International Perspectives* (2005), address this problem, such as, for instance, Elspeth Probyn's contribution (2005). Notwithstanding, Reed-Danahay (2005) points out the scholarly negligence and overshadowing of the implication of habitus for the study of emotion, to which she devotes a chapter in her study *Locating Bourdieu*. Reed-Danahay stipulates the importance of *Masculine Domination* as a study where Bourdieu explicitly laid out his view on emotion, which he linked with habitus, social reproduction and domination. Wetherell agrees with this view when she states: 'For Bourdieu, emotions more than anything seem to carry the unreflective or non-conscious aspects of habitus' (2012: 102). However, scholars such as Probyn, Reed-Danahay and Wetherell have teased out Bourdieu's statements on emotion and its intricate connection to the body and relations of domination. All these scholars bring out the social aspect of emotion to reinforce its link to the body overlooked by Bourdieu. Indeed, Wetherell states that by focusing too much on the non-conscious aspect of habitus, Bourdieu

loses sight of its embodied situation (its lived experience). By contrast, by focusing on the connection between habitus understood as a 'generative principle of regulated improvisations' (Bourdieu 1977: 78) and emotion, Wetherell aims to counter this imbalance in Bourdieu's perspective.

The significance attributed to emotion lies in the fact that it permeates most of Bourdieu's work. It can be traced in *The Weight of the World* (1993) based on social suffering; in his reflexive work; in his study of uprooted peasants; and in his photographs, as the visual method imparting most of this theoretical work. Reed-Danahay pertinently states: 'Bourdieu's proximity to the experience of peasants shaped the role that emotion and the body played in his theoretical formulation of the *habitus*' (2009: 136). In her statement about the role of emotion in Bourdieu's early work, Reed-Danahay also re-establishes the link between emotion and the body for the notion of habitus by contrast to a purely subjective or cognitive approach. Referring to Michelle Rosaldo's notion of 'embodied thoughts (1984: 143)', Reed-Danahay claims that 'Rosaldo was drawing on similar concepts of emotion and the body to those articulated by Bourdieu in his concepts of habitus and dispositions' (Reed-Danahay 2005: 100). The emphasis is on the phenomenological perspective bringing forward the idea that the person experiencing emotions as an embodied subject is located in the world, or, in other words, is being in the world. Reed-Danahay's position is in line with that of Wetherell when she considers embodied emotion as 'a relation to others, a response to a situation and to the world' (2012: 25). By emphasising the fact that emotion is not only part of an individual subjectivity, but is also a social act, she aims to reinforce the position of the social subject in Bourdieu's work. Not only is emotion an object inside the self, it is also a situated activity. In other words, emotion is not solely related to the inner aspect of the self or the non-conscious, as referred to by Bourdieu. This means that bringing to the fore the agency of the social subject, the idea of change (or improvisation) can be brought forward. One can talk of change in the sense that emotion can express the rupture in the dispositional body, as traced in Bourdieu's earlier work on the uprooting experienced by Algerian peasants resettled away from their home villages by the French colonial forces. In this instance, Reed-Danahay observes that: 'It was the traditional peasant (*paysan empaysanné*) who was left most emotionally displaced in this setting, according to the analysis, no longer feeling comfortable in his bodily habitus. The language of the peasant body was out of place in the resettlement camp' (2005: 87). The body or the body's disposition gives away emotional signs of the rupture with the past and of the traditional peasant's experience of dislocation. This example illustrates the delineation between habitual responses and conscious embodied life.

This condition is visually illustrated as part of Bourdieu's photographic archive, which can partly be found in Schultheis and Frisinghelli's recent publication, *Picturing Algeria: Pierre Bourdieu* (2012). Embracing the interdisciplinarity of Bourdieu's work, the link between habitus, embodied emotion, social act and change will be further enhanced and developed by turning to his photographs of Algeria during the war of independence. Following Frantz Schultheis' position, I will show that his pictures 'allow a new angle on his view of the social world' (2003: 2). This new angle will be informed here by a feminist reading of Bourdieu's photographs as illustrations of lived practice, understood as the social subject linked to social activity, that is to say an embodied (female) social actor.

BOURDIEU'S ILLUSTRATIONS OF HABITUS AND EMOTION

The connection between emotion and Bourdieu's work is made explicit in his visual illustrations of lived (embodied) experiences. They are a valuable database, conveying a strong link with his theoretical perspective on habitus as a 'generative structure'.

The photographs have allowed him to shape his theory of the social world, as illustrated in *Masculine Domination* regarding gender relations. Frantz Schultheis, Patricia Holder and Constantin Wagner state: '. . . we find indications that Bourdieu was systematically making use of his photographic archive to study the body techniques and the specific *hexis* of women and men' (2009: 453). Interviewed on several occasions, Bourdieu specified the importance of photography for his research; he affirmed that: 'It is quite normal to make a connection between the content of my research and my photos' (Bourdieu interviewed by Schultheis 2013: 308). Alongside other locations such as Béarn and urban France, Algeria features in his photography as the country where he conducted his first sociological fieldwork. Despite the significant role Bourdieu's photographs could play as regards Algerian cinema, they have until recently been overlooked or unnoticed. Indeed, until an exhibition in 2003 – a year after Bourdieu's death – and a publication in 2012, his photographs had hardly been considered from a scholarly perspective.[2]

This visual database functions as testimony, but also as a means of recording the Algerian situation, as Les Back indicates: 'The task that Bourdieu set himself was to "cast light" on the unfolding drama of decolonisation in Algeria' (2009: 476). Bourdieu deals with the disruptions, and consequently the transitory aspect of the Algerian society, during the war of independence, and its impact on gender relations. His use of the

visual as a personal and political commitment is in line with contemporary Algerian film-makers, such as Hadjaj and Bachir-Chouikh, who aim to reveal the impact of violence on Algerian society in the 1990s and early 2000s. Schultheis explains Bourdieu's photographs as a form of political commitment by pointing out the act of 'seeing in order to make something visible, understanding in order to make something understandable' (Schultheis 2012: 5). The suggested relation between the (sociological) gaze and his photographs is significant in uncovering the shifts in habitus.

Taken during the war of independence, Bourdieu's photographs do not show any direct signs of this Franco-Algerian conflict. As Kamel Chachoua observes: '*De même, les* photographies d'Algérie, *toutes prises en pleine guerre dans les environs d'Alger entre 1959 et 1960 ne montrent aucune arme (un seul tank), aucun militaire, aucun mort et même aucun Européen*' [Similarly, *photographs of Algeria,* all of them taken in the midst of the war in and around Algiers between 1959 and 1960 do not show any weapons (only one tank). They do not show any soldiers, dead people or even any Europeans] (2012, my translation). Bourdieu's photographic gaze is thus underpinned by the inconspicuous and unconventional perception of the war. For Bourdieu, the visual becomes a means of documenting and exposing social upheavals and their impact on the population, as for instance Algerian women. Bourdieu's photographs act as a trace for him (and us) to come back to in order to work on the philosophical notion of habitus. Paul Sweetman also appreciates their philosophical value by 'play[ing] a particularly helpful part in the investigation and uncovering of habitus' (2009: 493). In an interview with Schultheis, Bourdieu justifies his taking photographs in Algeria by stating that: 'I had the idea of taking photos of situations that touched me deeply because they mingled dissonant realities' (Bourdieu in Schultheis 2013: 304). The helpful part these photographs play can thus be found in their illustration of dissonance as informing the development of Bourdieu's habitus based on the tension, or ambiguities of social life. He illustrates his view by giving an example of a photograph he used for the cover of *Algeria 60* (1979) of 'two men in turbans, old-style Arabs, who are sitting on the running board of a car . . . and having a very serious discussion' (Bourdieu in Schultheis 2013: 304). The specificity of the war situation in Algeria is depicted in the representations of the improvisation of, or change in, the habitual form of the Algerian society (such as masculine domination). In other words, the dissonance lies in the depiction of ambiguity in Algerian people's (gendered) bodily dispositions (as naturalised social construction).

Bourdieu's photographs are personal as well as very private, not only regarding their subject matter (for example a circumcision), but also as far as their aesthetics are concerned. His pictures depict the ideas of transitions,

dislocations and uprootedness. They portray the suffering of Algerian individuals caused by the disruption and damage done to their lives by colonialism and the introduction of a new social and economic system. If the war is not directly represented, it is perceptible in the infinitely small details of an act – that is to say the individuals' postures, or what Bourdieu will later refer to in *Masculine Domination* as dispositions or (gender) habitus. The aforementioned example of the two traditionally dressed Arab men sitting on the running board of a car can be used as an illustration of changes in people's postures, dispositions or habitus. Showing the war as it is lived on a daily basis is also the way Bachir-Chouikh, Sahraoui and Hadjaj have filmed the civil war of the '90s.

Rachida tells the story of a young teacher who is forced by Islamists to place a bomb in her school. She refuses and is shot, but will survive to live in fear. Also a victim of terrorism, the young female doctor in *Barakat!* is looking for her husband who has been kidnapped by Islamists for, supposedly, his controversial writings in national newspapers. As for *El Manara*, the film centres on a group of three young people growing up together but who will be separated by the rise of Islamist ideologies in the 1990s. These films' main characters are ordinary women, each *'une simple citoyenne'* [only a citizen], as Bachir-Chouikh said to *Cahiers du Cinéma* about the protagonist of *Rachida*. Interviewed by *Cahiers* about her film, Bachir-Chouikh stresses: *'Je pense que Rachida transmet tout ça, leur vie, leur visage. Les gens se retrouvent dans tel out tel personnage, retrouvent leur frayeur, leur peur, leur humour, leur manière d'être dans ce drame'* [I think that *Rachida* conveys all this, their lives, their faces. People can see themselves in such and such character, see their own fear, humour, and their own way of being in this dramatic situation] (Yamina Bachir-Chouikh interviewed by Lequeret and Tesson 2003: 28, my translation). Bachir-Chouikh draws the critics' attention to the protagonists' bodies (their faces and way of being) as illustrative of the Algerian (social) condition at that time (fear, humour).

Bourdieu proposes a similar reading of one of his most typical pictures, that of the veiled woman riding a scooter in Algiers during the war of independence. Bourdieu's interpretation of this picture rests entirely on the woman's body in relation to her social environment represented by the scooter. The collision between tradition and modernity is the striking aspect of this representation. Bourdieu understands tradition to be represented by the veil (also mentioning the stereotypical gendered view of exotic Islam) and the scooter signifies modernity. Bourdieu explains what, in this scene, drew him to photograph it by saying that this was a situation that 'spoke to me because they [it] expressed dissonance' (Bourdieu cited in Calhoun 2003: x). Bourdieu uses terms such as 'double experience, contradictory or

ambiguous' (Bourdieu in Schultheis 2013: 310) to express the idea of disso-
nance, which he also associates with 'a break that divides a world that is in
the process of disappearing in its familiar and habitual forms, from a new
world that is very swiftly imposing itself' (Bourdieu in Schultheis 2013: 307).
The picture's evocation of 'double experience', transitions and dislocations
in the relation between the physical (woman's body) and the social are the
elements that will later form the basis of his theoretical work.

This picture of the veiled woman riding a scooter – its typicality and,
thus, significance – can be found in Calhoun's interpretation of the whole
scene as being 'a picture of a confident young woman moving about on
her own' (2003: xvi). This alternative reading gives a new dimension to the
picture, where its significance lies in its suggested confidence. Whilst from
a theoretical point of view Bourdieu's concept of habitus seems to highlight
a perpetuation of the same; his picture reveals a change (an improvisa-
tion) perceptible in the woman's feeling of confidence. In other words, the
engagement of the Algerian woman in this conflicted situation torn between
old and new is rendered through her feeling of confidence. Calhoun's
interpretation is a useful reminder that Bourdieu's pictures 'are not mere
illustrations but occasions for further thought' (2003: viii). Considering the
strong relationship that these pictures share with Bourdieu's theory, this
remark can be extended to his notion of habitus. This is an observation
with which Lois McNay seems to agree when she considers the habitus
as 'a dynamic, open-ended process' and not 'a principle of determinism'.
Indeed she argues: 'These criticisms fail to recognise, however, the force of
Bourdieu's insistence that habitus is not to be conceived as a principle of
determinism but as a *generative* structure' (1999: 100; original emphasis). In
the aforementioned picture, the relationship between the woman's emotion
of confidence, habitus, social reproduction and domination, as advocated
by Bourdieu in *Masculine Domination*, is challenged in the sense that this pic-
ture counters the idea that women are kept in a state of bodily insecurity. In
her recent publication, *Affect and Emotion: A New Social Science Understanding*
(2012), Wetherell has led the way by devoting a whole chapter to Bourdieu's
notion of habitus in relation to emotion, in the sense of the habitus being
'both the "weight of the world", in Bourdieu's terms, and a process of active
self-creation and new instantiation' (Wetherell 2012: 106).

Habitus is characterised, according to Bourdieu, by the dissonance
between permanence and change, which is highlighted by the woman's
conflicted behaviour in his photograph. However, what is emphasised in
Wetherell's thinking is the coexistence, as opposed to dissonance, between
change and permanence. It can, therefore, be inferred that Bourdieu's idea
of dissonance is counterbalanced by the fact that what is mostly conveyed

in the picture is the idea of the Algerian woman as neither a free agent nor a determined individual, but as an embodied emotional subject. This is a position that will be supported and further developed in the next section, which concentrates on three films about Algerian women's emotional position during the civil war in the 1990s. It will be shown that the co-presence of change and permanence destabilises the habitus of the social (female) agent expressed in their embodied emotion.

IMAGES OF ALGERIAN WOMEN'S EMOTIONAL HABITUS

The historical and social context addressed in *Masculine Domination* is pertinent to the three films studied here, in terms of its representations of permanence and change in recent Algerian society. In that sense, continuity seems to link both historical moments, also marked by change. Bourdieu's text and photos concern an Algeria at war (1954–1962), described by Paul Silverstein as 'a society in the process of revolutionary upheaval' (2004: 556). Silverstein adds that the war of decolonisation 'laid the groundwork for the construction of a new nation' (2004: 556). However, it is now well documented by testimonies such as those of Djamila Amrane (1999, 2007) that although the war of liberation was said to have brought an aura of change for Algerian women, this was quickly superseded by a continuation of patriarchal structures. For instance, 1984 marked the introduction of the Family Code, which made them minors in education, work, marriage, divorce and inheritance. Whilst women's participation in the war was crucial, masculine domination also seems to have been a constant in Algerian society. This position is echoed by Bourdieu's comment in *Masculine Domination* that: 'For the rest, even the changes in the condition of women always obey the logic of the traditional model of the division between male and female' (2001: 93). Bourdieu's theory of male domination seems to be extremely pertinent to explain the situation of Algerian women as depicted in recent films about the civil war. The three films considered in this study are built upon the idea of co-presence between past and present, or permanence and change, which is mainly depicted in the three Algerian women's bodies, but is also expressed through the films' aesthetic work, as will be highlighted.

The main narratives of *Rachida*, *Barakat* and *El Manara* concentrate on Algerian women's victimisation as well as courage. The films each tell the story of an Algerian woman's (inner) struggle during the civil war. These films focus on Algerian women portrayed as independent and active. The women follow their professional careers as a teacher, a doctor and a writer. Their professions take them outside the traditional feminised space of

the home, which allows them some freedom, as illustrated in the films by showing them in constant movement, going from place to place. The signs of modernity are also present in the female body itself. Taken as a representative example, the opening images of Bachir-Chouikh's film, *Rachida* introduce the heroine by showing sections of her body: red lips followed by curly hair. Both images stand for her femininity, but most importantly they are challenging images in the film's social context of the 1990s marked by the rise of fundamentalist factions, which led to repressive and oppressive acts towards women for their 'western' modes of dress or 'modern' behaviours. As a result, *Rachida*'s introductory shots show a liberated Algerian woman who assumes her unveiled and made-up body. This behaviour is contrasted with that of another woman who wears the veil and refuses to appear in the class photograph, for fear of upsetting her husband who lets her work. The most dreadful contrast, though, is predicated in the close-up of the red lipstick/lips, which is suggestive of the physical violence Rachida will be a victim of. The red lipstick is associated with the blood surrounding her body after she has been shot for refusing to carry the bomb into her school.

Women's bodies in these films are wounded; they bear the mark of their difference. Two films evoke the rape of women and their subsequent ostracism from their family and society. This is therefore a physical and psychical scar that is carried over into their future (*El Manara* evokes this idea by mixing past and present narratives). In *Barakat!*, the oldest woman (Khadidja) suffers from a continuous pain in her knee that slows her and her companion down in their quest. Khadidja's character represents the past generation who fought in the war of independence against the French. The cause of her physical pain is a stigma from that time and stands as a symbol of a past that does not go away. It is worth mentioning here that this line of reasoning is supported by Benjamin Stora in 'L'Algérie d'une guerre à l'autre' (2001a), 'Algérie: les retours de la mémoire de la guerre d'indépendance' (2002) and *La Guerre Invisible* (2001b). In this latter study, Stora mentions Bourdieu's reflection on the connections between both wars in terms of people's behaviours (*'les mêmes phobies, les mêmes automatismes, les mêmes réflexes'* [the same fears, the same automatism, the same reflexes] (Bourdieu cited in Stora 2001b: 10, my translation). The presence of the past in the present through the (female) bodily behaviours echoes Bourdieu's line of thought regarding the durability of his embodied subjects, or the habitus. This persistence, for Bourdieu, is attributed to gendered habitus, as expressed in *Masculine Domination*. Bourdieu's transhistorical emphasis on the continuity of masculine domination is therefore alluded to in the films; the past can be felt in the present in terms of continuity.

The mixing of past and present, old and new is also reflected in the films' narrative structures. *El Manara* is completely constructed around a flashback, which takes the audience and the main character back to memories of the personal disintegration she suffered from during the civil war. The narrative is based around a full circle, the persistence of the same image of a woman's reflective behaviour. The other two films share a similar structure in the sense that their opening scene is repeated at the end. Indeed, *Rachida* closes on a sequence showing the heroine at her workplace, the school. As for *Barakat!*, the film also concentrates on the female protagonist returning home. All three films are underpinned by the idea of return to a kind of 'home', despite outside disruptions. This return is cinematographically conveyed by the films' closing sequences on a fixed close-up of these women's faces confronting the camera (for *Rachida* and *Barakat!*). The films indicate an insistence and persistence of women's position and of women's bodily movements, but the camera's focus on their faces requires interpretation. Indeed, the final images of a shot or close-up of Algerian women refer to their role as bearers of social and cultural traditions. These last shots bear some resemblance to Bourdieu's aforementioned photograph of an Algerian woman with a scooter in their dissonance or rather coexistence between tradition and modernity, or permanence and change.

At the end of the films, the heroines have experienced a transformation as being involved in the world. From feeling detached from the events happening in their country, the troubles have been brought home to them by acts of suffering (being shot in *Rachida*, and through abduction in *Barakat!* and *El Manara*). The beginning of each film shows women carrying on with their own lives despite the ravages of the civil war until the day when these affect them in the flesh. In her article about Francophone postcolonial filmmaking, which includes *Rachida*, Margaret Flinn talks of 'giving a face to the conflict' (2011: 339) in order to 'en-vision' women as living society and *in* society. In other words, the emphasis is put on Algerian women being in the world through their bodies. Flinn pertinently indicates that women in such films as *Rachida* are not simply represented as enduring masculine domination through symbolic and physical violence, but are also granted agency. The type of agency she refers to is made visible in the final close-up of Rachida's face that 'refuse[s], return[s] and re-appropriate[s] the gaze' (2011: 340). Flinn adds 'in being envisaged, they "dévisagent", or stare back' (2011: 340–41). Flinn's remarks highlight the reciprocal relation between 'envisager' (to envision) and 'dévisager' (to stare back), bringing to the fore the reflective final act of these women.

Reed-Danahay stresses Bourdieu's work connection to emotion through his stance on reflexivity. Reflexivity underpins *El Manara* as a film about a

woman's personal narrative of her past. The film is founded on a flashback of the main female protagonist reminiscing about her long friendship with two male friends and their traumatic separation when one of them follows the ideologies of fundamentalist Islam. Her voice-over narration is imbued with emotion leading the spectator to her transformative position at the end of the film when she leaves a past location behind holding her daughter's hand and taking her towards a brighter future. Her reflective work has enabled her to share and make visible her experiences, bringing to the fore their Bourdieuian dissonance between permanence and change, noticeable in the protagonist's emotional embodied subjectivity.

These films thus concentrate on Algerian women's act of reflecting back and staring back, which emphasises their courage as being emotionally connected to others and a situation. This act of courage translates their emotional behaviour, and joins them to the society they live in (or have unwittingly left behind for the character in *El Manara*). Without a doubt, this position can be seen as a development of Bourdieu's habitus as simultaneously structured structure and structuring structure. In other words, the films expose Algerian women's durable dispositions, but at the same time they show them shaping their condition.

CONCLUSION

The relevance of Bourdieu's work to an understanding of contemporary North African film-makers' attempts to record or make visible the individual (female) experience of the Algerian conflict, as it is lived, is crucial. In *Masculine Domination*, Bourdieu specifically focuses on the permanence of the sexual order, which is expressed in the notion of 'symbolic violence' incarnated in bodies situated in time, and social fields. The historical context (or social field) of an Algeria at war or in conflict on which his theoretical work is based is important. He depicted this circumstance in numerous hitherto unnoticed photographs that are central in allowing a reappraisal of Bourdieu's theoretical work. This move also supports Stora's and Bachir-Chouikh's current position towards a fundamental pictorial record of the social situation of Algeria. Photography, like cinema, is a 'structured structure' as well as a 'structuring structure' (see Webb, Schirato and Danaker 2002) – that is to say that it is shaped but also helps to shape culture.

As far as Bourdieu's photographs are concerned, this study has shown that they have helped to introduce and uncover the notion of 'dissonance' within his theoretical perspective. An analysis of the contrast between old

and new allows a reconsideration of the connection between social agent and its social environment by focusing on emotion in the habitus, as introduced in Bourdieu's theory. Indeed, the theoretical reading these photographs lend themselves to lies in their aesthetic position of grasping the actual social situation of Algeria. This actuality is recorded through human (female) subjects, as evidenced by Bourdieu's photos, as well as the films explored here. Similar to Bourdieu, these film-makers also address the relationship between the individual social being and the social world in terms of emotional experience. The female characters as emotional beings in the world are shown as interacting with their milieu, challenging the idea of habitus subtending their relationship to the social world and informing the images the world has of them. It is worth quoting Norman Denzin who writes that 'without emotionality everyday life would be an endless empty exchange of repetitive, lifeless meanings, dull and devoid of inner, moral significance' (1984: x). The films of Bachir-Chouikh, Sahraoui and Hadjaj have shown that without emotionality, the life of these Algerian women would be regulated by 'censures inherent in the social structures' (Bourdieu 2001: 39). Bourdieu's photographs, together with the three films studied in this chapter, have highlighted the transformative aspect of emotion on Algerian women's embodied subjectivities, as the films end on images of women's courage and confidence.

NOTES

1. These expressions highlight the unchanged social and political situation in Algeria moving from a colonial (Bourdieu's time) to a postcolonial context.
2. A few articles devoted to Bourdieu's photographical work appeared in a special issue of *The Sociological Review*, 'Post-colonial Bourdieu' (2009) edited by Les Back, Azzedine Haddour and Nirmal Puwar.

REFERENCES

Adkins, L. and B. Skeggs. 2005. *Feminism After Bourdieu: International Perspectives.* Oxford: Blackwell Publishing.
Amrane-Minne, D. 1999. 'Women and Politics in Algeria from the War of Independence to Our Day', *Research in African Literatures* 30(3): 62–77.
——. 2007. 'Women at War. The Representations of Women in *The Battle of Algiers*', *Interventions* 9(3): 340–49.
Austin, G. 2012. *Algerian National Cinema*. Manchester: Manchester University Press.

Back, L., A. Haddour and N. Puwar. 2009. 'Special Issue: Post-colonial Bourdieu', *The Sociological Review* 57(3): 371–546.

Back, L. 2009. 'Potrayal and Betrayal: Bourdieu, Photography and Sociological Life', *The Sociological Review* 57(3): 471–90.

——. 1958. *The Sociology of Algeria*. Paris: Presses Universitaires de France.

Bourdieu, P., A. Derbel, J.P. Rivet and C. Seibel. 1963. *Work and Workers in Algeria*. Paris: Mouton.

Bourdieu, P. and A. Sayad. 1964. *The Uprooting: The Crisis of Traditional Agriculture in Algeria*. Paris: Minuit.

Bourdieu, P. 1977. *An Outline of a Theory of Practice*. Cambridge: Cambridge University Press.

——. 1979. *Algeria 1960*. Cambridge: Cambridge University Press.

——. 1990. *The Logic of Practice*. Cambridge: Polity.

——. 1993. *The Weight of the World: Social Suffering in Contemporary Society*. Chicago: Stanford University Press.

——. 2001. *Masculine Domination*. Trans. by Richard Nice, Cambridge: Polity.

——. 2013. 'Seeing with the Lens: About Photography. Interview with Franz Schultheis' in T. Yacine (ed), *Algerian Sketches. Pierre Bourdieu*. Cambridge and Malden: Polity: 301–14.

Calhoun, C. 2003. 'Foreword', in F. Schultheis and C. Frisinghelli (eds), *Picturing Algeria*. New York: Columbia University Press, pp. vii–xvi.

Chachoua, K. 2012. 'Pierre Bourdieu et l'Algérie: Le savant et la politique', *Remmm* (Revue des Mondes Musulmans et de la Méditerranée) 131.

Chambers, C. 2005. 'Masculine Domination, Radical Feminism and Change', *Feminist Theory* 6(3): 325–46.

Flinn, M. 2011. 'Giving a Face to the Conflict: Contemporary Representations of Women in Franco-North African Film', *International Journal of Francophone Studies* 14(3): 339–63.

Goodman, J. and P. Silverstein (eds). 2009. *Bourdieu in Algeria*. Nebraska: Nebraska University Press.

Lequeret, E. and C. Tesson. 2003. 'Yamina Bachir-Chouikh. Des gens viennent voir leur histoire, leur vie. Ce n'était pas arrivé depuis longtemps', *Cahiers du Cinéma* 26–31.

Lovell, T. 2000. 'Thinking Feminism With and Against Bourdieu', *Feminist Theory* 1(1): 11–32.

McNay, L. 1999. 'Gender, Habitus and the Field: Pierre Bourdieu and the Limits of Reflexivity', *Theory, Culture and Society* 19(3): 95–117.

Moi, T. 1991. 'Appropriating Bourdieu: Feminist Theory and Pierre Bourdieu's Sociology of Culture', *New Literary History* 22(4): 1017–49.

Mottier, V. 2002. 'Masculine Domination: Gender and Power in Bourdieu's Writings', *Feminist Theory* 3(3): 345–59.

Probyn, E. 2005. 'Shame in the Habitus' in L. Adkins and B. Skeggs (eds), *Feminism After Bourdieu: International Perspectives*. Oxford: Blackwell, pp. 224–48.

Reed-Danahay, D. 2005. *Locating Bourdieu*. Bloomington and Indianapolis: Indiana University Press.

Schultheis, F. and C. Frisinghelli (eds) 2003. *Picturing Algeria*, New York: Columbia University Press.

Schultheis, F. and C. Frisinghelli (eds). 2012. *Picturing Algeria*. New York: Columbia University Press.

Schultheis, F., P. Holder and C. Wagner. 2009. 'In Algeria. Pierre Bourdieu's Photographic Fieldwork', *The Sociological Review* 57(3): 448–70.

Schultheis, F. 2012. 'Pierre Bourdieu and Algeria. An Elective Affinity', in F. Schultheis and C. Frisinghelli (eds), *Picturing Algeria*. New York: Columbia University Press, pp. 1–6.

Silverstein, P. 2004. 'Of Rooting and Uprooting: Kabyle Habitus, Domesticity, and Structural Nostalgia', *Ethnography* 5(4): 553–78.

Stora, B. 2001a. *La Guerre invisible. Algérie, Années 90*. Paris: Presses de Sciences Po.

———. 2001b. 'L'Algérie d'une guerre à l'autre', Actes de la DESCO, Université d'été. http://media.education.gouv.fr/file/Formation_continue_enseignants/45/7/algerie_actestora2_111457.pdf

———. 2002. 'Algérie: les retours de la mémoire de la guerre d'indépendance', *Modern and Contemporary France* 10(4): 461–73.

Sweetman, P. 2009. 'Revealing Habitus, Illuminating Practice: Bourdieu, Photography and Visual Methods', *The Sociological Review* 57(3): 491–511.

Tresilian, D. 2003. 'Bourdieu and Algeria: An Elective Affinity', *Al. Ahram* 629.

Webb, J., T. Schirato and G. Danaker. 2002. *Understanding Bourdieu*. London: Sage.

Wetherell, M. 2012. *Affect and Emotion: A New Social Science Understanding*. London: Sage.

Yacine, T. 2004. 'Pierre Bourdieu in Algeria at War: Notes on the Birth of an Engaged Ethnosociology', *Ethnography* 5(4): 487–509.

Yacine, T. (ed.). 2013. *Algerian Sketches: Pierre Bourdieu*. Cambridge and Malden: Polity.

FILMOGRAPHY

Bachir-Chouikh, Y. 2002. *Rachida* (Ciel Production, Ciné-sud Promotion, Ministère de la République Française, Arte France Cinéma).

Hadjaj, B. 2005. *El Manara* (Production Machaho).

Sahraoui, D. 2006. *Barakat!* (Les Films d'Ici, BL Production, Nomadis Images, Arte France Cinéma, ENTV Algérie).

Sophie Bélot lectures at the Universities of Sheffield and Nottingham. Her research centres on philosophical approaches to representations of women in contemporary cinema as well as on documentary film and the essay film.

She has published a number of articles on these issues within contemporary French and Algerian cinema, and has recently completed a monograph on the director and scriptwriter Catherine Breillat for Rodopi. Currently she is working on a project exploring emotion in French and Francophone cinema.

The Taste Database
Taste Distinctions in Online Film Reviewing

Eileen Culloty

Since the 1980s, audience and reception studies have encouraged a move away from textual analysis to the contexts of film viewing. Working broadly within a uses and gratifications framework, such studies examine cultures of consumption on the basis that 'contextual factors, more than textual ones, account for the experiences that spectators have watching films and television and for the uses to which those experiences are put in navigating our everyday lives'(Staiger 2000: 1). From this audience perspective, the meaning of a film is part of a broader experience that may incorporate specific sites of film viewing like the art cinema or the multiplex (Acland 2006; Klinger 1997, 2006) and the personal identity of viewers as cinephiles or fans (Gray 2003; Jenkins 2012). In particular, reception studies has turned to what Martin Barker (2010: 13) calls 'ancillary material' to discern how promotional and review material shapes 'in advance the conditions under which interpretations of films are formed'. The study of ancillary material then provides 'a sense of what the historical prospects were for viewing at a given time by illuminating the meanings available within that moment' (Klinger 1997: 114).

In his opposition to scholasticism, Bourdieu's writing parallels the imperative of audience and reception studies, which seek to put flesh and circumstance on the figure of the film viewer. The 'structural constructivism' outlined in 'Social Space and Symbolic Power' (Bourdieu 1989) overcomes the theoretical rigidity of the opposition between the subjective and the objective by focusing on the relationship between social structures and

individual thought and action. As the foundational concept linking social structure and individual agency, the disposition or habitus of agents are 'the mental structures through which they apprehend the social world [which] are essentially the product of the internalisation of the structures of that world' (Bourdieu 1989: 18). Writing primarily in reference to French society in the 1960s and 1970s, Bourdieu argues that the dominant class possessing economic and/or cultural capital are able to legitimise their taste preferences as distinct from and superior to the tastes of subordinate classes. In rejecting the Kantian view that taste is a reflection of the individual's innate character, Bourdieu (1990: 142) argues that culture is 'a multidimensional arena in which economic and cultural capital are both the objects and the weapons of a competitive struggle between classes'. This chapter examines how current online practices of film reception both reflect and disrupt Bourdieu's class-based sociology of art.

The phenomenon of online user reviewing on websites like the *Internet Movie Database* (*IMDb*) greatly complicates Bourdieu's hierarchical taxonomy of taste preferences. As an extended practice of film consumption, the *IMDb* accumulates informal transnational reviews across the 'long-tail' (Anderson 2006) of film consumption from initial screenings at film festivals to the afterlife of DVD and television viewing years later. In this way, the *IMDb* undermines the traditional role of the film critic while allowing competing taste cultures to coexist. By framing their contributions in terms of their particular viewing contexts, online reviewers identify themselves as cinephiles, fans, subject experts and casual viewers with varying affinities to the individual film. While each contribution may reflect the positioning of users within distinct taste cultures, the online accumulation of these competing perspectives potentially deepens an understanding of the individual film as the parameters of film reception shift from an arena of social stratification and cultural consecration to 'spaces of points of view' (Bourdieu et al. 1999: 3). Surveying *IMDb* user reviews of *Hunger* (McQueen, 2008), the chapter outlines how user reviewers function as informal cultural intermediaries who present competing and contested claims regarding the film's status as art cinema, as historical representation and as generic entertainment.

THE NEW CULTURAL INTERMEDIARIES

The distinction between the public and the private has been seen as a hallmark of Western liberal thought. In the normative ideal of the Habermasian public sphere, private citizens come together as a public to debate and

engage with issues of common concern. Applying this framework to the 'aesthetic sphere', Jonathan Roberge (2011: 440) characterises criticism as an intermediary between cultural production and reception whereby the role of criticism is 'to link or to bridge creators and artists to individuals and collective audiences'. The critic then speaks as a public figure while individual audience perspectives remain private and personal. It is from her expert public position that the critic confers legitimacy or otherwise on cultural productions and adopts a pedagogical stance towards audiences.

Those working within the culture industry occupy a central role in the generation of hierarchies of artistic value. In defining cultural intermediaries, Bourdieu (1984: 359) referred specifically to the emergence of a growing faction of middle-class workers engaged in 'institutions providing symbolic goods and services' like 'sales marketing, advertising, public relations, fashion, decoration and so forth'. While lacking the economic and political capital to solidify their membership of the dominant class, cultural intermediaries seek to affirm their social position, and the autonomy of their field, through an ongoing process of cultural legitimisation and delegitimisation. Apart from replicating existing cultural hierarchies, cultural intermediaries 'legitimate new fields such as sport, fashion, popular music and popular culture as valid fields of intellectual analysis' (Featherstone 1991: 44).

By occupying a distinct field between producers and audiences, cultural intermediaries mobilise concepts of value and authority to reinforce group identities. On this basis Bourdieu (1989: 19) observes that 'nothing classifies somebody more than the way he or she classifies'. Taste distinctions and classifications imply 'a practical anticipation of what the social meaning and value of the chosen practice or thing will probably be given their distribution in social space' (Bourdieu 1984: 466).

Online communication has greatly disrupted the role of the cultural intermediary by bringing the personal perspectives of audience members into an intermediate space of civic culture 'positioned between "the public" and "the audience"' (Livingstone 2005: 17). Since the mid 1990s, the *IMDb* has prioritised informal user reviews, while the more recent development of social media platforms has given rise to a culture in which people readily archive their opinions through 'technologies of self-documentation' (Schwarz 2010: 1). Within this ambiguous middle ground between the public and the private, these online spaces invite 'private, individual, anonymous contributions to an – at times personal, at times political – public discussion' (Livingstone 2005: 17). Consequently, there is a growing discourse of individual private citizens competing with the discourse of media professionals.

As digital culture fosters collaborative and audience-driven modes of textual production and textual sense-making (Berry 2011), it gives rise to a 'wealth of networks' in which content is 'not treated as proprietary and exclusive but can be made available freely to everyone' (Benkler 2006: 14). However, as Henry Jenkins (2006: 3) observes, 'not all participants are created equal' in this participatory culture. Developing upon Dallas Symthe's (1981) argument that it is the audience who work for the media industry by attracting advertisers, Jenkins employs the notion of 'fan-labour' to account for those who freely produce content to support media franchises. The *Amazon*-owned *Internet Movie Database*, for example, has been highly successful in monetising its vast database of film information, which was largely compiled for free by film fans. At the same time, fan labour is vital to the online promotion of texts. In contrast to the 'stickiness' of texts within traditional industry models, online users 'recommend, discuss, research, pass along, and even generate new material in response' (Jenkins, Ford and Green 2013: 116).

Unsurprisingly, there has been a backlash against an online culture of amateur production (Carr 2010; Keen 2007). In *The Cult of the Amateur: How Today's Internet is Killing Our Culture*, the entrepreneur and Internet critic Andrew Keen (2007) takes issue with the declining authority of experts in contemporary culture. Keen, however, is assuming that user reviewing is simply an amateur imitation of the professional practice and that user reviewers have the same motivations and concerns as professional critics. In fact, there are important differences between professional film criticism and online user reviews. Professional critics typically write to a standardised format coinciding with a film's cinematic release. Embedded within the culture of promotion, they view films at press screenings where they are also supplied with press packs, resulting in a glut of similarly themed content emerging across a range of publications at the same time.

User reviewing, by contrast, is a voluntary exercise conducted by those who are sufficiently motivated to register online and write a review for a non-specified readership. Although biased towards the Anglophone and computer literate, the *IMDb* accumulates informal transnational reviews in an open archive across the long tail of film reception. Within a 1,000-word limitation, *IMDb* reviewers define for themselves what constitutes a legitimate review of a particular film. Perhaps for this reason, reviews tend to be highly personal as users disclose their expectations and reasons for viewing, where they viewed the film and with whom. In many instances, reviewers refer to memories or associations inspired by the film rather than to the film text alone. In this way, value judgements are supported by claims to

personal experience because reviewers write as experts of the private rather than as public authorities.

While Bourdieu is rather silent on the role media consumption plays in the social capital of everyday life, communication theorists are increasingly looking to the political salience of informal communication networks. As Todd Graham (2009: 14) argues, 'it is through ongoing participation in everyday talk' that 'citizens become aware and informed, try to understand others, test old and new ideas, and express, develop, and transform their preferences'. More broadly, critics have noted that online communication has produced a 'seismic shift in epistemology' whereby the classical understanding of formal knowledge has given way to a form of knowledge production that combines 'facts with other dimensions of human experience, such as opinions, values and spiritual beliefs' (Dede 2008: 80). For Lisebet van Zoonen (2012: 56) the salience of informal knowledge networks reflects 'a contemporary cultural process in which people from all walks of life have come to suspect the knowledge coming from official institutions and experts and have replaced it with the truth coming from their own individual experience and opinions'.

Understood in this way, user reviewing is an expanded field of reception in which various kinds of specialist knowledge along with personal and idiosyncratic dispositions are made relevant. In the cross-cultural context of the *IMDb*, notions of cultural capital and taste distinction are opened up to multiple and opposing formulations. Regarding the phenomenon of citizen journalism, Nick Couldry (2009: 139) notes that the 'space of writer-gatherers is fragmented and not a clearly defined field in Bourdieu's sense . . . [of] a competitive space organized around a common set of resources and practices'. It is perhaps more useful then to conceive online reviewing in terms of 'spaces of point of view' that 'work with the multiple perspectives that correspond to the multiplicity of coexisting, and sometimes directly competing, points of view' (Bourdieu et al. 1999: 3–4). The coming together of different points of view is particularly interesting for a film like *Hunger*, because it allows the analyst to trace the multiple ways in which notions of art cinema, historical film and genre are mobilised by a diverse range of viewers. In the process, the categories and classifications that have defined film studies, film promotion and professional criticism are called into question.

THE ART FILM AND CULTURAL RECEPTION

Studies on the social experience of film viewing have attempted to map the ways in which taste and reception practices vary 'from region to region,

between small towns and cities, between racial, ethnic and gendered groups' (Maltby and Stokes 2007: 2). Such research has found that 'specific cinemas have different meanings for different people' (Jancovich et. al. 2003: 174) with the art or independent cinema set against the globalisation of Hollywood films in multiplexes (Miller et al. 2001; Acland 2003). By mobilising notions of intellectualism, high culture and prestige, independent cinemas showcasing art films, documentaries and foreign-language films allow people 'to distinguish themselves from "ordinary" filmgoers' (Wilinsky 2001: 3). Studies of U.K. audiences further point to an overlap between class identity and choice of cinema venue (Evans 2011; Hollinshead 2011).

In 'A Question of Perception: Bourdieu, Art and the Postmodern' Nick Prior (2005: 123) argues that the relationship between class and cultural taste proposed by Bourdieu is now looser because 'beyond the shift to a less rigid taxonomy of social formations, the immense expansion of the visual arts complex has opened up possibilities for the dissemination of art knowledge beyond the cultivated bourgeois'. This is particularly evident regarding alternative avenues for film distribution. The centrality of art cinemas, typically located in major cities, is now offset somewhat by the availability of films on DVD and through online subscription services. In a culture in which artworks can be easily and cheaply accessed by those sufficiently interested to do so, consumption patterns are not as readily mapped onto class figures. That is not to imply that social class does not play a role in the reception of films but that a much wider range of interests and perspectives are at play.

In this regard, it is notable that *Hunger* was released and received in very different domestic and international contexts. As an avant-garde film by visual artist Steve McQueen, *Hunger* was primarily treated as an art film internationally and thereby confined to film festivals and short runs in select cinemas. In Britain, *Hunger* was additionally prompted as a prestige project of the domestic film industry while the film played in multiplexes across Ireland reflecting the historical interest for local audiences. In these varying contexts, different levels of cultural competence are mobilised when assessing *Hunger* as an art film.

Much like the modernist art discussed by Bourdieu, art films like *Hunger* have a reputation for being difficult. In 'Outline of a Sociological Theory of Art Perception', Bourdieu (1968) argues that avant-garde art is fundamentally linked to social stratification, as the competence to understand the work is relative to socially acquired ideas about taste and value. Viewers who have acquired the necessary cultural competence to decode artworks develop a 'pure gaze' and are able to separate and privilege the aesthetic over other elements like story and narrative. Those lacking sufficient grounding in the

schemes of avant-garde art remain reliant on their practical experience and grasp only the 'primary significations' of 'mutilated perception' (Bourdieu 1993: 219). However, in the analysis below, it may be seen that many user reviewers who 'get' *Hunger* do so not because they understand the codes of the art film but because they have an understanding of the film's political subject and themes. Consequently, while Bourdieu understands the bourgeois audience for its ability to master and internalise the pure aesthetic of art, the politically knowledgeable audience has a mastery of the subject that may critique and refine an artistic understanding of form. Social, political and art perspectives, then, inform each other.

HUNGER (MCQUEEN, 2008)

Hunger, the debut feature film by visual artist Steve McQueen, depicts the efforts of Irish Republican Army (IRA) prisoners in Northern Ireland's Maze Prison to secure political prisoner status from the British government.[1] Opening amid the prisoners' 'blanket' and 'dirty' protests, the film culminates in the death of Bobby Sands (Michael Fassbender), who led the 1981 hunger strikes. *Hunger* is structurally and stylistically unconventional as McQueen largely eschews expositional devices in favour of highly atmospheric thematic episodes punctuated with strikingly poetic images and scenes of unflinching violence.

Structurally, the film is divided into three distinct thematic sections. In the opening third, the inherent violence of the situation is established through a series of isolated snap shots with little dialogue. Preparing for work, a prison guard, Raymond Lohan (Stuart Graham), reflectively bathes his bruised hands and checks beneath his car for bombs while a high angle on a new IRA prisoner, Davey Gillen (Brian Milligan), reveals a bloody gash on his head. These residual traces of violence are later substantiated in scenes of extreme brutality; most notably, the beating of inmates by the prison guards, Lohan's murder by the IRA, and the prisoners' ongoing debasement of their own bodies. In one of *Hunger*'s most striking visual compositions, the extremity of the situation and the strength of the prisoners' resolve are both neatly encapsulated in the image of excrement smeared into a spiral on a cell wall.

In the second section, McQueen introduces Bobby Sands through a virtuoso seventeen minute single take conversation between Sands and a priest, Father Moran (Liam Cunningham). In a rapid-fire exchange, the men engage in 'idle banter' before Sands outlines his plan for a renewed hunger strike. Although sympathetic to his cause, Father Moran attempts

to dissuade Sands and accuses him of seeking martyrdom. Sands, however, remains resolute and relates an anecdote about a boyhood trip to the countryside in which he courageously killed a dying foal when others refused to do so. The scene concludes with Sands affirming, 'I'm clear of the reasons and I'm clear of the repercussions. I will act and I will not stand by and do nothing'.

In the following scene, a prison guard sweeps urine through the corridor while the non-diegetic voice of British Prime Minister Margaret Thatcher asserts, 'there are no political crimes only criminal ones'. The final third then charts the slow progression of Sands' physical decay as he repeatedly refuses food; no other hunger striker is shown. On the verge of death, Sands imagines himself a boy jogging through lush autumnal countryside. He stops to look directly at the camera/viewer before continuing on his way. The closing titles reveal that Sands was elected a Member of the British Parliament during the hunger strikes and outline the eventual move towards the power-sharing Northern Ireland Peace Process in the 1990s.

It is in the context of this Peace Process that recent film representations of the conflict constitute an ethos of public memory that can draw attention to 'activations and eruptions of the past as they are experienced in and constituted by the present' (Grainge 2003: 1). In reference to art and historical memorialisation, Eugene McNamee (2009) suggests that films like *Hunger* fit into a wider tapestry of ongoing memory acts. On this very local understanding, a single film does not constitute a definitive account of the past; it is only definitive for the distant audience, who may not fully understand the background. In both the critical and user reviews of *Hunger* discussed below, many contributors exhibit concern for an abstract distant viewer who may not have sufficient knowledge to assess the accuracy of the film representation. There is considerable disagreement, however, about the nature of this representation and the extent to which history is being distorted.

THE CRITICAL RECEPTION OF *HUNGER*

Critically, *Hunger* has been assessed as both a prodigious work of art cinema and as a more controversial mediation on recent political history. Naturally, the primary categorisation privileged by reviewers gives rise to a particular set of evaluative concerns. As the first feature film by a Turner Prize winning artist, which also won the Caméra d'Or at the 2008 Cannes Film Festival, *Hunger* was embraced as the work of an emerging auteur by art film critics. In prestigious film magazines like *Cahiers du Cinéma*, *Hunger* received largely celebratory reviews focusing on the film's formal qualities and McQueen's

merits as an auteur. Many British film magazines additionally emphasised the emergence of a new British film-making talent and the use of public film funds to support indigenous cinema.

British and Irish critics also assessed *Hunger* for its ideological representation of recent political history. For his part, McQueen has repeatedly stressed that it was the visual and physical nature of the hunger strikes as a political statement, rather than the specifics of Northern Irish politics, which drew him to the subject (see Crowdus 2009). Critics, however, have been divided on the extent to which *Hunger* remains politically neutral. As would be expected, the slant of these reviews is heavily influenced by the national and political orientation of the publications in which they appear. Interestingly, articles in *The Belfast Telegraph* have largely declined to offer any political evaluation in favour of commenting on the actors' skilled performances and the film's critical success.

While *The Daily Telegraph* film critic Sukhdev Sandhu (2008) finds that the film avoids 'taking sides', those who find fault with *Hunger* do so precisely on the grounds that it does take sides. Reviewed under the banner 'more pro-terrorist propaganda', Chris Tookey (2008) in the British *Daily Mail* argues that *Hunger* replicates Irish Republicans' anti-British feeling and furthers the values of the British Left by portraying Margaret Thatcher as an uncaring Prime Minister. Alternatively, a number of reviewers contend that *Hunger* is insufficiently political. Writing in *The Guardian* Phelim O'Neil (2009) describes the film as 'deliberately ambiguous' conveying a message that is personal rather than political. In her *Reverse Shot* review, Caroline McKenzie (2008) similarly observes that 'the title itself, *Hunger*, predicates a privileging of the emotional over the political; notably the film wasn't called *Strike*'. For McKenzie, the film leaves the uninformed viewer none the wiser as to the causes and consequences of the hunger strikes and consequently reaffirms Margaret Thatcher's dismissal of the strikes as a public relations stunt.

In *The Irish Times*, Fintan O'Toole (2008) argues that McQueen's interests as a visual artist feed into the political aesthetics of the Irish Republican movement because 'the hunger strikes themselves were a kind of art' aimed at a 'reordering of perceptions'. On this basis, he argues, 'it is utterly naive to think that you can both plug into the hunger strikes as an aesthetic event and give them a neutral political treatment'. Citing the positive reception of the film among Republicans, O'Toole believes *Hunger* naturalises a Republican view of Northern Irish history. Much like McKenzie, O'Toole's concern is for an uninformed impressionable viewer and relates to a long-standing fear of glorifying Irish Republicanism in Southern Ireland.[2]

In academic literature, some critics have additionally drawn parallels between the subject of *Hunger* and contemporaneous debates about

Guantanamo Bay and the War on Terror. Omar Assem El-Khairy (2010: 187), for example, places *Hunger* 'at the heart of the biopolitics of the "war on terror"'. There is, however, a possible distortion in equating the illegal detention of foreign nationals in Guantanamo Bay with the imprisonment of avowed Republicans in Northern Ireland. As such, this strand of film interpretation appears to embody the naturalisation of Republican rhetoric feared by O'Toole and indicates that in transferring local conditions to a global discourse a certain amount of distortion occurs. While the professional critics have made claims about the inherent politics of the film, it is clear that their positions are relative to particular reception contexts and to their social proximity to the subject. These varying concerns are reflected in the user reviews discussed below along with more varied and idiosyncratic assessments.

IMDB USER REVIEWS OF *HUNGER*

Between May 2008 and January 2014 there were over 105 reviews of *Hunger* submitted to the *IMDb*. In terms of geographical spread, the majority of these reviews are from Anglophone countries, with users from the United Kingdom and Ireland accounting for 33 reviews and users from North America and Australia accounting for 32 reviews. Judging by their usernames and comments, many American reviewers appear to be of Irish descent. The remaining reviews emanate from a broad spread of nations including: Bahrain, Belgium, Germany, Japan, Norway, Pakistan, Portugal, Serbia, South Africa, Sweden and Turkey.

The trajectory of user reviews reflects the exhibition path of the film, with the first reviews appearing after special screenings in Northern Ireland for families and community groups, followed by reviews arising from film festival screenings in Sydney and Toronto. There is then a spike of reviews after the film's cinematic release, and since then there have been sporadic updates reflecting isolated DVD and television viewings. To summarise and discuss the nature of these reviews, they have been categorised into four broad groups: film fans and cinephiles; politically invested reviewers; genre fans; and pragmatic advisors.

Film Fans and Cinephiles

Film fans and cinephiles typically account for the earliest reviews in *IMDb* archives and they are often the most prolific reviewers on the website.

Reflecting the notion of a cultural omnivore (see Peterson and Kern 1996), these reviewers are invested in the cultural status of film and are adept at discussing formal qualities along with authorial characteristics and influences. In particular, they attach symbolic capital to film festivals and awards. The fourth entry in the archive begins with the reviewer describing his reasons for seeing *Hunger*: 'I saw Hunger at TIFF [Toronto International Film Festival]. I heard it was a hot ticket, and pre-festival buzz was good so I was elated when I got tickets' (Warmolhaus, Toronto). Similarly, another reviewer describes his interest in *Hunger* in terms of festival 'buzz': 'the buzz at the Palm Springs International Film Festival on *Hunger* was that it was bloody, violent, disgusting, unwatchable . . . My Chicago Film Festival friends had told me, however, that *Hunger* should not be missed. I'm so glad I took their advice' (JoelHberg, United States).

Those who attend film festivals are able to review films that will not be on general release for many months. As they are the first to register an opinion, these reviewers are more likely to be read and are able to establish an exclusive status as film 'insiders'. To this end, they report on festival audience reactions and Q&A sessions with writers and directors. Other cinephile reviewers frequently complain about having to wait to see a film that is not yet playing in their area and some report travelling to cities to see the films they are excited about. In this way, issues of access and availability that are rarely acknowledged by professional critics are highlighted by online film fans.

The submissions of film fans and cinephiles are often modelled on professional reviews. They provide details about the film's production, summarise the plot and draw comparisons with the work of other filmmakers. Focusing primarily on the aesthetic, cinephile reviewers affirm the status of *Hunger* as a prodigious work of art cinema. One reviewer compares the film to the work of Derek Jarman and identifies a homoerotic element 'what with the superb lighting of undernourished male torsos [and] facial close-ups of young men screaming and crying' (Radu A, Germany). Others indicate extensive background reading, with one user recommending an article in *Film Comment* as 'a starting point' for thinking about 'the film's form and the sound design' (A Metaphysical Shark, unknown). For these users, the film is primarily an aesthetic triumph with a universal message: 'regardless of where you stand politically the message is universal and just like the circle of faeces smeared on Sands' cell wall, McQueen has crafted something beautiful out of something horrible' (Come To Where I'm From, UK). It is against these aesthetic values and assumptions that politically invested viewers and genre fans challenge or endorse the film's reception.

Politically Invested Reviewers

The second category of reviewer is politically invested in the film's subject. Many of these reviewers are single contributors who have not returned to review any other film. Motivated primarily by their strong reaction to the film's political representation, these reviews often do not make any reference to the film in formal or artistic terms. Among these invested users, the intensity of engagement with the film's political representation reflects the 'social gravity' of 'emotions such as political anger and hatred, whereby the tension between participation and observation is compounded with the tension between the political and the analytical' (Hage 2010: 150).

The first review in the archive is by a former inmate of the prison who most likely viewed the film at special screenings in Northern Ireland: 'I have to admit my prejudice for the film because of my past as one of the prisoners depicted in the film . . .' (SamBrinks, UK). He goes on to confer legitimacy on the film as an authentic representation of prison life. While claims to authenticity conferred by war experts and witnesses are especially valued in the promotion of war films (Basinger 2004), the 'frames of war' (Butler 2009) perpetuated by film-makers, marketers and subsequently critics typically privilege one set of agents over another. Online reviewing disrupts this process by highlighting contrary perspectives.

Another first time reviewer takes issue not just with *Hunger* but with the broader tendency of film-makers, critics and user reviewers to overidentify with Northern Irish Nationalists at the expense of Unionists: 'why is it that every film about the troubles in Northern Ireland has a distinct [republican/nationalist] slant passed off as fact? . . . I find it amazing that no one was interested in aftermath of the brutal murder of the prison officer' (Stepjo, UK). In this regard, many user reviewers describe the film as being balanced or politically neutral but they do so in terms that blatantly, if unconsciously, identify with an Irish Republican perspective. For example, reviewers mistake Northern Irish prison guards for British soldiers, assume that Northern Ireland is unquestionably Irish and simplistically link the events in the film to the centuries-old struggle for Irish independence from Britain.

It is precisely because historical films function as a form of informal pedagogy that criticisms of historical inaccuracies and biases are so strident. As Malachi O'Doherty (2010) observes regarding *Fifty Dead Men Walking* (Skogland, 2008), when film-makers try 'to keep things simple for a foreign audience' they risk reproducing propagandistic narratives that 'will be taken seriously by many as an authentic account'. Against this tendency for overly simplified and distorted history, user reviewers with

local understanding challenge assumptions and biases while drawing atten-
tion to the cultural significance of micro representations within the film. A
number of reviewers question the use of Christ-like iconography, with one
reviewer observing 'when a film is introduced to you as important your first
instinct should be to ask, "to whom?" . . . McQueen's assertion is that this
is reportage, vérité, not myth making, but he should know better' (David
Frames, unknown). More stridently, a reviewer from Ireland describes
Hunger as 'a dangerous film with the potential to recruit even more gullible
teenagers into this phoney war'. Invoking the experience of those who lived
through the conflict, the reviewer asserts 'shame on you Mr McQueen and
I hope the horror visited upon the people of [Northern] Ireland by people
like Sands never comes to your door and secondly should it happen I hope
no one makes a movie that rubs your nose in it like this one does' (Josie44,
Ireland).

In addressing the gap between the local or knowledgeable audience
and the distant audience, there is a clear pedagogical impetus as reviewers
seek to extend the reach of the film by suggesting additional or alternative
sources of information. As one reviewer notes, 'there was to my knowledge
much more about Sands' character, morals [and] beliefs that were interest-
ing . . . and would make a better film' (Wayne King Brown, UK). Reviewers
who are knowledgeable about the subject often express disappointment
with the film's dearth of political context: 'it is a story that needs to be told,
but there needs to be more to it. They need to tell what happened before
and after this [hunger strike], and during, in other places, besides that lame
prison' (Rushhire, United States).

Genre Fans

There are now so many films about the Northern Irish 'Troubles' that the
conflict almost constitutes a distinct genre (see Hill 2006). On this basis,
some users contextualise their interest in *Hunger* in terms of their personal
interest in the conflict more generally. They cite childhood memories of
hearing about the conflict and recall trips to Northern Ireland or encounters
with people from the region. One reviewer, for example, describes his 'grim
fascination' with Northern Ireland since he overheard 'a conversation in a
1970 railway carriage between two Englishmen discussing the start of "The
Troubles" in the late sixties, only to be interrupted by a waking Irish voice
in the corner explaining that "The Troubles" started long before' (Ron
Plasma UK). Similarly, a Canadian reviewer frames her interest in terms
of being 'married to a man from Belfast for long enough to hear about the

terrors he and his friends and family endured on a daily basis' (Roxanne Tellier, Toronto). Those drawn to films about conflict in Northern Ireland often take issue with *Hunger*'s reliance on stylised art codes in place of traditional narrative: 'the filmmaker chose a "heavy" subject that would be well received at independent film festivals . . . [but] if you want to see a good film about Northern Ireland watch *In the Name of the Father*' (Ronan MacRory, United States).

A second strand of genre fan is drawn to films about prison life. Many of those seeking out a prison film find *Hunger* 'boring' and 'pretentious' and dismiss art cinema in general: 'movies with almost no dialogue irritate me. They almost never work, and the only thing they do is pander to the avant-garde film elite, and inflate the filmmakers ego by allowing them to proclaim themselves "artists"' (MovieSleuth2, Unknown). Alternatively, other genre fans suggest that the lack of conventional narrative is more authentic: 'as most prison movies/TV series (being fact or fiction based) usually give us this false impression of what prison life is like, almost making you say, '[it] might be cool to be in prison' . . . this talented artist turned director chose the perfect story to set everyone straight' (Ashdarr, South Africa). Another reviewer defends the film based on his own experience of imprisonment: 'writing this as someone who has experienced some time in prison . . . I would say that the pace of this movie was at time slow but necessarily so as it gave you a little taste . . . of the atmosphere men in solitary confinement feel' (LuccaBrasi, United Kingdom).

Pragmatic Advisors

The last category of user reviewer offers practical advice and comments about film viewing. For example, many suggest that it is useful to read a little about the subject before watching *Hunger* because there is very little narrative exposition. Others suggest that given the speed of the dialogue and possible unfamiliarity with the accents, it is better to watch it on DVD with subtitles. On an even more practical level, many point out that it is a difficult and unpleasant film to watch: 'I was meant to go see this with my girlfriend but she pulled out at the last minute . . . I was mightily relived that she had in fact missed this because there are scenes and imagery in this movie that she would not have coped with at all' (Rahul Prasad, Australia). In these rather simple ways, online reviewing is a counterpoint to the prevailing values of professional criticism, which tends to ignore these ordinary concerns.

CONCLUSION

This chapter has explored how user reviewing promotes reflexivity about cultures of film consumption and in the process undermines efforts at cultural consecration by professional film critics. Given the extent of his writing on the sociology of taste formation, Bourdieu is a particularly interesting theorist for audience and reception studies. The value of analysing online reception from a Bourdieuian perspective is twofold: firstly, individual reviews serve as testimonies of reception, allowing the analyst to trace the range of taste cultures in which a film has been received. Secondly, in bringing together contrasting cultures of reception, the database supports an internal dialogue about film taste and value. In this way, the *IMDb* reveals individual efforts at social positioning within taste cultures while the collective body of reviews undermines the claims and assumptions of those taste cultures.

With a complex work like a feature film, the range of cultural allusions operating within the text exceeds the capacity of individual reviewers. By accumulating transnational reviews from users with varying aesthetic, political and social interests in a given film, websites like the *IMDb* give readers access to a broad range of perspectives that potentially increases their cultural understanding. The online reception of *Hunger*, for example, disrupts categorical distinctions between art, politics and entertainment by allowing competing values of film viewing, as well as varying levels of political and artistic knowledge, to critique and inform each other.

As users take on the role of informal cultural intermediaries, the cultural authority of professional critics is challenged. Much like the citizen journalism discussed by Couldry (2009), it is not yet clear whether user reviewing will evolve into a clearly defined field of activity. Currently, the transnational reception space does not constitute a defined field of action in so far as users do not have a common set of standards or interests that guide their contributions. There are, however, evident distinctions among online film reviewers. Cinephiles and film fans, for example, dominate *IMDb* reviewing through their prolific output and their ability to establish themselves as 'insiders' who view films prior to their general release. Many of these *IMDb* reviews provide links to their film blogs and indicate an interest in moving into professional film criticism. In opposition to these practices, politically invested reviewers are motivated by their strong reaction to an individual film. Often single contributors who do not return to offer opinion on any other film, these reviewers seek to inform or correct perceived bias and misunderstanding within the film and among reviewers. The capacity of the *IMDb* to promote reflection on film value is then staked on the coexistence

of these competing categories of film reviewer. While the past thirty years of audience and reception studies has provided valuable insight into the contexts of film viewing, current online practices of reception raise further questions about how people positioned within taste cultures assess and respond to perspectives from opposing taste cultures. Addressing this issue necessitates an examination of how Bourdieu's 'spaces of points of view' can transform or revise the habitus of individual contributors.

NOTES

1. As one of the most decisive events of the Troubles, the 1981 Republican Hunger Strike led by Bobby Sands has been the subject of a number of films including *Some Mother's Son* (George, 1996), *H3* (Blair, 2001), the independent Italian film *Il Silenzio dell'Allodola/The Silence of the Skylark* (Ballerini, 2004), and *Hunger* (McQueen, 2008).
2. For a discussion of cinema and Irish nationalism see John Hill (1987).

REFERENCES

Acland, C. 2003. *Screen Traffic: Movies, Multiplexes and Global Culture*. Durham: Duke University Press.

Anderson, C. 2006. *The Long Tail: Why the Future of Business is Selling Less of More*. New York: Hyperion.

Barker, M. 2010. 'News, Reviews, Clues, Interviews and Other Ancillary Materials: A Critique and Research Proposal', *Scope* (16). Retrieved 14 March 2014 from http://www.scope.nottingham.ac.uk/reader/chapter.php?id=2

Basinger, J. 2004. 'The World War II Combat Film', in R. Eberwein (ed.), *The War Film*. Philadelphia: Rutgers, pp. 30–52.

Benkler, Y. 2006. *The Wealth of Networks. How Social Production Transforms Markets and Freedom*. New Haven: Yale University Press.

Berry, D. 2011. 'The Computational Turn: Thinking about the Digital Humanities', *Culture Machine*, 12. Retrieved 15 March 2015 from http://www.culturemachine. net/index.php/cm/issue/view/23

Bourdieu, P. 1968. 'Outline of a Sociological Theory of Art Perception', *International Social Science Journal* 20(4): 589–612.

———. 1984. *Distinction. A Social Critique of the Judgment of Taste*, trans. R. Nice. Cambridge: Harvard University Press.

———. 1989. 'Social Space and Symbolic Power', trans. L. Wacquant. *Sociological Theory* 7(1): 14–25.

———. 1990. *In Other Words: Essays towards a Reflexive Sociology*, trans. M. Adamson. Cambridge: Polity.

——. 1993. *The Field of Cultural Production: Essays on Art and Literature*, edited and translated by R. Johnson. Cambridge: Polity.

Bourdieu, P. et al. 1999. *The Weight of the World: Social Suffering in Contemporary Society*, trans. P. Parkhurst Ferguson. Stanford: Stanford University Press.

Butler, J. 2009. *Frames of War: When is Life Grievable?* London: Verso.

Carr, N. 2010. *The Shallows: How the Internet is Changing the Way We Think, Read and Remember*. London: Atlantic Books.

Couldry N. 2009. 'New Online News Sources and Writer-Gatherers', in N. Fenton (ed.), *New Media, Old News: Journalism and Democracy in the Digital Age*. London: Sage, pp. 138–69.

Crowdus, G. 2009. 'The Human Body as a Political Weapon: An Interview with Steve McQueen', *Cineaste* 34(2): 22–25.

Dede, C. 2008. 'A Seismic Shift in Epistemology', *EDUCAUSE Review* 43(3): 80–81.

El-Khairy, O. 2010. 'Snowflakes on a Scarred Knuckle: The Biopolitics of the "War on Terror" through Steve McQueen's Hunger and Kathryn Bigelow's The Hurt Locker', *Millennium-Journal of International Studies* 39(1): 187–91.

Evans, E. 2011. 'Superman vs Shrödinger's Cat: Taste, Etiquette and Independent Cinema Audiences as Indirect Communities', *Participations* 8(2): 327–49.

Featherstone, M. 1991. *Consumer Culture and Postmodernism*. London: Sage.

Graham, T. 2009. 'What's Wife Swap Got to Do With It? Talking Politics in the Net-Based Public Sphere', academic dissertation. Amsterdam: University of Amsterdam. Retrieved 14 March 2014 from http://dare.uva.nl/record/314852

Grainge, P. 2003. 'Introduction: Memory and Popular Film' in P. Grainge (ed.), *Memory and Popular Film*. Manchester: Manchester University Press, pp. 1–20.

Gray, J. 2003. 'New Audiences, New Textualities: Anti-Fans and Non-Fans', *International Journal of Cultural Studies* 6(1): 64–81.

Hage, G. 2010. 'Hating Israel in the Field: On Ethnography and Political Emotions' in J. Davies and D. Spencer (eds), *Emotions in the Field: The Psychology and Anthropology of Fieldwork Experience*. Stanford: Stanford University Press, pp. 129–54.

Hill, J. 1987. 'Images of Violence', in K. Rockett, L. Gibbons and J. Hill (eds), *Cinema and Ireland*. London: Routledge, pp. 147–93.

——. 2006. *Cinema and Northern Ireland: Film, Culture and Politics*. London: British Film Institute.

Hollinshead, A. 2011. '"And I felt Quite Posh!" Art-house Cinema and the Absent Audience – the Exclusions of Choice', *Participations* 8(2): 392–415.

Jancovich, M. et al. 2003. *The Place of the Audience: Cultural Geographies of Film Consumption*. London: BFI Publishing.

Jenkins, H. 2006. *Convergence Culture: Where Old and New Media Collide*. New York: New York University Press.

——. 2012. *Textual Poachers: Television Fans and Participatory Culture*. New York: Routledge.

Jenkins, H., S. Ford and J. Green. 2013. *Spreadable Media: Creating Value and Meaning in a Networked Culture*. New York: New York University Press.

Keen, A. 2007. *The Cult of the Amateur: How Today's Internet is Killing Culture*. London: Nicholas Brealey.

Klinger. B. 1997. 'Film History Terminable and Interminable: Recovering the Past in Reception Studies', *Screen* 38(2): 107–28.

——. 2006. *Beyond the Multiplex*. London: University of California Press.

Livingstone, S. 2005. 'On the Relation between Audiences and Publics', in S. Livingstone (ed.), *Audiences and Publics: When Cultural Engagement Matters for the Public Sphere*. Bristol: Intellect Books, pp. 17–41.

Maltby, R. and M. Stokes. 2007. 'Introduction' in R. Maltby et al. (eds), *Going to the Movies: Hollywood and the Social Experience of Cinema*. Exeter: Exeter University Press, pp. 1–22.

McKenzie, C. 2008. 'Names and Faces', *Reverse Shot* 34. Retrieved on 14 March 2014 from http://www.reverseshot.com/article/hunger

McNamee, E. 2009. 'Eye Witness – Memorialising Humanity in Steve McQueen's Hunger', *International Journal of Law in Context* 5(3): 281–94.

Miller, T. et al. 2001. *Global Hollywood*. London: BFI.

O'Doherty, M. 2010. 'Film Review: *50 Dead Men Walking*', *Culture Northern Ireland*, 13 October 2010. Retrieved 14 March 2014 from http://www.culturenorthernireland.org/article/2571/film-review-50-dead-men-walking

O'Neil, P. 2009. 'DVD Review; *Hunger*', *The Guardian*, 21 February 2009. Retrieved 14 March 2014 from http://www.theguardian.com/film/2009/feb/21/hunger-dvd-review

O'Toole, F. 2008. '*Hunger* Fails to Wrest the Narrative from the Hunger Strikers', *Irish Times*, 22 November 2008. Retrieved 14 March 2014 from www.irishtimes.com/newspaper/weekend/2008/1122/1227288132671.html

Peterson, R. and R. Kern. 1996. 'Changing Highbrow Taste: from Snob to Omnivore', *American Sociological Review* 61(5): 900–7.

Prior, N. 2005. 'A Question of Perception: Bourdieu, Art and the Postmodern', *The British Journal of Sociology* 56(1): 123–39.

Roberge, J. 2011. 'The Aesthetic Public Sphere and the Transformation of Criticism', *Social Semiotics* 21(3): 435–53.

Sandhu, S. 2008. 'Hunger by Steve McQueen', *The Daily Telegraph*, 31 October 2008. Retrieved 14 March 2014 from http://www.telegraph.co.uk/culture/film/film reviews/3562731/Hunger-by-Steve-McQueen-review.html

Schwarz, O. 2010. *Representations of Self in Everyday Life: New Technologies of Self-documentation and Their Uses*. Jerusalem: Hebrew University of Jerusalem.

Staiger, J. 2000. *Perverse Spectators: The Practices of Film Reception*. New York: New York University Press.

Symthe, D. 1981. *Dependency Road*. Norwood, NJ: Ablex.

Tookey, C. 2008. 'Hunger: More Terrorist Propaganda', *Daily Mail*, 30 October. Retrieved 14 March 2014 from www.dailymail.co.uk/tvshowbiz/reviews/article-1081911/Hunger-More-pro-terrorist-propaganda.html

Wilinsky, B. 2001. *Sure Seaters: The Emergence of Art House Cinema*. Minneapolis: University of Minnesota Press.

Zoonen van, L. 2012. 'I-Pistemology: Changing Truth Claims in Popular and Political Culture', *European Journal of Communication* 27(1): 56-67.

FILMOGRAPHY

H3 2001, directed by L. Blair, motion picture, Metropolitan Films, Ireland.
Hunger 2008, directed by S. McQueen, motion picture, Film4, United Kingdom.
Fifty Dead Men Walking 2008, directed by K. Skogland, motion picture, Handmade International, United Kingdom and Canada.
Il Silenzio dell'Allodola/The Silence of the Skylark 2004, directed by D. Ballerini, motion picture, Esperia Films, Italy.
Some Mother's Son 1996, directed by T. George, motion picture, Castle Rock Entertainment, Ireland and United States.

Eileen Culloty recently completed a Ph.D. at Dublin City University on user-generated archives of Iraq War documentaries. Her research focuses on the impact of digital convergence on the production, distribution and reception of audiovisual narratives. She has published in *Critical Studies on Terrorism* and *Studies in Documentary Film*.

Millennials Protest

Hipsters, Privilege and Homological Obstruction

Anthony P. McIntyre

In late 2011, Occupy Wall Street emerged, as if from nowhere, to call attention to the growing inequality that increasingly characterised U.S. life in the twenty-first century. Just as quickly as it materialised, the movement seemed to disappear from sight again. While there has been much scholarship debating the legacy of Occupy and the causes of its ephemeral existence,[1] in this chapter I use Pierre Bourdieu's concepts as a means to evaluate the impact of an increasingly multi-mediated environment on public attitudes towards the protestors. In particular, I trace how tropes of privilege, entitlement and bohemianism circulating around this time served to block any potential homologies, which would have seen the discontent marshalled by a predominantly middle-class protest cohort ignite a similar response in other class formations.

Bourdieu's theoretical framework enables us to examine how the habitus reproduces and reinforces the political and social system in a time of social turbulence. Through an analysis of the connections between the Occupy Wall Street protest in Zucotti Park, New York, the initial news representation of the protestors and roughly contemporaneous texts such as adverts and television series, I will show how these cultural representations are complicit in reshaping the schemes of perception incorporated into forms of habitus and by extension how they serve to shore up the status quo.

My contention is that under contemporary neo-liberal capitalism a number of factors contribute to an atomising tendency within various forms

of habitus that block the potential for homology. In Bourdieu's theoretical framework homologies between positions in different fields – that is, the potential for those in the dominated section of the dominant class (tradition-ally the bourgeoisie), for instance, to make common cause with those of a lower socio-economic status – are essential for any radical disruption of the status quo (1991: 244–45). The theorist describes the habitus as 'the durably installed generative principle of regulated improvisations [which] *tend to* [my emphasis] reproduce the regularities immanent in the objective principles of their generative principle, while adjusting to the demands inscribed as objective potentialities in the situation' (1977: 78). Thus the process of social reproduction inconspicuously goes on, 'short of a radical transformation' (ibid.). I shall look at how incongruence between the position agents hold in different fields is emphasised in such diverse cultural texts as advertise-ments, newspaper articles, celebrity star texts and viral videos, in a way that stabilises the position of the existing objective structure (of which habitus is the product) by preventing homologies from forming that would cause a radical disruption to the prevailing habitus.

Bourdieu's theoretical works have often been criticised for a perceived pessimism regarding the possibility of social change. In *Pascalian Meditations* (2000) he argues how through field, habitus and symbolic violence the dura-bility and stability of the social order is perpetuated. In the final chapter he does allow for a 'margin of freedom' in which a gap between the habitus and the field allows for contestation during a time when the existing social structures are in a 'state of uncertainty and crisis' and 'arbitrariness and fragility' is revealed (2000: 236). The economic turbulence of the early twenty-first century constitutes such a crisis moment when the arbitrary and precarious nature of the market system in which we held trust became apparent. Therefore, an examination of the functioning of field, habitus and symbolic representation from the first three months of the 2011 Occupy NY protest provides an ideal opportunity for an examination of how cultural texts impact upon the possibility of social change. Specifically, my interven-tion will look at how a series of discourses pertaining to a bohemian subset of society, popularly crystallised in the figure of the 'hipster', serve to close down the margin of freedom in this case.

HIPSTERS AND HIPSTERISM

The term 'hipster' came into vogue in the 2000s (although it is a reappro-priation of a term used to describe a countercultural group that stems back to the 1940s) and somewhat derogatively denotes a taste culture emanating

from the 'Indie' scene, members of which display an overinvestment in authenticity, which paradoxically results in a confused conformity. Michael Z. Newman notes that 'like earlier waves of alternative scenes, the Indie hipsters constitute a habitus rich in cultural capital and hipsterism is its means of reproducing this capital' (2013: 75). As suggested by Newman's use of terminology, Bourdieu's *Distinction* has been used by a number of scholars (including, for instance, Greif, Ross and Tortorici 2010) to examine this cultural phenomenon. Recent studies have shown that this social type is particularly unpopular with the wider public and it is common to see the denigration of the hipster in popular media. Examples of this form of coverage include an article that reports on a (somewhat dubious) poll (Americans not Hip to Hipsters 2013) and an older article from *The Guardian*, 'Why do People Hate Hipsters?' (Rayner 2010), and the prevalence of such attitudes provided the impetus for Grief, Ross and Tortorici's collection *What Was the Hipster? A Sociological Investigation* (2010).

The reasons for such animosity must be interrogated to understand the blocking of potential homology that I identify in this case. The hipsters that are on the receiving end of such opprobrium are part of what has been termed the Millennial generation. The term 'Millennials' is used to describe the generational cohort that followed 'Generation X'. Although there is some debate over the precise dating of the cohort, most commentators agree that Millennials are those born between the early 1980s and the early 2000s. The term was popularised by Neil Howe and William Strauss (2000) in their book *Millennials Rising: The Next Great Generation*. Newman notes that this generation were born into 'a hypersaturated consumer capitalism and also a world of fluid identities and hyperconsciousness of cultural difference, meritocracy and egalitarianism, especially within the privileged communities of white elite cosmopolitan culture wherein educational institutions promote such ideals as received wisdom' (2013: 75). In the following analyses, I show that the hipster seems to be a cultural type that crystallises the inherent contradictions of the contemporary age, when notions of egalitarianism and privilege sit so uneasily alongside one another. My further contention is that when media attention codes the protestor as hipster, a politically neutralising move is effected. The inclusion of such disparate texts as television advertisements, newspaper reports, and television series in this study reflects the multi-mediated environment of today's 'convergence culture', characterised by a 'flow of content across media platforms, cooperation between media industries, and migratory behaviour of media audiences' (Jenkins 2006: 2). We can trace the reproduction of culturally resonant tropes through different types of texts and with each successive iteration their impact upon habitus is amplified.

RECESSION-ERA POPULISM

One result of the economic crises that have characterised the early decades of the twenty-first century has been the emergence of recession-era populism, perhaps the most prominent aspect of which, in Western countries, has been the Occupy movement, although the (arguably more politically effective) Tea Party movement in the United States is also part of this phenomenon. The Occupy protestors' main success has been to bring widespread attention to the growing financial gap between the rich and the poor, as can be evidenced by the fact that terms like 'the 99%'[2] have entered public discourse (Chomsky 2012: 70; Milkman, Luce and Lewis: 2013).[3] However, initial enthusiasm for the movement has waned and the group is now seeking to build upon its initial successes by broadening its support base to include larger sections of the wider public whose needs correspond with their own. Groups such as Occupy Data, Occupy Research and Occupy Sandy have shown the various permutations of the movement that are still thriving long after the evictions from public space.[4] An appraisal of the movement that interviewed protestors involved in the Zucotti Park protest optimistically notes that '[W]hether Occupy continues to have a presence "as Occupy" or not, the networks that were formed by its efforts will remain' (Milkman, Luce and Lewis 2013: 40).

Occupy's aim to establish connections to different groups with similar objectives corresponds with Bourdieu's conception of the homology that he finds necessary to change the dominant system within a society. He describes homologies as groupings from different sections of the field of class relations, which 'give rise to ideological effects which are produced automatically whenever oppositions at different levels are superimposed or merged' (1993: 44). However, the atomising function I have identified in the habitus of this period often acts as a blocking device between homological correspondences. The difficulties of developing such homologies were, in part, due to the contradictory fields in which the agents in the protests were situated. That is, the question of how you could be a member of an economically privileged taste culture yet still campaign for equitable distribution of wealth. Bourdieu's concepts of field and habitus enable an exploration of this terrain. However, whilst simultaneous investment in diverse fields is a common feature of any differentiated society it does draw attention from the news media and culture industries (Lane 2006: 66). Indeed, the veracity of a news story often comes second to the supposed trumping of hypocrisy, which popular news media use to justify their public interest mandate.

In such a manner, with the most prominent protest, Occupy Wall Street (OWS), based in Zucotti Park in the financial district of New York, media

attention often stressed the essentially privileged nature of the participants and an ascribed hypocritical sense of entitlement underwriting their protest (e.g., Flynn 2011). Many news items in the tabloid press used this as the main focus of their coverage of the events. A typical headline of this reportage can be seen in this example from the United Kingdom's *Daily Mail*: 'A Very Privileged Protest: Wearing $300 Jeans and from Some of the Most Exclusive Schools, the Children of the One Per Cent out for a Good Time at Occupy Wall Street' (Bentley and McLucas 2011).[5]

Such negative reportage was not limited to U.K. tabloids. For instance, *The New York Post* ran a story detailing how 'A high-strung hipster, "stressed" by the indignity of having to wait for the arraignment of his Occupy Wall Street buddies, flipped out in court today and wound up in handcuffs himself' (Gorta 2012). A somewhat more measured account in *The Washington Post* still focused on the hipster as exemplary protestor of the movement in a comment piece entitled 'The Irony of Occupy Wall Street', which again dwelled on the images of protestors with iPhones. This type of coverage, of course, helped to eclipse the common ground asserted by a diverse group of activists. Although this media attention often emanated from the more right-wing press, it was further elaborated in viral parody videos from websites such as collegehumor.com, and even the left-of-centre satirical U.S. politics programme *The Daily Show*. The bohemian and hipster nature of *some* of the protestors was a salient feature of the reportage. The writers often suggest wealthy family backgrounds, alluding to 'daddy's money' and 'trust funds'. In addition, references to employment were often couched in disparaging terms, with one writer mentioning the 'gathering of angry actors, graphic designers and various other hipsters' (O'Neill 2011). The somewhat hysterical tone evident here suggests a fierce territorial stance attacking arts-based professions for taking up a position in a bastion of financialism.

Such negative representations of the protestors in terms of an ascribed position of privilege, however, fail to take into account links between inequality and political activity. Economist James K. Galbraith has shown that as economic inequality increases, voter turnout among the poor and working class decreases considerably (Galbraith quoted in McChesney 2013: 60). This suggests that the exigencies of everyday life among the working poor discourage engagement in such political activities and results in a vicious circle whereby a lack of resistance contributes to further inequality leading to increased apathy ad infinitum.[6] Such findings would suggest there is some truth in Bourdieu's pessimism regarding the discursive possibilities available to the working class to coherently articulate an oppositional position, a view that has drawn criticism – in particular from Lane (2006).

Sociologist Jennifer M. Silva's (2013) work seems to corroborate such a view. She argues that:

> [I]n an era defined by neoliberal ideology and policy, collective solutions run counter to common sense. Young working-class men and women understand personal choice and self-control as the very basis for who they are, and blame themselves, rather than large-scale economic precariousness and risk privatization, for lacking the tools they need to privatize their futures. (2013: 155)

Some excellent work has been done on the role that television, and particularly reality television, plays in the development of subjectivities that '[demand] a heightened form of personal responsibility and self-discipline from individuals' (Oullette 2009: 240). The pedagogical function scholars such as Laurie Oullette discern in contemporary televisual texts – that is, the inculcation of a doctrine of personal responsibility – underlines the role the media plays in the construction of forms of habitus that are increasingly impervious to the homological influence Bourdieu saw as a possible means of transforming existing societal conditions.

Figures from the social class who were politically active in Zucotti Park could be seen as examples of the 'autonomous' cultural producers that Bourdieu sees as being in a position to impact upon the political structure. He claims that 'cultural producers are able to use the power conferred on them, especially in periods of crisis, by their capacity to put forward a critical definition of the social world, to mobilize the potential strength of the dominated classes and subvert the order prevailing in the field of power' (1993: 44). Bourdieu's view was developed through analysis of the fields of literary and artistic production in France in the nineteenth century and, as such, has been criticised as overly simplistic in its treatment of modern culture industries (Hesmondhalgh 2006: 220) and, as mentioned, at its core, extremely elitist (Lane 2006: 122) due to its suggestion that the dominated in society can in no way vocalise a coherent opposition. Nevertheless, rather than inspiring a homological process of identification through different fields of class relations as Bourdieu predicts, the depictions of the protestors fed a growing discourse of 'entitlement' in the media, which allied them with the very groups they were in opposition to. Any vocalisation of the common plight of workers and other lower socio-economic groupings seen to be coming from this source, as depicted in news media, would therefore be unlikely to forge a common bond.

A key source of the perceived hypocrisy of the movement was the imaging of protestors using the latest Apple iPhone, which was disseminated through news media at the beginning of the protest. Excessive usage of

commodities and gadgets is a common trope when depicting Millennials in various media. In a spring 2013 article in the *New Yorker*, George Packer argued that the intense focus on technological innovation that saturates contemporary media functions as a smokescreen for growing economic inequality. Although the writer admits it is an unprovable thesis, he asserts that our excessive fixation on the technological advances in our gadgets (thinner phones, ever more highly pixelated screens, faster download speeds) creates a discourse of progress that belies most indicators of a flourishing society, such as wealth distribution, well-being, job satisfaction, educational levels, etc. (Packer 2013). The images of protestors with their gadgets and iPhones spawned comedy sketches and jokes in the popular media, due no doubt to the contradictions they crystallised. By simultaneously inhabiting seemingly conflicting fields of economic protest, a taste culture of distinction, and consumerism – contradictory aspects of what has been termed a 'bohemian habitus'– were revealed (Binkley 2009). The construction of this bohemian habitus can be traced through the development of Indie (or alternative) culture. This movement owes a lot of its central tropes to the Indie music scene, which developed after punk in the mid eighties and was often characterised by a troubled relationship with commercialism. As Hesmondhalgh (1999) states, 'Indie's celebration of obscurity and failure was intended as a gesture of contempt for those who revelled in a notion of success founded on competitive individualism' (1999: 55). However, the independent record labels founded according to this credo soon faced financial pressures just to stay afloat, leading to corporate buyouts. This tension between commercialism and authenticity is still evident today in the current bohemian habitus, such as it is.

The account of hip consumerism provided by Thomas Frank in *The Conquest of Cool* (1997) details how since the 1960s the power of advertising inscribes rebellion *within* the process of consumption. Building on this scholarship, as well Bourdieu's work on taste cultures, Newman has analysed the complex relations between 'Indie culture' and consumer culture. He traces how companies like Volkswagen and Apple 'perpetuated the processes of configuring alternative culture as a taste culture and of bestowing distinction on its participants' (2009:16). Apple has followed this policy for several years in its advertisements by emphasising the 'creative' nature of its products and by extension its customers, and this has culminated in it holding the contradictory position of selling a phone that is simultaneously a mark of cultural distinction and one of the most common phones on the market. Indeed, the stereotypical Apple customer corresponds to the somewhat dated concept of the 'creative class', urban professionals, who tend to work in (or aspire to work) within the culture industries and, according to Richard

Florida's description in his book on the phenomenon, 'believe they cannot be defined by their job . . . devote their lives to things other than money, but end up with a stable income' (2002: 99). This concept has been reformulated in a recent book *The Flat White Economy* (2015) by U.K. economist Douglas McWilliams, named after the coffee of choice for the workers who fuel the Internet-driven small companies the term describes. Such books tend to uncritically champion the combination of entrepreneurialism, technology and bohemian sensibilities that define this economic sector, ignoring, for instance, such businesses' increased exposure to risk, and arguably over-estimate their contribution to the overall economy. Nevertheless, this for-mulation in its various iterations serves to claim the hipster as exemplary neo-liberal subject.

One discourse that highlighted the contradictions of hipster youth surrounded the phenomenon of technological fetishism, which manifested itself in the overnight queues for the latest incarnation of the iPhone in the 2000s and early 2010s. The occupation of public space in New York and various other major global cities by the Occupy movement uncon-sciously mimicked one of the more highly visible and indeed celebrated (in terms of media coverage) aspects of modern consumer capitalism: the ritual queuing of consumers in city streets overnight, waiting to be among the first in possession of the latest electronic device.[7] In particular, this craze is identified with Apple. Although the electronics giant is not the only company associated with such phenomena, due to its carefully cho-reographed release strategies, establishment of prominent 'flagship' stores in major cities, and the global popularity of its iPhone device, Apple has particularly benefited from this very public display of consumer demand. Notably, the aggressive commercialisation of urban space that has been one of the key features of the neo-liberal mode of capitalism (a trend that has exacerbated in recent years) has enabled such spectacular forms of consumer collectivism.[8]

The obvious parallels between those occupying public space in an overt display of consumer technological fetishism and those occupying space as a protest against neo-liberal policies that stress the primacy of the market, amplified the impact of the news reportage. Newspaper pictures, for instance, taken at the Zucotti Park protest prominently feature electronic devices – in particular iPhones – as evidence of the protestors' perceived hypocrisy. Indeed, one meme that circulated widely, and that was the sub-ject of news media commentary at the time, satirically identifies the various brands represented in a picture of the protest with prominent labels and the tagline 'Down with Evil Corporations!' A similar approach can be detected in the 'Next Big Thing' advertisement campaign in October 2011 produced

for Apple's main rivals in the smartphone market, Samsung, for its Galaxy S2 device. The advert depicts a number of young people standing in line for a new smartphone and during their wait they see other people casually using a superior (Samsung) phone. Through their overspecific choice of coffee, the prominence of horn-rimmed glasses, plaid shirts and flat-caps, as well as an allusion to a 'creative' barista, the people in the line are coded as bohemian hipsters. In a reformulation of the strategy previously used by Volkswagen in a famous campaign throughout the 1960s (Frank 1997: 68), Samsung are unmasking the lifestyle being sold through advertising and in the process scoring points against their rivals. The fact that Apple is never mentioned in the advertisement demonstrates how prominent in popular culture the trope of the hipster and their love of Apple technology has become. By contrasting the people waiting in line with the regular, common sense Samsung customers, the advert is activating the same assumptions that serve to block the homology between Occupy and the groups it is trying to ally itself to, such as labour groups and the unemployed.

ZOOEY DESCHANEL AND *GIRLS*

A further example of tropes circulating through media that serve to block the homology between Occupy and other groupings can be found in the celebrity star text of figures associated with hipsterism. In particular, looking at the intensively multi-mediated star text of actress Zooey Deschanel, we can clearly detect the contradictions evident within the habitus of the hipster. The star has recently come to prominence with a very distinctive image, which feeds off the tropes of Indie culture. Deschanel's past work in Indie films such as *All The Real Girls* (2003) provides her with cultural capital in this regard. She is also part of a music-recording duo called *She and Him* with M. Ward, a successful indie singer-songwriter in his own right. With a foot in both film and music Indie camps, Deschanel has been continually associated with the 'hipster demographic' (Schnell 2012; Casserly 2012). In addition, the actress comes from an 'insider' Hollywood family, both her mother and sister being actresses, and her father an academy-award nominated cinematographer. This links her with other current celebrities commonly coded as hipsters, such as Lena Dunham, the star and writer of *Girls* (2012 –), who makes open and ample use of her privileged New York background in her works; Zosia Mamet, fellow star of *Girls*, and the daughter of famed playwright and director David Mamet and the actress Lindsay Crouse. This further feeds into the discourse of nepotism, which was a feature of the news reportage of the protestors at OWS.[9]

Of late, Deschanel has boosted her level of celebrity through the success of her television comedy *New Girl* (2011–), which was anticipated in crossover roles in films such as *Failure to Launch* (2006). *New Girl* is a hugely popular show portraying the lives of a group of three male thirty-somethings who come to share a flat with Jess, the new girl of the title, who has been variously described as 'kooky', 'quirky', 'cute' and 'adorkable'. These adjectives coalesce around a performative style that foregrounds Jess's childlike nature through qualities such as clumsiness and a lack of vocal control, and they emphasise the demonstrative body with its exaggerated postures such as pouting and her tendency to dance in an uncoordinated way. The dominant discursive function of Jess's cuteness, I suggest, is the neutralisation of current political fracture points associated with her generational demographic. The other flatmates (all male) function as embodiments of social types in crisis. Indeed, the series has not shied away from current issues such as recession, changing gender relations in the workplace, and the notion of a politically divided society. However, as Lori Merish has argued 'cuteness domesticates Otherness' (2006: 200). Typical *New Girl* episodes revolve around a problem faced by one of the male flatmates paralleled with a crisis involving Jess. Often the male will have to rescue her and in the process make a self-discovery, which ameliorates the initial crisis. Like the Shirley Temple performances Merish analyses, through a combination of pity and sentimentalisation the character of Jess restores patriarchal norms that have been put under duress.

Deschanel's 'Rainy Day' (2011) advertisement for the Apple iPhone references the character of Jess through the setting (loft apartment), the clothing, and the acting style, although elements of the mise en scène, such as the ukuleles in the apartment, allude to elements of crossover with the actress' musical persona. The advert itself emphasises tropes of insularism that re-enact the politically neutralising elements of *New Girl*. In addition, the character is coded as semi-bohemian, and through this, as well as her appointment as the face of Pantene, the star embodies the contradictions of a youth movement wanting change yet unwilling to forego its consumer fetishism. In particular, the advertisement channels the contradictory embodiment of authenticity and commercialism that has been seized upon in media depictions of Occupy.[10]

The trope of entitlement and hypocrisy is central to many recent cultural texts both addressing and portraying the demographic who are some of the most significantly affected by the 2008 recession. As Joseph Stiglitz has noted, twenty-somethings in 2012 are 'faced with a world of anxiety and fear. Burdened with student loans that they know they will struggle to repay and that would not be reduced even if they were bankrupt, they search for

good jobs in a dismal market' (2012: 347). Indeed, coverage of Millennials in the press tends to not only obfuscate the material conditions of this generational cohort, but actively portray it as needy and self-obsessed, and some of the prominent cultural texts that this generation are starting to produce themselves rather than contest such a mischaracterisation, broadly comply with this notion.

The HBO comedy-drama series, *Girls*, which is peopled by recently graduated 'bohemian types' living in New York, many of whom have no discernible source of income, is one such text. Series star Lena Dunham created the show along with producer Judd Apatow, and she writes as well as directs a large amount of the programme. The pilot episode is indicative of many of the clichés used to describe Millennial youth. The episode centres on Dunham's character, Hannah, an aspiring writer, who lives in New York where she works as an unpaid intern. The key scene in this episode, and one that was cited in many reviews of the show, is one in which Hannah Horvath (Dunham) meets her parents, Loreen (Becky Ann Baker) and Tad (Peter Scolari), in a restaurant, as they visit her in the city. The scene is worth quoting at length:

> Tad: . . . Hannah, your mother and I have been, um, talking, and we feel that it may be time . . . How can I phrase this? Well, we see how well you're doing at work, and you really seem to be figuring out what it is that you want. Um, but it may be time for, one final push.
> Hannah: What is a "final push"?
> Loreen: We're not gonna be supporting you any longer.
> Tad: See, I wasn't going to phrase it like that, Loreen. The way you phrased it.
> Hannah: But I have no job!
> Loreen: No, you have an internship that you say is going to turn into a job.
> Hannah: I don't know when.
> Loreen: You graduated from college two years ago. We've been supporting you for two years and that's enough.
> Hannah: Do you know how crazy the economy is right now? I mean, all my friends get help from their parents.
> Tad: (Nodding) We are sympathetic to that.
> Hannah: But I'm your only child. It's not like I'm draining all your resources. This feels very arbitrary.
> Loreen: You don't know anything about our finances. We're professors, Hannah, professors! We can't keep bankrolling your groovy lifestyle . . .
> Hannah: My 'groovy' lifestyle?
> Loreen: The bills add up. We're covering your rent, your insurance, your cell phone.
> . . .

Hannah: ... I am so close to the life that I want. To the life that you want for
 me, that for you to just end that right now!
Loreen: [slowly and deliberately] No. More. Money.
Hannah: Starting when?
Loreen: Starting now! We can talk about it tomorrow.
Hannah: I don't want to see you tomorrow.
Tad: But we fly out Tuesday?
Hannah: I have work. And then I have a dinner thing. And then I am busy ...
 trying to become who I am.

The scene highlights a number of statistical truths about Millennials,
including an increased dependence on parental support beyond university
and the growing prevalence of unpaid intern positions. However the under-
lying reasons for these trends go unexamined. One such reason is the fact
that a generational wealth gap has been developing in the United States,
and many other developed nations, where 'for the first time in modern
memory, a whole generation might not prove wealthier than the one which
preceded it' (Lowrey 2013). The clash between the baby boomer generation
and youth depicted in *Girls* compounds the view that Millennials are needy
and narcissistic, while failing to acknowledge the very real economic gulf
between the two generational cohorts. The rise of forms of precarious work
such as the unpaid internship that Hannah does at the outset of the series
exacerbates such matters for Millennials. As Madeline Schwartz notes: 'The
intern's obscurity and uncertainty characterize a labor force that has grown
more contingent, relying on part-time, unstable, and insecure work. Interns
will work for months without pay, benefits, or basic workplace protection'
(2013: 41). The rise of such forms of contingent labour extends far beyond
the creative industries Hannah wants to work in.

However, although the resonance of a young woman struggling for
money and pursuing a series of unfulfilling jobs matches the social reality
of its moment of inception, the programme suggests a disavowal of any
cause for that hardship beyond Hannah's selfishness and, as such, is doing
a disservice to the generation of twenty-somethings Stiglitz describes, as
well as to those who were driven to protest their economic uncertainty. We
can trace the genealogy of *Girls* via the mumblecore films of the 2000s, with
which her debut feature *Tiny Furniture* (2010) – arguably an earlier version of
Girls exhibiting the same thematic concerns and many of the same perform-
ers – was commonly associated back to the early 1990s recessionary figure
of the slacker, described by Andrew Kopkind as 'a rational response to
casino capitalism, the randomization of success, and the utter arbitrariness
of power' (1992: 187). The slacker figure was mediated through independent

films such as *Slackers* (1991) and *My Own Private Idaho* (1991) as well as popular comedy series *Friends* (1994), which attempted a rehabilitation of the maligned figure. However, much like *Girls*, such films failed to examine the underlying economic conditions that fuelled their depictions of an alienated youth cohort. Henry Giroux's comments on the depictions of youth on film from well over a decade ago still resonate today:

> Against the constant reminders of a society that tells youth it neither needs or wants them, youth are only offered right-wing homilies about relying on their own resources and cunning . . . the dystopian notion that there are no alternatives to the present order reinforces the message that young people should avoid at all costs the prospect of organising collectively in order to address the social, political and economic basis of individually suffered problems. (2003: 158)

Similarly, in his work *On Television and Journalism* (1996) Bourdieu makes the point that 'television, which claims to record reality, creates it instead . . . imposing a way of seeing the world' (1996: 22). While this selection of lectures mostly deals with news journalism, the point made can be broadened considerably to encompass the wide variety of screen media that compels our attention in the twenty first century, including advertisements and memes and television programmes as alluded to above. The way of seeing the world imposed by these various texts serves to, I argue, foster a political quietism and in tandem close down legitimate protest through the blocking of homological identification.

CONCLUSION

Bourdieu's focus, particularly in his later work, on the pernicious effects of neo-liberal capitalism will remain an inspiration and an important theoretical tool in future scholarly examinations of the inequalities that permeate contemporary society. Indeed, concepts central to field theory such as habitus and the various forms of capital continue to be refined and adapted to contemporary developments and, as such, are central to future analyses of various media texts and their impact on wider societal structures.[11] Towards the end of *Pascalian Meditations* Bourdieu strikes an optimistic note, suggesting that:

> [T]hrough the social games it offers, the social world provides something more and other than the apparent stakes . . . there is a happiness in activity which exceeds the visible profits – wage, prize, or reward – and which consists in

the fact of emerging from indifference (or depression), being occupied, projected towards goals, and feeling oneself objectively, and therefore subjectively, endowed with a social mission. (2000: 240)

At a time that is marked by what some scholars have termed 'political depression' the Occupy movement seemed to briefly organise the political energies of Millennials and other groups with a sense of the 'social mission' Bourdieu refers to above. The emergence in 2011 of this burgeoning collective consciousness with the potential to ignite hopes for an alternative to the present order makes the analysis of popular culture's role in the containment of such energies of particular importance to the present era.

I have argued that media representations often function to derail the development of the homologies Bourdieu felt to be an essential step towards a restructuring of the objective societal structure. To this end, I have used the representation of the OWS protestors as a case study, tracing how news reportage reduced a heteronymous grouping to privileged bohemian 'hipsters', thereby activating a series of tropes circulating in the media environment. Three features are particularly noteworthy here; firstly, the depiction of 'hipster' as privileged hypocrite, incorporating tropes of consumer fetishism and nepotism; secondly, the representation of associated 'bohemian' or hipster celebrity star texts as a gendered reformulation of 'cuteness' that serves to neutralise fractious political conditions; and thirdly a homological relationship between public protest and technological consumer fetishism that further bolsters accusations of privilege and hypocrisy. These features have the effect of preventing 'contagion' through the development of homologies that would threaten the prevailing habitus. This leveraging of existing discourses antithetical to the movement's ethos of economic equality and collectivism thereby inhibits the movement's legitimate social critique.

NOTES

1. See, for instance, Gitlin (2012) *Occupy Nation: The Roots, The Spirit, and The Promise of Occupy Wall Street*; Castells (2012) *Networks of Outrage and Hope: Social Movements in the Internet Age*; Chomsky (2012) *Occupy*. For a less optimistic view that specifically critiques the role of academics in the Occupy movement, see Frank (2012) 'To the Precinct Station: How Theory Met Practice . . . and Drove it Absolutely Crazy'.

2. This refers to the somewhat approximate statistic that 99 per cent of the wealth is held by 1 per cent of the population popularised by Occupy's 'We are the 99%' slogan.

3. Milkman, Luce and Lewis (2013) provide data showing a spike in the amount of U.S. news mentions of 'income inequality' during the height of the protest in September/October 2011. Although the rate subsequently dropped again, it remains significantly higher than pre-Occupy levels.

4. Occupy Data's mission is to produce statistical charts and analyses that help to raise awareness of income inequality; Occupy Research similarly encourages and facilitates academic work broadly supportive of Occupy's aims; Occupy Sandy was set up to provide relief in the wake of the hurricane and reflects the fact that many of the activists 'are more likely to focus their efforts on direct action and mutual aid than on legislative or electoral campaigns' (Milkman, Luce and Lewis 2013: 41).

5. One reason hipsters were such an easy target for elements of print media was the fact that there was a grain of truth to the claims made. Although many hipsters are in a precarious financial position, this is by no means true for all members of this social type. Mark Greif (2010) suggests that rather than being one homogenous taste culture, hipsterism comprises three distinct groupings: 'the children of the upper middle class who move to cities after college with hopes of working in the "creative professions"'; 'trust-fund hipsters'; and finally, 'the couch-surfing, old-clothes-wearing hipsters who seem most authentic but are also often the most socially precarious – the lower-middle-class young'.

6. A further correlation of note has been posited by the psychiatrist Oliver James, who in his book *The Selfish Capitalist* determines a direct link between the neoliberal mode of capitalism practised in countries such as the United Kingdom and the United States and rising levels of mental illness (Fisher 2009: 19).

7. Although, as Mukherjee and Banet-Weiser note, the histories of social protest and consumerism are inextricably linked, so much so that consumers have 'often contradictorily . . . embraced consumption as a platform from which to launch progressive and political projects' (2012: 5).

8. Miriam Greenberg gives an in-depth account of how neo-liberal trends and the commercialisation of space work in tandem. Through a dual process of intensive marketing and pro-business economic reforms, the writer describes how, during a period of economic crisis, New York in the 1970s was 'branded' through both 'the real and symbolic commodification of the city, and of the simultaneous production and marketing of a hegemonic, consumer- and investor- oriented vision of New York' (Greenberg 2008: 10–11).

9. A considerable amount of scholarship has emerged on *Girls* since its first broadcast. On the question of the depiction of privilege and various other issues this series has raised, see, for instance, Betty Kaklamanidou and Margaret Tally's edited collection *HBO's Girls: Questions of Gender, Politics, and Millennial Angst* (2014).

10. For an extended analysis of the star text of Deschanel, see McIntyre (2015).

11. Notable examples of the extension and development of Bourdieu's concepts can be seen in the work of Eva Illouz (2007), Zizi Papacharissi and Emily Easton (2013), and Olivier Driessens (2013) to name but a few.

REFERENCES

'Americans not Hip to Hipsters'. 2013. *Public Policy Polling*, 13 May. Retrieved 29 May 2013 from http://www.publicpolicypolling.com/main/2013/05/americans-not-hip-to-hipsters.html

Bentley, P. and M. McLucas. 2011. 'A Very Privileged Protest: Wearing $300 Jeans and from Some of the Most Exclusive Schools, the Children of the One Per Cent out for a Good Time at Occupy Wall Street', *Mail Online*, 11 November. Retrieved 14 June 2012 from http://www.dailymail.co.uk/news/article-2047664/Occupy-Wall-Street-Children-1-good-time-protests.html

Binkley, S. 2009. 'The Bohemian Habitus: New Social Theory and Political Consumerism', in K. Soper, M.H. Ryle and L. Thomas (eds), *The Politics and Pleasures of Consuming Differently: Better than Shopping*. New York: Palgrave Macmillan.

Bourdieu, P. 1977. *Outline of a Theory of Practice*, trans. R Nice. Cambridge: Cambridge University Press.

——. 1991. *Language and Symbolic Power*, ed. J.B. Thompson. Cambridge: Polity.

——. 1993. *The Field of Cultural Production: Essays on Art and Literature*, ed. R. Johnson. Cambridge: Polity.

——. 1996. *On Television and Journalism*, trans. P.P. Ferguson. London: The New Press.

——. 2000. *Pascalian Meditations*. Cambridge: Polity.

Castells, M. 2012. *Networks of Outrage and Hope: Social Movements in the Internet Age*. Cambridge: Polity.

Casserly, M. 2012. 'Girls' Club: Zooey Deschanel Laughs Her Way to Success'. *Forbes*, 16 May. Retrieved 1 October 2012 from http://www.forbes.com/sites/meghancasserly/2012/05/16/girls-club-zooey-deschanel-celebrity-100-hellogiggles/

Chomsky, N. 2012. *Occupy*. London: Penguin.

Fisher, M. 2009. *Capitalist Realism: Is There No Alternative?* Winchester: Zero.

Florida, R.L. 2002. *The Rise of the Creative Class: And How it's Transforming Work, Leisure, Community and Everyday Life*. New York: Basic.

Flynn, D. 2011. 'The Rich Kids of Occupy Wall Street', *FrontPage Magazine*, 4 November. Retrieved 14 June 2012 from http://www.frontpagemag.com/fpm/111242/rich-kids-occupy-wall-street-daniel-flynn

Frank, T. 1997. *The Conquest of Cool: Business Culture, Counterculture, and the Rise of Hip Consumerism*. Chicago: University of Chicago.

——. 2012. 'To the Precinct Station', *The Baffler*, no. 21. Retrieved 4 July 2013 from http://www.thebaffler.com/salvos/to-the-precinct-station

Giroux, H. 2003. 'Neoliberalism and the Disappearance of the Social in Ghost World', *Third Text* 17(2): 151–61.

Gitlin, T. 2012. *Occupy Nation: The Roots, the Spirit, and the Promise of Occupy Wall Street*. New York: Itbooks.

Greif, M. 2010. 'The Hipster in the Mirror', *New York Times*, 12 November. Retrieved 16 June 2015 from http://www.nytimes.com/2010/11/14/books/review/Greif-t.html?_r=0

Greif, M., K. Ross and D. Tortorici (eds). 2010. *What Was the Hipster? A Sociological Investigation.* New York: n+1.

Gorta, W.J. 2012. 'Hipster Flips in Court, Winds Up in Cuffs', *New York Post*, 31 January. Retrieved 12 June 2015 from http://nypost.com/2012/01/31/hipster-flips-in-court-winds-up-in-cuffs/

Greenberg, M. 2008. *Branding New York: How a City in Crisis was Sold to the World.* New York: Routledge.

Hesmondhalgh, D. 1999. 'Indie: The Institutional Politics and Aesthetics of a Popular Music Genre', *Cultural studies* 13(1): 34–61.

——. 2006. 'Bourdieu, the Media and Cultural Production', *Media, Culture & Society* 28(2): 211–31.

Howe, N. and W. Strauss. 2000. *Millennials Rising: The Next Great Generation.* New York: Vintage.

Illouz, E. 2007. *Cold Intimacies: The Making of Emotional Capitalism.* Cambridge: Polity.

Jenkins, H. 2006. *Convergence Culture: Where Old and New Media Collide.* New York University Press: New York.

Kaklamanidou, B. and M. Tally (eds). 2014. *HBO's Girls: Questions of Gender, Politics, and Millennial Angst.* Newcastle-Upon-Tyne: Cambridge Scholars.

Kopkind, A. 1992. 'Slacking toward Bethlehem', *Grand Street* 10: 177–88.

Lane, J.F. 2006. *Bourdieu's Politics: Problems and Possibilities.* London: Routledge.

Lowrey, A. 2013. 'Do Millennials Stand a Chance in the Real World?', *The New York Times*, 30 March. Retrieved 30 April 2013 from http://www.nytimes.com/2013/03/31/magazine/do-millennials-stand-a-chance-in-the-real-world.html?pagewanted=all&_r=0

McChesney, R.W. 2013. *Digital Disconnect: How Capitalism is Turning the Internet against Democracy.* New York: New Press.

McIntyre, A.P. 2015. '*Isn't She Adorkable!* Cuteness as Political Neutralization in the Star Text of Zooey Deschanel', *Television and New Media* 16(5): 422–38.

McWilliams, D. 2015. *The Flat White Economy: How the Digital Economy is Changing London and Other Cities of the Future.* London: Duckworth Overlook.

Merish, L.1996. 'Cuteness and Commodity Aesthetics: Tom Thumb and Shirley Temple', in R. Garland-Thomson (ed.), *Freakery: Cultural Spectacles of the Extraordinary Body.* New York: New York University Press.

Milkman, R., S. Luce and P. Lewis. 2013. *Changing the Subject: A Bottom-up Account of Occupy Wall Street in New York City.* New York: CUNY.

Mukherjee, R. and S. Banet-Weiser (eds). 2012. *Commodity Activism: Cultural Resistance in Neoliberal Times.* New York: New York University Press.

Newman, M.Z. 2009. 'Indie Culture: In Pursuit of the Authentic Autonomous Alternative' *Cinema Journal* 48(3): 16–34.

——. 2013. 'Movies for Hipsters', in G. King, C. Molloy, and Y. Tzioumakis (eds), *American Independent Cinema: Indie, Indiewood and Beyond.* New York: Routledge.

O'Neill, B. 2011. 'The Teenage Moralism of the Occupy Wall Street Hipsters almost Makes me Ashamed to be Left-wing', *Telegraph*, 3 October. Retrieved 1 June 2012 from http://blogs.telegraph.co.uk/news/brendanoneill2/100108713/the-teenage-moralism-of-the-occupy-wall-street-hipsters-almost-makes-me-ashamed-to-be-left-wing/

Oullette, L. 2009. '"Take Responsibility for Yourself": Judge Judy and the Neoliberal Citizen', in S. Murray and L. Oullette (eds), *Reality TV: Remaking Television Culture*, 2nd ed. New York: New York University Press.

Packer, G. 2013. 'Upgrade or Die: Are Perfectionism and Inequality Linked?', *The New Yorker*, 6 March. Retrieved 25 April 2013 from http://www.newyorker.com/online/blogs/comment/2013/03/technological-perfectionism-and-income-inequality.html

Papacharissi, Z. and E. Easton. 2013. 'In the Habitus of the New: Structure, Agency and the Social Media Habitus', in J. Hartley, A. Bruns and J. Burgess (eds), *New Media Dynamics*. Oxford: Blackwell.

Rayner, A. 2010. 'Why do People Hate Hipsters?', *Guardian*, 14 October. Retrieved 29 May 2013 from http://www.theguardian.com/lifeandstyle/2010/oct/14/hate-hipsters-blogs

Schnell, J. 2012. 'Sprint Goes after Hipster Demographic with Zooey Deschanel iPhone 4S Commercial', *Macgasm*, 16 April 2012. Retrieved 23 October 2012 from http://www.macgasm.net/2012/04/16/sprint-goes-after-hipster-demo-graphic-with-zooey-deschanel-iphone-4s-commercial/

Schwartz, M. 2013. 'Opportunity Costs: The True Price of Internships', *Dissent* 60(1): 41–45.

Silva, J.M. 2013. *Coming up Short: Working-class Adulthood in an Age of Uncertainty*. Oxford: Oxford University Press.

Stiglitz, J.E. 2012. *The Price of Inequality: How Today's Divided Society Endangers our Future*. New York: W.W. Norton.

Anthony P. McIntyre is an associate lecturer at University College Dublin. He has recently published an article in the journal *Television and New Media* and has a chapter forthcoming in *Hysterical! Women in American Comedy,* edited by Linda Mizejewski and Victoria Sturtevant (University of Texas Press). He is a co-editor, along with Diane Negra, Joyce Goggin, Julia Leyda and Joshua Paul Dale, of the forthcoming collection *The Aesthetics and Affects of Cuteness* (Routledge, 2017).

A Bourdieuian Approach to Internet Studies

Rethinking Digital Practice

Richenda Herzig

INTRODUCTION

The absence of a Bourdieuian agenda towards Internet studies is striking in light of the impact of his work upon debates within more traditional media and cultural studies (Benson and Neveu 2005). While it is true that Bourdieu omitted new media from his extensive empirical concerns, this has not inhibited researchers from exporting his perspective to a diverse range of interests, such as Migration studies (Erel 2010) or International relations (Senn 2013). Furthermore, Internet researchers have not hesitated in drawing inspiration from other traditional social theories, such as social network theory or Habermas' concept of the public sphere. Why, we should ask, has Bourdieu not evinced substantive appeal among researchers in this area?

The answer to this question becomes clear if we consider the conceptual development of Internet research. Dominant approaches within this area manifest a clear relationship to the parent assumptions and concerns that guided the earliest research in the field. Foremost among this heritage is a preoccupation with the 'newness' of the Internet as a medium, a technology, a site of practice and even an ontology. Although researchers today have acknowledged and distanced themselves from the more problematic optimism and pessimism characteristic of early Internet research (Consalvo

and Ess 2013: 4), the newness of the Internet remains the dominant point of departure, and it lives on as the strongest raison d'être for research in this field. This has vital repercussions for the construction of the Internet as a research object, and the selection of certain theoretical principles over others. Accordingly, Habermas' public sphere held an inevitable appeal to researchers who understood the Internet as offering a new, more equitable and accessible kind of public space. Postmodern theories appealed to researchers who hoped that 'virtual reality' would liberate users from the constraints of their 'real life' identities (Turkle 1995). Actor-network theory (ANT) has been profoundly valuable to researchers seeking to appreciate the constraints and affordances introduced by web design (Cavanagh 2007). Finally, the rise of the Internet is also understood by theorists such as Lash and Castells as confirmation of a fundamental shift in global social structure, with information taking over as a dominant form of power, and 'networked individualism' as the principal arrangement of collective life (Castells 1998; Lash 2002). From this perspective, critics have sought to characterise Bourdieu's field theory as limited to an earlier form of modernity, one still primarily defined by nation states, and an advanced division of labour (Lahire 2011). It is not much wonder, therefore, that his theory may be deemed irrelevant by researchers of the Internet.

However, these assumptions are deeply mistaken. In boldly calling for a 'comparativism of the essential' (Bourdieu 1998: 13), Bourdieu is not trying to advance a prescriptive theory, but rather a conceptual procedure. Contextual features combine with each component of the framework in order to form an entirely unique construction. This context sensitivity means that Bourdieu's approach is not confined to a particular national or temporal setting, but rather applicable to any instance of human practice. Recognising this flexibility affirms the compatibility of this approach to Internet studies.

Furthermore, Bourdieu's approach offers fresh avenues for researching digital practice. Implicit in the application of Bourdieu's conceptual tools in this context is the assumption that certain principles of social practice remain constant in the face of material variation. A Bourdieuian approach would therefore retain social practice as the principal frame of reference, as opposed to focusing on the novelty of the Internet as its point of departure. In doing so it enables a research design devoid of prior assumptions regarding the role and significance of the Internet for particular contexts of practice. The value in adopting this approach will be demonstrated by contrasting it with related social perspectives on the Internet. Having accomplished this, the next step is to consider the ways in which field, capital and habitus might be operationalised in Internet research. What are some of

the challenges implicated in this task, and what are the initial theoretical suppositions that researchers will need to recognise and account for in the process of formulating their research object? The first half of this chapter is thus devoted to bringing Bourdieu into conversation with prominent social theories in Internet studies, while the second half of the chapter puts forward some tentative suggestions regarding possible applications of Bourdieu's concepts within Internet studies, and those features that need further theorisation in order to be fully operationalised within this area.

WHY DO WE NEED A BOURDIEUIAN APPROACH TO INTERNET STUDIES?

A casual observer might be forgiven for thinking that social fields bear a striking resemblance to the concepts of homophilous networks (Cook, McPherson and Smith-Lovin 2001) or public spheres. For instance, in describing 'networks of power' Yochai Benkler asserted that, 'we live our lives in systems. Each of us . . . functions within multiple overlapping systems of constraint and affordance. The configuration of each of these systems and of the overlapping systems relevant to a situation has a large amount of influence on what we want, do and attain in these systems' (Benkler 2011). Additionally, Castells speaks of a 'multiscalar' network structure in which 'each of these levels of practice, and each spatio-temporal form, (re)produce and/or challenge power relationships at the source of institutions and discourses' (2009: 15). These descriptions are not dissimilar to Bourdieu's portrait of overlapping fields, which present opportunities and barriers to agents, and operate according to a specific logic. Indeed, Bourdieu has characterised the field as a kind of network (Bourdieu and Wacquant 1992: 97), and Postill traces Bourdieu's concept of field to a more structuralist (versus interactionist) strand of the social network approach pioneered by the Manchester school of Anthropology earlier in the twentieth century (Postill 2011: 17). However, there are vitally distinct features of field theory that grant it a different functionality than that pertaining to its alternatives. Firstly, fields are profoundly social in principle. That is to say that understanding human behaviour in relation to fields prohibits a methodologically individualist conception of practice. Accordingly individuals are always considered in relation to other actors, and in relation to particular species of power. By contrast, network theorists such as Wellman and Castells endorse 'networked individualism' as the dominant pattern of sociality, arguing that agents establish personalised networks customised to their particular needs and interests (Castells 2001; Wellman 2001). Furthermore, Benkler

sees it as a particular advantage of network theory that the individual is clearly demarcated. The individual, from this perspective, remains at the centre of the research framework. The social orientation of field theory undermines an emphasis on individuals, by drawing attention to the way in which habitus is shaped by cumulative interactions with multiple fields, and by emphasising the significance of relative positioning for orienting action.

However, while a Bourdieuian approach problematises an emphasis on the individual, it can also be understood as attributing to human actors more agency than in alternative strands of network theory. For example, having characterised individuals as 'nodes' within networks, Castells asserts that, 'when nodes become unnecessary for the fulfilment of the network's goals, networks tend to reconfigure themselves, deleting some nodes and adding new ones. Nodes only exist and function as components of networks' (Castells 2009: 20). Castells attributes to select elite institutions or individuals the power to form and programme networks, but the average individual has a fairly limited degree of power and influence within this structure. Once initiated, networks have a kind of logic and power of their own. Similarly, while ANT radically opposes the tendency of other network theories in over-privileging the individual, Cavanagh suggests that, 'in the process of forming a network, the identity of the elements from which the network is comprised is subservient to the problematization, the over-riding definition of the situation' (Cavanagh 2007: 34). And so it is that certain network approaches to the Internet precipitate the rare condition in which a Bourdieuian approach might be accused of overemphasizing agency. In contrast to these perspectives on social structure, each human actor has a vital role within Bourdieu's account. Fields come into being as a result of human actors attaching value to particular commodities, skills, or resources, and orientating their behaviour accordingly (Bourdieu and Wacquant 1992). Thus it is the values and interests of actors that lead to the formation of the objective social structures that they must then negotiate. Therefore the social character of Bourdieu's framework attributes to human actors considerable power in shaping social structures according to their interests, even though this is understood to be a collective process, and one that actors are often consciously disconnected from.

The most striking feature distinguishing fields from networks, however, consists in the kinds of connections that draw nodes or actors together into a configuration. Fields are formed of relations, rather than the interactions or 'ties' that link nodes in networks. Bourdieu asserts that, 'the real is relational: what exist in the world are relations – not interactions between agents or intersubjective ties between individuals – but objective relations which exist "independently of individual consciousness and will," as Marx

said' (Bourdieu and Wacquant 1992: 97). Important features are introduced by this distinction. Firstly, a Bourdieuian approach to practice recognises that actors can be connected to and influenced by other actors without sharing ties with them, however separated or 'latent' (Haythornthwaite 2002) these ties may be. We can see the truth of this if we consider an example like credential inflation. Agents investing in institutional cultural capital are all influenced by the level of qualification attained by other agents in society irrespective of whether they are members of the same social networks. We can also think of further examples in which individuals are influenced by the actions and thoughts of others, without sharing any interactive tie, such as when we respond to norms, or adopt a discourse. A further facet of this observation is the recognition that we have objective social positions that influence us regardless of whether or not we consciously identify with them. By contrast, the concern with interactive ties in network theories places a heavier emphasis on the role of consciousness and communication in ordering social structure. This is especially true for accounts that seek to interpret the Internet through the paradigm of an 'Information society'. Castells exemplifies such a perspective when he asserts that, 'conscious communication (human language) is what makes the biological specificity of the human species. Since our practice is based on communication, and the Internet transforms the way in which we communicate, our lives are deeply affected by this new communication technology' (Castells 2001: 5). Therefore, where networks allow us to piece together the world as it is understood by agents (a world intentionally structured by the instrumental, communicative bonds agents make with each other), fields work to additionally highlight background historical, cultural, normative and discursive properties that have a bearing upon agents in their struggles for distinct types of power.

A final, but important implication of emphasising the social structure that arises from interaction rather than power relations is that social capital becomes the primary immaterial capital that is recognised. Accordingly, researchers within the social network approach frequently use social capital to cover a diverse range of assets or resources, as a result of omitting alternative forms of capital (Harvey, Knox and Savage 2006). Therefore Coleman characterised the inculcation of knowledge and work ethic by immigrant parents to their offspring as an example of social capital, rather than cultural capital (1988). Furthermore, quantitative studies on social capital and the Internet have utilised a highly diverse range of measures for social capital, such as self-esteem, online shopping and political participation (see Holbert, Kwak and Shah 2001; Crank and Pigg 2004; Ikeda, Kobayashi and Miyata 2006; J-Young 2006; Ellison, Lampe and Steinfield 2007). 'For Bourdieu', in the words of Postill, 'SNA [social network analysis] conflates

structure with interaction, exaggerating the importance of "social capital", i.e. the capital that accrues from social connections, whilst neglecting other species of capital such as cultural and symbolic capital' (Postill 2011: 17). This neglect includes an oversight of more tacit and embodied forms of capital, such as the acquisition of elite tastes, and the practical orientation of agents that finds expression not only within communicative acts, but also in motivations, habits and perceptions (Bourdieu 1972).

When we compare field to the public sphere or online community as characterisations of online social space, a Bourdieuian approach can be distinguished as more critical, and more exploratory with regard to presuppositions about the form that online behaviour takes. The use of 'community' as a popular descriptor of online groups has faced criticism for its emotive and normative connotations (Kendall 2013). The term elicits a focus on positive user activities such as sharing, bonding, cooperation, empowerment or discussion of shared interests. The literature recognises the negative aspects of online communities, such as the potential for sheltering individuals from views or attitudes they disprefer (Norris 2004), the possibility of co-option by extremist or criminal groups (Wojcieszak 2010), and the prevalence of antisocial behaviours like flaming or trolling (Smith 1999). Nevertheless, the use of 'community' still draws upon an idealised preconception of online sociality, and it implicitly promotes a dichotomy between social and antisocial types of use. Sterne and Cavanagh have also illustrated how the concept of online communities has been co-opted and perpetuated by commercial interests (Sterne 2003; Cavanagh 2007). It is precisely the social benefits of online collectives that appeal to managers of online communities, and discussion within this sector therefore tends to focus on fostering this ideal. By contrast, a Bourdieuian perspective recognises that users may exhibit both combative and cooperative practices, depending on the particular motives and interests invested in different contexts. This approach benefits from seeking to explain practice in terms of users' dispositions and relation to power, rather than concerning itself with general or essential features of online social spaces.

Where the notion of an online community points towards bounded and intimate groups that foster their own norms and culture, the public sphere is an ideal, characterised as inclusive, universally accessible and appealing to diverse entities and actors. Online public spheres therefore bear similarities to online communities insofar as they frame online behaviour in an optimistic light (Chadwick 2006; Postill 2011). For Habermas, public spheres are founded on communicative action, a form of practice motivated by agents' intrinsic interest in mutual understanding (Habermas 1984). Habermas additionally recognises strategic action as another form of practice, but he

sees this as taking place within a distinct 'system world'. While Habermas acknowledges increasing incursions on the 'life world' by the 'system world', it is mostly the communicative action component of his thought that is operationalised within Internet research. Research in this field tends to neglect his notion of strategic action and the system world. Instead it is concerned with the potential of the Internet to act as an independent platform for collective normative deliberation (Benson 2007). We can make sense of this by considering how the notion of communicative action serves to affirm the centrality of the Internet to the very fabric of social life, by singling out communication as the principal 'social glue'. In doing so, it bears similarities to social network perspectives, and enjoys popularity within Internet research for much the same reason. An important outcome of this emphasis is that the power struggles and stratification within public spheres are sidelined. Public spheres flatten social space by assuming a level playing field for their participants.

Therefore while these perspectives are unquestionably social in a way that cannot be said of social network theory, they operate on optimistic assumptions about the nature of online interaction that render them ill-suited to tracing and accounting for power disparities. These presuppositions also preclude more nuanced conceptualisations of online social space, and of the diversity of motivations, behaviours and positions within such a space.

In contrast to public spheres or online communities, a field is inherently hierarchical, being, as it is, shaped entirely by the distinct position-takings of different actors with relation to capital (Bourdieu and Wacquant 1992: 97). The shape and boundary of a field constantly changes as a result of continual struggles by agents to improve their position and to secure interests. The implications of these features are that researchers cannot apply the notion of a social field without first identifying the particular type of power influencing the social context in question. The very action of mapping a field is one and the same as identifying the distribution of power, and connecting this distribution to the positions, practices and motivations of actors. The notion of field is not accompanied by presuppositions regarding the implications of the Internet for sociality. Instead, this has to be ascertained through investigating the origins of practices within the field. Finally, fields are homologous with other fields; a fact that obliges researchers to avoid constructing social spaces as bounded entities (Postill 2011), and encourages them to understand these as porous and interrelated.

While it is to be expected that Internet researchers may view Bourdieu's social stance with suspicion, there is much benefit to be gained from thinking outside of preconceptions regarding the social significance of the Internet.

Such preconceptions have led to a technologically determinist refashioning of practice, as evinced by the overemphasis on communicative ties and individualism running through network accounts, and the idealism underscored in public sphere and community perspectives. Bourdieu's relationalism enables an enhanced recognition of cultural and collective factors and the power struggles running through digital practices. It also highlights how embedded these practices are in offline daily life (Postill 2011). However, while the benefits to be gained from a Bourdieuian approach are clear, the application of key concepts to online practice poses certain challenges.

OPERATIONALISING FIELD, CAPITAL AND HABITUS IN INTERNET STUDIES

There are a variety of conceptions of power within Internet research that resemble Bourdieu's theory of capital. Capital (or power) in Internet studies tends to be addressed through one of two guiding interests. The first is a concern with the kind of power that enables agents to access, engage with or exploit the Internet for their own benefit. From this perspective, grand theorists such as Castells, Lash and Poster have asserted the notion of the virtual or network classes (Poster 1990; Castells 1998; Lash 2002). The most vital form of power from this perspective is that of inclusion within or exclusion from networks, or the Information society. Similarly, there is a long tradition of research charting 'the Digital divide'. Originally researchers in this area focused solely on the demographics surrounding Internet access; however, this debate has progressed to recognition of a plurality of 'divides', including those distinguishing different types of use and engagement online (Hargittai 2002). This includes identification of a range of digital skills and literacies. Many theories of this kind pose a shallow affinity with Bourdieu's capitals. For instance, Warschauer addresses a variety of human, physical, digital and social 'resources' necessary for inclusion online (2003), and for van Dijk these resources are material, temporal, social, cultural and 'mental' (2005). Clearly digital inclusion is also an implicit concern of debates exploring online public spheres, and the link between the Internet and civic engagement.

For examples of research concerned with what agents get out of the Internet, the literature on social capital is an excellent candidate. While studies in this area frequently focus on interactions taking place online, the motivating factor is to identify the benefits that individuals are able to leverage from these interactions for use in 'real life'. On a wider scale, this is also true of the digital labour debate (Terranova 2000). At the heart of

research in this area is an interest in the balance of power between ordinary users and global corporations. Are users being empowered or exploited by Facebook, for instance?

The purpose of this observation is not to question the value of these debates. Instead I argue that we would go even further in identifying 'arenas of struggle' (Bourdieu and Wacquant 1992) if we were to rethink our assumptions regarding the sources and forms of power that are implicated in instances of practice that arise around the Internet. These assumptions shape the kind of questions that are asked and hold implications for how the Internet as a whole is conceptualised within research. For instance, if we focus on what agents get out of the Internet, or on its assumed influence on society, we implicitly treat the Internet as a resource or a tool, rather than a site of practice. Conversely, an emphasis on inclusion and exclusion downplays stratification and power dynamics within online networks, implicitly constructing these as internally neutral (Postill 2011). While research on digital skills and literacies recognises the Internet as a locus for practice, imbued with inequalities, it nevertheless adopts technologically determinist assumptions regarding what this stratification might look like. This precludes the identification of additional, unanticipated inequalities. It is therefore not much wonder that there is a growing recognition of the need for increased theorisation of digital inequalities (Halford and Savage 2010; Livingstone 2010). In contrast, we can identify several features of a Bourdieuian approach that would enable a reconceptualisation of digital inequality, and fresh methodological strategies for exploring it.

One such feature lies in Bourdieu's recognition of multiple forms of immaterial capital, and economies of practice that go beyond the transparent economic field of material struggle (1986). The efficacy of immaterial capitals is compounded by their widespread misrecognition. A striking implication of this perspective is that more than one type of capital might be implicated in users' practice online. Furthermore, these capitals might well be effectively disguised. This issues a challenge to studies that are tailored to one type of power that is assumed to hold significance. If more than one form of power is in operation, the precise local configuration and balance of these powers holds implications for the functioning of any single form of power. Therefore an exploratory methodological approach is needed that constructs its definition of power to reflect the unique landscape of local struggles. In practice we would operationalise this by asking certain open questions. We would explore the interests of users in choosing to engage with a particular online environment. We would consider the nature of skills and resources strategically deployed within these environments, and the relative value that these accrue in different contexts. However we would

also seek to ascertain any dynamics that arose as a result of the particular combination of a unique collective of individuals, and the interests and resources they brought with them. These questions could reveal unanticipated forms of power, and the dynamics orchestrating their interrelations.

These questions also highlight the schemes of classification that users hold, and the symbolic order they impose onto online spaces. A recent study by Brashears and Tufekci described the 'unequal distribution of disdain for digitally-mediated sociality', illustrating persistent divisions in social dispositions towards online interaction (2014). While their study addressed the significance of this division for access to online environments, such attitudes can have profound effects upon power and status within online environments too. This was evident in my own ethnographic research on The Student Room, a major U.K. online community. Here I found a sharp difference in the status attached to usage oriented towards social interaction and entertainment, versus usage oriented towards instrumental or 'serious' pursuits such as factual queries. Users had reproduced the tacit assumption that online social interaction was somehow 'sad', or ersatz, in the respect and value they attributed towards different kinds of online activity. Users engaging in instrumental usage benefited from an alibi, whereas users attracted to lower status pursuits were forced to use disclaimers in conversation, distancing themselves from their activity. These users also laboured to consecrate their own site-specific form of capital in defence. This clearly shows how agents' schemes of 'vision and division' (Bourdieu 1998) have strong ramifications for power disparities online. Users negotiate online environments with the guidance of particular dispositions and a doxic scheme of evaluation. These orientations lead to the imposition of a unique system of value upon existing manifest skills, aptitudes or resources. Furthermore, this value system may lead to the formation of new forms of symbolic capital. Therefore it is not merely that researchers of digital inequality must consider multiple forms of capital simultaneously; they must also identify the relative meanings attached to these capitals collectively in order to fully grasp their operation.

Field is of vital importance as a tool for revealing capitals and the symbolic order that governs them. However it is also the most challenging concept to operationalise in Internet research. Various a priori applications of the concept may hold intuitive appeal to researchers. For instance, we might wish to conceive of the Internet in its entirety as a field on the basis that it exhibits its own logic, distinct forms of power, and semi-autonomy vis-à-vis 'the real world'. In other contexts we might wish to identify distinct fields of competing online communities, blogs or platforms, such as a field of social networking sites like Twitter and Facebook. On the other hand, a specific

platform or online community might additionally be seen to constitute a field in itself. Could Twitter constitute its own field, bearing in mind that the logic governing the acquisition of followers or retweets is particular to its layout? Or should we see online practices as playing out at an intersection between a multitude of overlapping fields, some entirely web based, and others spanning mediated and co-present environments, like a virtual learning environment, or a University society Facebook group? These examples illustrate some of the difficulties and pitfalls that are implicated in this exercise. I would argue that deploying a distinction between 'online' and 'offline' fields falls prey to the technological fetishism rife in existing conceptions of digital sociality. On investigating an instance of practice, we may well find that mediation is a significant factor in determining the position of agents and the kind of power at their disposal. Nevertheless, it should not be assumed that this will be the case, and several studies problematise the distinction between 'online' and 'offline' by illustrating the extent to which agents blend mediated communication with day-to-day practice (Baym 1995; Miller and Slater 2000; Haythornthwaite and Wellman 2002). The definition would clearly break down when faced with examples such as the Arab Spring, where we would wish to include both online and offline instances of practice within the same plane of struggles. By contrast, a field ensconcing diverse websites or platforms might err in riding roughshod over important differences in web layout. If we wish to analyse a field of impact or visibility online, can we really treat blog subscribers, Facebook friends and Twitter followers alike? Closer inspection suggests that the motivation for friending someone on Facebook might be entirely unrelated to a choice to follow their blog or Twitter account. Furthermore, one blog follower could be worth several followers on Twitter if attention quality and quantity were at issue (Boyd 2014). In this instance the kind of relationship and communication facilitated by a durable connection is determined by the specific affordances that distinct site designs grant their users. A further example includes rating and reputation systems online. From Amazon, to the *Daily Mail*, to Facebook, various sites allow users to 'like', 'favourite', 'rate' or 'vote' on content. Reputation systems facilitate trust and quality control in response to common challenges imposed by the lack of physical cues and social markers in digitally mediated social environments. This has led Masum and Tovey to herald the rise of 'the Reputation Society' (2011). However, although we might wish to recognise online reputation as a form of power, it is questionable whether we are dealing with a comparable phenomenon when we contrast the use of the Facebook 'like' button with seller feedback on eBay. This remains an issue even if we compare much more similar reputation systems. For instance, the reputation system on

The Student Room allows users to accumulate reputation points, which appear as green gems on each of their posts. Reputation is a marker of status across the site, and it affords users symbolic power in interactions. It is intuitive to compare reputation on The Student Room with the reputation systems on sites using similar proprietary forum software. However, it is doubtful whether users of entirely different communities can be seen to operate in a field of reputation if reputation points from one website are not convertible for use on another forum. Reputation of this kind might also be tightly bound up with the values of a particular community. How far I am influenced by a user's reputation might well depend on my understanding of how the user earned this reputation, how far I identified with the community that bestowed it upon them and thus how legitimate I perceived this indicator to be. As a user seeking to acquire reputation as a form of power, I might covet reputation on one forum, but have a negative or indifferent attitude towards it on another. Thus it is by no means clear that users of a plethora of sites and platforms can be relationally defined by a generalised form of online reputation.

Each of these examples illustrates the dangers of deploying field as a metaphor rather than an analytic method. The most ready adaptations of field to the Internet are those that tacitly accept pre-constructed categories of perception such as online or offline, social network site or online community, and construct the field within these boundaries. Such approaches miss out on the full potential offered by field in providing fresh insights into power dynamics surrounding the Internet. This is best articulated by Bourdieu, when he argues that, 'the notion of field does not provide ready-made answers to all possible queries, in the manner of the grand concepts of "theoreticist theory" which claims to explain everything and in the right order. Rather, its major virtue, at least in my eyes, is that it promotes a mode of construction that has to be rethought anew every time' (Bourdieu and Wacquant 1992: 110). Constructing the field afresh is possible by seeking out the struggles evident in a given context of practice, and tracing their boundaries (Bourdieu and Wacquant 1992). This is likely to promote a more complex picture in which digital power relations map out onto a variety of fields. Some struggles relating to digital sociality might span online and offline environments. Others might reside solely online, either within or across distinct communities and platforms. Alternatively, distinct online communities or platforms may also comprise a field. Situating the Internet within particular struggles and strategies in this way makes it possible to avoid constraining the scope of inquiry according to preconceived expectations regarding the nature of power struggles, and the role of digital mediation within these struggles.

Like field, habitus also offers interesting avenues for conceptualising digital social practice. While early Internet researchers made much of the opportunities afforded to individuals by the anonymity and disembodied nature of 'virtual' reality, particularly with respect to identity (Barlow 1996), habitus instead points towards the organisation of agents' thoughts, intuitions and emotions into a coherent, if not consistent (Wacquant 2013), whole. While agents adopt different strategies within different fields, habitus points towards the durable dispositions that build up over time, and how these shape the orientation agents have towards each new environment. In understanding digital practice, this is especially important, as it calls for research that contextualises the engagement of users towards the Internet with reference to personal histories and overall life trajectories by means of a methodological strategy that spans online and offline spaces. This perspective is important considering the continued academic interest in framing digitally mediated spaces in an emancipatory light. Application of habitus in this context encourages a nuanced and case-specific perspective towards online sociality, while also serving as a framework for ascertaining how any benefits accrued relate to users' positions in other fields.

Most interesting, however, is the tacit and embodied dimension to habitus. Bourdieu holds that dispositions are physically incorporated, habitual and manifest in attributes such as taste, mannerisms, gait and accent. At first glance we can identify possible counterparts in online practice. Choice of online pursuits, the grammar, vocabulary and spelling used in posting comments, the personalisation of post bits and public profiles, and levels of self-disclosure could arguably be interpreted as reflecting user dispositions. However, the nature of digitally mediated habitus is far from clear. For example, which dispositions and orientations do users import into online environments, given their relative disembodiment within these contexts? Furthermore, does this transition result in a reflexive recognition of dispositions, either carried forward or lost in transit? And if so, to what extent? It is of great significance if adaptation to online environments heightens reflexive awareness in users, yet the significance may be less pronounced if this reflexivity were very short-lived. On an a priori basis it is possible to imagine scenarios in which 'virtual' experiences may catalyse a marked reflexive awakening, but they may instead enable a far more limited and temporary reflection. Furthermore, even though users might consciously strive to identify methods for articulating features like identity or taste online, this would not necessarily alter the fact that these tastes or self-perceptions were taken for granted. To the extent that users grow habituated to particular online environments, habitus will prove valuable to Internet researchers by inspiring a concern for unconscious influences on practice, and pointing

towards the evolution of these influences. Meanwhile, any evidence of heightened reflexivity would represent an excellent opportunity for deepening our understanding of habitus and agency more broadly. It would also be strongly relevant to those concerned with the potential of the Internet for emancipation. Finally, while the absence of physical co-presence is of clear significance in the above discussion, habitus also demands a phenomenological concern for the physical influences and experiences pertaining to online practice. As Wacquant argues, 'carnality is not a specific domain of practices but a fundamental constituent of the human condition, and thus a necessary ingredient of all action' (2013: 12). A side effect of emphasising the disembodied features of digitally mediated sociality is that those aspects that continue to involve the body tend to be sidelined. Investigation of the physical sensations that characterise different kinds of online practice, be it gaming, tweeting or watching YouTube videos, may reveal important differences in users' orientations. Overall, while some features of habitus can be simply applied, there is much scope for testing out the extent to which habitus is altered by digital mediation.

CONCLUSION

We have seen how various preconceptions frame existing approaches to researching digitally mediated sociality and the power relations running through it. These include a reification of the newness of the Internet, and a tendency towards technological determinism in the definitions of social dynamics and power deployed. A Bourdieuian approach offers an alternative through constructing the research object according to different assumptions. No a priori significance is attached to the Internet, but instead a universe of collective hierarchical space is assumed. Human agents are objectively positioned by their relationship to different powers, rather than by their communicative ties. In opposition to methodological individualism, this perspective always refers to the collective social dynamics in understanding any individual instance of practice. Operationalisation of field, capital and habitus issues challenges to existing approaches to digital inequality, and opens up new issues for further study. A Bourdieuian interpretation of power indicates that no form of power should be studied in isolation, as its full functioning is not clear without reference to the local dynamics that command the balancing of multiple forms of power within a given field. Furthermore, it stresses the need for further recognition of symbolic and immaterial forms of power, in addition to more transparent forms. This is only possible with reference to the values and perceptions that users deploy

in practice. Field challenges the salience of dominant schemes of classifying the Internet by demanding an exploratory, practice-driven construction of social space. In many cases this runs across the division between online and offline domains. Field and habitus reveal the importance of historical processes, both collective and individual, for revealing the underlying order shaping digital practices. Habitus additionally opens up important questions about levels of reflexivity in users' digital practices, and the precise nature of their dispositions as well as their phenomenological experiences of this practice. Further work is needed to reveal the full range of logistical concerns implied in operationalising Bourdieu's approach within Internet research, but it is already clear that it provides valuable insights with regards to digital practices and power relations.

REFERENCES

Barlow, J. 1996. *A Declaration of the Independence of Cyberspace.* Retrieved 1 June 2014 from https://homes.eff.org/~barlow/Declaration-Final.html

Baym, N. 1995. 'The Emergence of Community in Computer-Mediated Communication', in S.G. Jones (ed.), *Computer-Mediated Communication and Community.* Thousand Oaks, CA: Sage, pp. 138–63.

Benkler, Y. 2011. 'Networks of Power, Degrees of Freedom', *International Journal of Communication* 5: 721–55.

Benson, R. and E. Neveu. 2005. *Bourdieu and the Journalistic Field.* Cambridge: Polity Press.

Benson, R. 2007. *After Habermas: The Revival of a Macro-sociology of Media.* Retrieved 1 June 2014 from http://steinhardt.nyu.edu/scmsAdmin/uploads/000/677/Benson%20ASA%202007.pdf

Bourdieu, P. 1972. *Outline of a Theory of Practice.* Cambridge: Cambridge University Press.

———. 1986. 'The Forms of Capital', in *Handbook of Theory and Research for the Sociology of Education.* New York: Greenwood, pp. 241–58.

———. 1998. *Practical Reason.* Oxford: Polity.

Bourdieu, P. and L. Wacquant. 1992. *An Invitation to Reflexive Sociology.* Cambridge: Polity.

Boyd, D. 2014. 'Why Snapchat is Valuable: It's All About Attention', *Social Media Collective.* Retrieved 1 June 2014 from http://socialmediacollective.org/2014/03/21/snapchat-attention/Brashears, M.E. and Z. Tufekci. 2014. 'Are We All Equally at Home Socializing Online? Cybersociality and Evidence for an Unequal Distribution of Disdain for Digitally-Mediated Sociality', *Information, Communication and Society* 17(4): 486–502.

Castells, M. 1998. *The Information Age: Economy, Society and Culture.* Oxford: Blackwell.

——. 2001. *The Internet Galaxy: Reflections on the Internet, Business, and Society.* Oxford: Oxford University Press.

——. 2009. *Communication Power.* Oxford: Oxford University Press.

Cavanagh, A. 2007. *Sociology in the Age of the Internet.* Berkshire: Open University Press.

Chadwick, A. 2006. *Internet Politics: States, Citizens, and New Communication Technologies.* Oxford: Oxford University Press.

Coleman, J. 1988. 'Social Capital in the Creation of Human Capital', *The American Journal of Sociology* 94: 95–120.

Consalvo, M. and C. Ess (eds). 2013. *The Handbook of Internet Studies.* Oxford: Blackwell.

Cook, J.M., M. McPherson and L. Smith-Lovin. 2001. 'Birds of a Feather: Homophily in Social Networks', *Annual Review of Sociology* 27: 415–44.

Crank, L. and K. Pigg. 2004. 'Building Community Social Capital: The Potential and Promise of Information and Communications Technologies', *The Journal of Community Informatics* 1(1): 58–73.

Ellison, N., C. Lampe and C. Steinfield. 2007. 'The Benefits of Facebook 'Friends': Social Capital and College Students' Use of Online Social Network Sites', *Journal of Computer-Mediated Communication* 12(4): 1.

Erel, U. 2010. 'Migrating Cultural Capital: Bourdieu in Migration Studies', *Sociology* 44(4): 642–60.

Habermas, J. 1984. *The Theory of Communicative Action Vol. 1: Reason and the Rationalization of Society.* Boston: Beacon.

Halford, S. and M. Savage. 2010. 'Reconceptualising Digital Social Inequality', *Information, Communication and Society* 13(7): 937–55.

Hargittai, E. 2002. 'Second-Level Digital Divide: Differences in People's Online Skills', *First Monday* 7(4).

Harvey, P., H. Knox and M. Savage. 2006. 'Social Networks and the Study of Relations: Networks as Method, Metaphor and Form', *Economy and Society* 35(1): 113–40.

Haythornthwaite, C. 2002. 'Strong, Weak and Latent Ties and the Impact of New Media', *The Information Society* 18: 385–401.

Haythornthwaite, C. and B. Wellman. 2002. *The Internet in Everyday Life.* Oxford: Blackwell.

Holbert, N., D. Kwak and R. Shah. 2001. '"Connecting" and "Disconnecting" with Civic Life: Patterns of Internet Use and the Production of Social Capital', *Political Communication* 18: 141–62.

Ikeda, K., T. Kobayashi and K. Miyata. 2006. 'Social Capital Online: Collective Use of the Internet and Reciprocity as Lubricants of Democracy' *Information, Communication and Society* 9(5): 582–611.

J-Young, K. 2006. 'The Impact of Internet Use Patterns on Political Engagement: A Focus on Online Deliberation and Virtual Social Capital', *Information Polity* 11: 35–49.

Kendall, L. 2013. 'Community and the Internet', in M. Consalvo and C. Ess (eds), *The Handbook of Internet Studies.* Oxford: Blackwell, pp. 309–26.

Lahire, B. 2011. *The Plural Actor*. Cambridge: Polity.

Lash, S. 2002. *Critique of Information*. London: Sage.

Livingstone, S. 2010. 'Interactive, Engaging but Unequal: Critical Conclusions for Internet Studies', in *Media and Society*, 5th ed. London: Bloomsbury, pp. 122–44.

Masum, H. and M. Tovey. 2011. *The Reputation Society: How Online Opinions are Reshaping the Offline World*. Cambridge, MA: MIT Press.

Miller, D. and D. Slater. 2000. *The Internet: An Ethnographic Approach*. Oxford: Berg.

Norris, P. 2004. 'The Bridging and Bonding Role of Online Communities', in *Society Online: The Internet in Context*. Thousand Oaks, CA: Sage, pp. 30–41.

Poster, M. 1990. *The Mode of Information: Poststructuralism and Social Context*. Chicago: University of Chicago Press.

Postill, J. 2011. *Localizing the Internet: An Anthropological Account*. Oxford: Berghahn.

Senn, M. 2013. 'Bourdieu and the Bomb: Power, Language and the Doxic Battle Over the Value of Nuclear Weapons', *European Journal of International Relations* 20(2): pp. 316–40.

Smith, A.D. 1999. 'Problems of Conflict Management in Virtual Communities', in M.A. Smith and P. Kollock (eds), *Communities in Cyberspace*. London: Routledge, pp. 134–63.

Sterne, J. 2003. 'Bourdieu, Technique and Technology', *Cultural Studies* 3–4: 367–89.

Terranova, T. 2000. 'Free Labour: Producing Culture for the Digital Economy', *Social Text* 63 18(2): 33–58.

Turkle, S. 1995. *Life on the Screen: Identity in the Age of the Internet*. New York: Simon and Schuster.

van Dijk, J. 2005. *The Deepening Divide*. Thousand Oaks, CA: Sage.

Wacquant, L. 2013. 'Homines in Extremis: What Fighting Scholars Teach Us about Habitus', *Body and Society* 20(2): 1–15.

Warschauer, M. 2003. *Technology and Social Inclusion: Rethinking the Digital Divide*. Cambridge, MA: MIT Press.

Wellman, B. 2001. 'Physical Place and Cyberplace: The Rise of Personalized Networking', *International Journal of Urban and Regional Research* 25(2): 227–52.

Wojcieszak, M. 2010. '"Don't Talk to Me": Effects of Ideologically Homogenous Online Groups and Politically Dissimilar Offline Ties on Extremism', *New Media and Society* 12(4): 637–55.

Richenda Herzig is a Ph.D. candidate at the Political, Social and International Studies Department of the University of East Anglia. Her research explores online reputation systems and the importance of symbolic capital for understanding digital practice. Richenda is additionally interested in digital labour, digital inequality and materialism. She is also a teaching assistant for the Universities of Cambridge and East Anglia, where she teaches social, political and media theory and sociology.

Chapter 7

Obtain and Deploy

Mobile Media Technologies as Tools for

Distinction and Capital

Justin Battin

INTRODUCTION

This chapter explores what is 'the work on one's self' (Bourdieu 1986: 244) through an investigation of the mobile media practices between three different media professionals based in Austin, TX (United States). My primary objective for this study is to unearth how these three participants use their mobile media technologies as tools to differentiate the self and secure cultural capital in their respective media industries. The project attempts to highlight not only the cognitively self-aware aspects associated with capital acquisition, but also the embodied pre-reflective actions as well. Furthermore, my secondary goal is to draw attention to how capital acquisition through the utilisation of mobile media technologies emerges from within the habitus, defined by Wetherell as 'past practices [that] become embodied in social actors so they acquire a kind of sediment of dispositions, preferences, tastes, natural attitudes, skills and standpoints' (Wetherell 2012: 105).

My intent is to reveal the practices these interviewees engage with to differentiate the self and acquire capital, which, 'for Bourdieu ... acts as a social relation within a system of exchange, and the term is extended to all the goods, material and symbolic ... that present themselves as rare and worthy of being sought after in a particular social formation' (Harker,

Mahar and Wilkes 1990: 1). However, capital also 'presupposes a process of embodiment, incorporation, which, insofar as it implies a labour of inculcation and assimilation, costs time, time which must be invested personally by the investor . . . the work of acquisition is work on one's self' (Bourdieu 1986: 244). This chapter seeks to reveal the nuanced intricacies of that investment.

METHODOLOGY AND INFORMATION ON PARTICIPANTS

Because the project explores the participants' experiential perspective with these technologies, I have selected a phenomenological approach for the project's philosophical foundation and its empirical techniques. However, because my interviewees' job obligations, to an extent, require social networking, I have also chosen to rely on what Kozinets refers to as netnography (see Kozinets 2010). Therefore, my investigation is not simply focused on extracting experiential accounts via discussion-based interviews, but also through the mining of social networking sites, such as Twitter, Facebook and Google+ for pertinent posts, comments, shares and photo/video uploads. The rationale for choosing this approach is because of its attentiveness to how much of our social world has gone digital and, as Kozinets explains, it is a 'form of ethnographic research adapted to the unique contingencies of various types of computer-mediated social interaction' (ibid: 20). I have chosen to incorporate this particular form of ethnographic investigation into the project because of the potential for immersive environmental activity without the pressure of my presence; the pressure that may arise due to my physical presence is, hopefully, alleviated when someone 'privately' interacts through digitally mediated domains such as Facebook, Twitter or Instagram. Kozinets suggests 'a "pure" ethnography could be conducted using data generated via face-to-face interactions and their transcription in field notes, with no data from online interactions. A "blended" ethnography/netnography would be a combination of approaches, including data gathered in face-to-face as well as online interaction' (Kozinets 2010: 65).

The project's first participant, Gene, is a producer and creative director at a prominent Spanish language media organisation in the United States. Gene considers himself a power user and is the owner of a Sprint Evo LTE, a smartphone equipped with an Android operating system. My second participant, Michael, is a freelance film-maker, writer and editor. He is also employed as the on-site media technician for a community college campus. Michael uses Apple's iPhone 5. Unlike Gene, Michael did not

intend to rely on his mobile media technology for work purposes due to the stationary nature of his position; however, despite this, it is still an instrument that remains with him at all times in case a situation calls for its use. The final participant, Claudia, is the short film programmer for South By Southwest (SXSW), the world's largest film, music and interactive media festival. Claudia's chosen instrument is also the iPhone 5. While only Gene characterised himself with the label of power user, based on my observations it was clear that these technologies have been incorporated into the lives of each participant far more than they may realise, a phenomenon made evident by the amount of mobile activity on social networks and passionate sentiments that emerged when discussing the manner in which it has infiltrated their lives.

The choosing of these three individuals as the sole participants is inspired by two specific rationales. First, each resides within close proximity to the other, so from a logistics standpoint my ability to meet with them was geographically convenient. Second, although they each work in separate industries, all come from similar socio-economic backgrounds and are recent graduates of the Moody College of Communication at the University of Texas, a nationally recognised comprehensive college that requires its students to collaborate on a variety of projects, both practical and theoretical, as well as diversify their strengths across several interrelated departments in order to better equip themselves for potential challenges they may face across a wide range of media industries. Because the project seeks to explore how mobile media technologies are utilised within media industries, I specifically targeted participants that displayed a diversification of skill sets across numerous media fields who possessed substantive experience with collaborative assignments. Finally, I desired a small sample simply so I could devote more time to creating a comfortable environment for the participants, thus permitting them to feel more at ease when revealing detailed information about their personal habits.

THE HABITUS – FRAMING THE STUDY

Proclaiming that mobile media technologies have permeated many aspects of our lives is a fairly obvious statement (29.5 per cent of the global population has an active 3G or 4G subscription (Mobile network statistics 2015)). However, the most fascinating aspect about these technologies is not necessarily their pervasiveness in multiple, diverse societies, but rather how these technologies become incorporated into a person's day-to-day activities and how they are deployed to fulfil a variety of motivations, eventually

becoming an inseparable and seemingly natural component of a person's self-perception. In previous works (Battin 2015a, 2015b), I have argued for the recognition of how the practical application of objects encourages a 'mergence' (Seamon 1979: 101) between the self and object and how through recursive practice this synthesis becomes a factor that influences how one moves through both the material and immaterial world. According to Nigel Thrift, the chief architect of cultural geography's non-representational turn, 'the human body is what it is because of its unparalleled ability to co-evolve with things, taking them in and adding them to different parts of the biological body to produce something, which, if we could see it, would resemble a constantly evolving distribution of different hybrids with different reaches' (2007: 10). A person's ability to forge amalgamative bonds with material entities is indicative of a person's investment with the things of the world. As Merleau-Ponty states, 'our relationship with things is not a distant one: each speaks to our body and the way we live. They are clothed in human characteristics and conversely dwell within us as emblems of forms of life we either love or hate' (2004: 49). This ongoing negotiated investment with the life-world, as Bourdieu proposes, can be viewed with the recognition of habitus, the modifiable memory pad that not only bridges the subjectivist and objectivist divide, but subsequently influences the naturalisation of cultural production and reproduction. Mobile media technologies, as devices that we encounter daily and carry with us, have simply become yet another taken-for-granted and ordinary aspect of life absorbed into our habitus (see Ling 2012).

Bourdieu defines the habitus as 'an infinite capacity for generating products – thoughts, perceptions, expressions and actions – whose limits are set by the historically and socially situated conditions of its production' (1990 [1980]: 55). Thus, when a person purchases an iPhone, tablet or similar instrument, the cultural fields, or the objective structures of a culture, such as economy, education and politics, in part, define its conventional use. However, while Bourdieu does advocate for this mode of structuralist thinking, he is also very insistent on the recognition of individual agency; the ability to improvise and negotiate ways of being whilst comprehending our own actions. Rather than prioritise either an objectivist or subjectivist model, Bourdieu sees the two in concert, always intertwined with the other. The important element to consider here is that while Bourdieu does maintain that a person's action, or practice, is always imbued by a person's agency, this must be contextualised through its relationship to cultural fields. With mobile media technologies specifically, while a person may deploy these technologies with full awareness of their potential uses and use value, these actions are simultaneously informed and limited by the cultural field(s) from which these actions both occur and are derived.

While the habitus is indispensable for many reasons, I find the most value in its prioritisation of embodiment. When performing with the world, particularly a world that is familiar, agents tend to move and relate to things in a taken-for-granted manner. When features of the life-world become embodied and taken for granted, they are simply absorbed into the collective flow, blend into the background and often go unquestioned. A sort of acceptance occurs that this is how things simply are; 'the natural and social world appears as self-evident' (Bourdieu 1977 [1972]: 164). As Webb, Schirato and Danaher point out, 'the most crucial aspect of habitus, then, is that it naturalises itself and the cultural rules, agendas, and values that make it possible' (2002: 40). While the habitus does inform our movements through the world, it does so in a way that blinds us to the crucial relations that encourage such a state. However, this innate feature does not imply that a person's habitus is permanently fixed; Bourdieu always maintained that the habitus is open to modification: 'dispositions are subject to a kind of permanent revision, but one which is never radical, because it works on the basis of the premises established in the previous state. They are characterised by a combination of constancy and variation which varies according to the individual and his degree of flexibility or rigidity' (Bourdieu 2000: 161). In the end, habitus maps out how modes of being-in-the-world become engulfed into a doxic attitude; however, it also provides a pathway to see how these contingencies take shape and continually reproduce.

Before unpacking the ethnographic material, it must be stressed that the participants are, first and foremost, employees with obligations to their employer. This simple distinction correlates to another Bourdieuian notion. Bourdieu regularly drew on Nietzsche's oft cited 'will to power' to advocate that an agent performing a purely disinterested act is a simple fabrication. Self-interest, whether recognised by the agent or not, is always in play. However, in no way does this manifestation of self-interest indicate malicious intent; a person's ongoing tactical manoeuvring to position the self in order to acquire capital is simply an intrinsic feature of the human condition. As Bourdieu posits, 'cultural capital can be acquired, to a varying extent, depending on the period, the society, the social class, in the absence of any deliberate inculcation, and therefore quite unconsciously' (1986: 244). For instance, one participant suggested that he draws upon common knowledge and previous experiences from within his industry to position himself as not only a quality employee with the foresight to improve methods of fulfilling job responsibilities, but also to gain notoriety for when he encounters representatives from other firms within the industry. Similar to attending university or learning a musical instrument, this interviewee is

simply trying to enrich and imbue himself with value. Therefore, his goal is not only to put the company in a position to succeed, but also his individual self. His mobile media use reflects this compulsion. As mobile media technologies become further entrenched into a person's habitus, the person, depending on the cultural field(s) that they inhabit, generates a practical sense for how to use these technologies for advantageous positioning. The people using these technologies develop an embodied sensibility for the best way to make use of them and incorporate them into their day-to-day life-world. However, it is critical to remember that an element that Bourdieu takes from Nietzsche's 'will to power' is how we never explicitly reveal our intentions; rather we mask our behaviour, often unconsciously, by equating it with common sense, inevitability or by using terminology such as 'it is good for the team'. While all action is interested, our interest must never overtly come across, otherwise we may appear selfish and calculating. Therefore, we must subdue any explicit sense of our interest.

Because we are all, at our core, self-interested, the goal with these technologies, in the context of these interviewees' job responsibilities, is to differentiate the self in specific ways that are recognised and, subsequently, rewarded with capital, which, as Bourdieu posits, 'is accumulated labour' that 'takes time to accumulate' (ibid: 241). Cultural capital is personified through three forms: the embodied, objectified and institutionalised state. The embodied form, which exists as 'long lasting dispositions of the mind and body' (ibid: 243), can be viewed within this study as the attitudes drawn upon and dispositions performed by each participant to differentiate the self. The objectified state, which typically takes the form of cultural goods, can be seen in this study as the person's chosen piece of technology. This instrument, after all, is a costly device and, if signing a contract, requires a credit score in good standing, thus excluding many people from potentially having opportunities to experiment with the technology and reap its benefits. Also, depending on where it is utilised, its mere presence possibly grants a sense of pizazz and cultural exclusivity to the user, particularly if possessing Apple's iPhone (I do recognise that a person's possession of an iPhone may also result in indifference or outright rejection due to the wide variety of opinions about the Apple brand). Lastly, the institutionalised form manifests in several ways, such as education and job position. These three forms of capital are not, of course, universally accepted; in order for capital to be recognised and granted, the possible carriers must reside and perform within a cultural field that values such distinctions.

TACTICAL APPLICATION

The first common thread between the three participants is that much mobile usage was performed for tactical reasons. What was considered tactical and how it revealed itself, however, was unique to each participant and the cultural field in which they reside; as Bourdieu suggests, 'dispositions do not lead in a determinate way to determinate action; they are revealed and fulfilled only in appropriate circumstances and in the relationship with a situation' (2000: 149).

For Gene, a realisation occurred when on a trip to Jalisco, a city in western Mexico. While passing through a market, he noticed two young indigenous girls selling handmade products. During their downtime, the two girls giggled amongst themselves about information accessible through their phones' Facebook mobile application. Gene suggested that, from his vantage point, the two girls flowed with the instrument in a way that insinuated a form of intimacy between the person and the technology; the two girls displayed a mergence between self and object. Gene proclaimed that viewings such as this, which have become commonplace throughout his travels, indicate how our very nature of socialising, maturing and consuming media as human beings has changed. Drawing from this example, he described that:

> To be successful in my world, you need to speak that language. My job makes me need to be at that forefront of this. The people that aren't are left in the dust. If you're not connected, your technical gap will be so great! You don't want to be left out, especially if your industry is dependent on creating revenue from this generation, which, of course, television is. (Gene (alias), producer and creative director, personal communication, 23 December 2013)

From Gene's perspective, aligning his being with his target demographic is the most effective tactical measure to employ. In order to accomplish this, he not only relies on the traditional methods of data mining, such as focus groups, questionnaires and ratings reports, but also his younger sister, now a first-year student at university, for first-hand accounts regarding how younger generations consume media. With this alignment, the goal becomes clear. Because television is still a medium funded primarily by advertising revenue, audiences must 'tune in' to generate profits. Luring audiences requires quality content; after all, content is what inspires dialogue; content, used liberally, is what Gene viewed the two girls discussing at their jewellery stand in Jalisco.

More significantly, however, Gene recognises that content is not the only important factor. With the variety of obligations people face in the modern

world, an aspect to consider is how people will reach the provided content and in what ways this content can then spread. Gene stated that his own practice is to binge his content at improvised intervals. He recalls that, 'my standard day begins with waking up in the morning and refreshing Twitter, Facebook and Google+ to see if there's anything pertinent worth consuming or sharing; then I get on with my day. I repeat this procedure a couple of times a day at random breaks' (Gene, personal communication). Drawing from his own use patterns, he proposed that to assume young people and young professionals, the target demographic in this instance, still follow a set schedule for most of their media consumption is a mistake infused with dire consequences. Rather, media entertainment is simply swept up in the flow of a person's daily life. While some forms of media broadcast still draw large audiences at a given time, particularly sports programming and reality contestant shows like *X-Factor*, a significant amount of content is consumed whenever possible, including traditional programming, particularly if this content is available via digital stream, such as a podcast. Gene stated that, when adopting the practices of his target demographic, an element that stood out to him was where broadcasted material should be available. Gene's target demographics, in today's world, are mobile and desire to consume media on their own terms. It is a generation that, due to a number of factors, desires the freedom to pursue media in ways that do not disrupt the flow of their specific life-world. If content providers are not flexible with how their programming is broadcast, then people will, for the most part, simply stop participating and either move to another provider or consume materials via illegal downloads/streams. From Gene's perspective, his own mobile media usage is partly inspired by a need to get to know his audiences, to stay relevant with how people consume and spread media to others; having a grasp of this phenomenon permits him to stay malleable and differentiate himself because his own practices provide an example of how the demographics the company wishes to reach, can be reached.

Another tactical manoeuvre employed by Gene is to reconceive the notion of office. While his company has provided him with an elaborate multimedia workstation, his office, per se, is not a physical location. Rather, his office location takes the form of informational and storage-based applications accessible through the cloud (the Internet). The ability to work through the cloud is key for productivity and the differentiation of self. He described that operating with an office free of physical constraints is beneficial because, in his own words, 'I can drop into any city and automatically be a pro as where to go, where to eat, where to stay, and all of my transactions take place online. Everything I have is strategically built into these apps' (Gene, personal communication). Gene's ability to be anywhere

and immediately be equipped to handle potential scenarios is an important distinction because of the flexibility it offers, particularly when meeting with clients. All that he requires is available via his Sprint Evo LTE smartphone. In particular, downloading Evernote – an application that permits a substantial amount of storage online, retrievable as long as the Internet is available – has been an invaluable decision. For instance, he claimed:

> I need access to information at any given moment, whether that is to find a quality restaurant to treat clients or showing a client a YouTube video or pulling up a document or script or using the camera on my phone to take notes or to document a certain area. In my field we're working with clients, the fact that I am so well connected and that I can use technology to my benefit, I think it really sells me as a knowledgeable candidate to give them great marketing advice or branding – the fact that I can be able to use technology to my advantage lets clients know that I would know how to communicate their brand message to other people, I think it shows on a fundamental level my communicational and organisational skills. (ibid)

In the end, Gene's tactical utilisation of his Sprint Evo LTE manifests itself in two forms: first, in the aligning of being, achieved by being attentive to the use practices adopted by his target demographics; and second (because he often travels and meets with potential clients) by being both prepared and adaptable in carrying the benefits of a traditional office within one small technological instrument.

Like Gene, Michael's tactical use was about improvisation, albeit in ways that permit cost reductive and time-saving measures. As a freelance film-maker, Michael finds the iPhone a beneficial tool because it permits impromptu location scouting and note-taking. During our discussion, he stated, 'you could simply take photos of places to shoot if you're out and a place catches your eye. All you have to do is stop and click, click, click. The quality of the camera is pretty good too; it's not my Nikon, but it's good' (Michael (alias), personal communication, 15 January 2015). Prior to owning an iPhone, Michael would often have to conduct location scouts with a larger, more cumbersome camera and, in part because the camera cannot simply be left in the car unattended, he had to schedule time to fulfil these obligations. Now, with an iPhone, if Michael is driving through town and notices an ideal filming location, he can quickly park the vehicle, jump out and take a few photographs for later analysis. The benefit of the iPhone, for Michael, is that it allows for flexible, improvisational modes of pre-production. Rather than set aside time to drive around and scout for areas to shoot, he can perform these duties on the fly in a manner easily incorporated into regular patterns of life activity, a benefit that opens up opportunities

for him to engage with other obligations or happenings. Additionally, the presence of the mobile is advantageous in that it not only assumes the role of camera, but also a notepad. Because Michael is also a writer, he often seeks new ideas or ways to amend previously conceived stories and the presence of an iPhone with numerous applications suited for note-taking, in Michael's estimation, gives him a tactical advantage because any spontaneous idea or occurrence can immediately be jotted down for later use.

Film-making aside, Michael said that his iPhone provides benefit for his technician job as well. If instructional equipment goes awry, he finds that the iPhone is a useful and reliable tool that permits him to efficiently diagnose and solve equipmental problems. In particular, because of the device's small stature, it can easily be positioned behind a television to take a photograph of the minute model number. Then, by using the contents contained within the photo Michael is able to use an installed application to quickly identify the steps necessary to resolve the dilemma. For Michael, the improvisational qualities offered by his iPhone and the benefits that it provides are what stimulate the differentiation of self. He can adapt, document, explore and quickly find solutions for everyday problems, particularly in the purview of others.

The final participant, Claudia, claims that she is 'an organisational addict. I love being strategic about utilising technology to improve my work and personal efficiency' (Claudia (alias), personal communication, 15 April 2014). Claudia discussed that because she travels often her iPhone is imperative for managing the day-to-day activities in her life. In her own words:

> [I like] to improve transportation and travel so I use apps to locate Austin's car and bike share vehicles near me, as well as apps that help me determine my per diem based on location, track pesky confirmation numbers for travel plans like flights, car rentals and hotel rooms and find out which baggage claim carrousel my bag will come out on while I'm still on the plane. Eliminating the time wasted stopping to check if your flight has been delayed or changed gates or pull out your printed hotel confirmation is like organisational crack to me. This carries over to simple things that can be done more efficiently on an application, like buying movie tickets, ordering smoothies, placing an order for to go food, refilling prescriptions by barcode scan, or checking the yoga schedule. It's all strategically designed to help save time and eliminate stress when you're on the move. For me, it's all about improving the ease of movement through life and work. (ibid)

While Claudia principally described how the iPhone directly relates to her work obligations, she also mentioned that there are other uses that, while not tied to SXSW, unquestionably assist in maintaining a healthy and

stable lifestyle, which, in turn, encourage a more positive attitude overall that carries over to other aspects of her life, including her work. For instance:

> I use my device for a few unique things, specifically an app that logs and tracks my daily meditation practice and a custom reminder that pops up to tell me to be nice to my boyfriend when I get within a mile radius of our house. That nudge to be mindful of how I treat him is especially helpful when I've had a stressful day at work. (ibid)

Unlike Michael and Gene, whose usage is mostly geared towards improvising and being adaptable, Claudia has organised her device to improve her efficiency. However, similar to Gene and Michael, Claudia's motivation is inspired by a desire to differentiate the self and improve her overall standing within her company. She humorously joked that, because of the organisation it permits, in addition to how it helps relieve stress, the technology 'allows [her] to be the best employee of all time' (ibid).

THE SELF AS BRAND – BUILDING VALUE

Another principal similarity between the participants is the way that their mobile media usage permits the construction of self in terms of branding. Each person, as Goffman writes, 'when in the presence of others . . . [works] to convey an impression to others which it is in his interest to convey' (1959: 15–16). People actively work to position the self in a light that brings value. Thus, when a person considers their self with a brand-like mentality, the person is charged with creating positive associations and linking these with the self.

Gene, the self-proclaimed power user, regards his Sprint Evo LTE as a tool that provides benefit because it allows him to continuously construct and monitor words, ideas and images affixed to his brand image (principally his social networking persona). For him, how a person positions the self in terms of positive associations, in this particular industry, is vital. With this piece of technology, he says:

> I feel like I have the advantage, the upper hand, over someone not using that social network or not maximising their phone's hard drive. I think in my industry I create value, whether real value or perceived. I think being able to demonstrate this to colleagues and clients when they see that I'm really fine-tuned with devices and social media platforms, it creates a sense of authority. I am the right person to move your brand forward. (Gene, personal communication)

One way that Gene demonstrates his brand is through social media applications accessible via his Sprint Evo LTE. When using social media in his industry, the user needs to remain intuitive about what sort of information is presented on their various pages. When thinking about the self as brand, Gene mentioned that, while he possesses no qualms about cats, babies or photos of parties, those posts will not create value or move him forward in his industry. He states:

> Our generation is unique because we have been thrown into social media. We have set the rules. Initially it was about connecting with other people; now it is about evaluating other people. I post every day because I know that peers in my industry are evaluating my social media. People are interested in how you relate to things, what you are working on. It becomes both an industry trade magazine and a person dossier. I know out of habit when I think of other talented people, scouting for talent or looking at other people to join my team to collaborate with, my initial thing is to look them up and see what they're about. Does this person have a Facebook presence or are they simply speaking to no one? For better or worse, it has a big deal with how you receive people. I could be uploading photos of a party, but instead I will share a link about Amazon's new drone shipment methods. I keep it very safe. I ask myself, before I post anything, what value does this bring to other follows or to other people in my network? It is completely limited, the amount of sharing that I do. It keeps me from posting inane material. A value judgement is made when I post. (ibid)

For Gene, using social media through his Sprint Evo LTE smartphone is motivated by the need to showcase himself in a positive light. His comments encouraged me to investigate what exactly was displayed on his page. Primarily, aside from a few photos of Gene with his fiancé or check-ins at 'hip' locales, his Twitter and Facebook pages promote work-related projects or events and consist of what he perceives as pertinent information (such as breaking news on Malaysian flight MH370). Often these posts are accompanied with a hashtag so it is capable of being seen or shared by others. These posts are uploaded with intent to not only share information, but also to present a particular self for others. While he is a person performing on a social network, he is also an ongoingly constructed brand laden with meaning.

Like Gene, Michael also actively fashions himself as a brand; however, rather than focus on aspects intended to correlate back to work, Michael seeks to bridge together select aspects of his identity. He explained to me:

> My iPhone allows me to stay around hobbies I enjoy. People can then look at my social media and know that I go to concerts, people know I get tickets

to shows, people know . . . I don't want to say that I have created this percep-
tion, but the perception definitely might be there. I always go to these shows
and they are exclusive. My brand image is mostly because of my phone. I go
to a show, I take a picture, film a clip, tweet from there. You can go to a show
and check-in on Facebook from there. People probably know I like BBQ too,
mostly because I tweet about it a lot, especially if I'm in the middle of having
BBQ! I'll tweet photos and check-in. A lot of it just comes from checking in and
taking about stuff. It is a sort of bragging and while I hate that term, I'm not
a dick about it. It is vanity masqueraded through subtlety. (Michael, personal
communication)

When Michael uses his phone to interact with social media, he carefully
selects certain topics to post. These uploads not only provide evidence of his
hobbies, but also insinuate an authority regarding these hobbies due to the
sheer amount of posts and rich commentary about said hobbies. A careful
examination of his Facebook and Twitter page revealed that Michael often
posts about topics pertaining to BBQs, the San Antonio Spurs basketball
team, and music shows he has attended. On Twitter, in particular, Michael
often retweets information to his followers that build on his desired brand
image. He says, 'I may retweet something on film-making. People follow me
on Twitter just because award-winning film-maker is in my biography and
I feel sort of obliged to maintain that presence' (ibid). Through his social
networking, maintained while mobile and in situ, Michael positions himself
as someone 'in the know', a person with knowledgeable expertise regarding
a few select topics.

CONCLUSIONS

Wrapping up, it is clear that mobile media technologies can be used as tools
to acquire capital and distinction. My usage of the term capital in this piece
is, admittedly, a bit broad. To clarify, each of these participants engages in
practices in particular contexts that provide them with both social capital
and cultural capital (specifically in the case of the iPhone, which, as a pro-
lific and recognisable brand, is loaded with symbolic meaning). However,
my use of the term capital also implies how it becomes a tangible benefit
deployable for the bearer of said capital. Accumulated social and cultural
capital becomes a weaponised tool capable of advancing the self when
tactically deployed in specific cultural and social contexts. However, as
Bourdieu suggests, while capital acquisition and deployment occurs via
cognitive awareness, it often occurs unconsciously and the bearer's actions
are thus not performed deliberately or maliciously. As the project fieldwork

indicates, people use these technologies purposefully in daily life to demonstrate abilities or knowledges affixed to their self in order to be recognised for how they stand apart from others. Each attempts to forge positive associations with certain qualities, aptitudes and ways of being. The purpose of demonstrating this differentiation is because it, depending on the cultural field and particular situation, highlights specific values that grant the user cultural capital. This phenomenon certainly extends beyond these three employees as well. Social networking sites provide an extensive arena to view how people are using mobile media technologies to continuously monitor and construct the self in ways that, from their vantage point, will enrich them with capital.

The reason for this exploration is primarily inspired by Bourdieu's insistence on reflexivity; the need to break with or bracket the seemingly natural attitude, or what Husserl coined *epoche*, a method where one suspends judgement about everything in the external world (see Moran 2000: 146–52). When bracketing the natural attitude, these technologies are no longer neutral objects that reside with us, but objects that, when utilised in a variety of cultural contexts, produce value. As Bourdieu states, 'the social world is accumulated history, and if it is not to be reduced to a discontinuous series of instantaneous mechanical equilibria between agents who are treated as interchangeable particles, one must reintroduce into it the notion of capital and with it, accumulation and all its effects' (1986: 241).

When a person uses these technologies, whether it is an iPhone, Android or tablet, a motivation exists; no act is ever disinterested. What we must consider, however, is that as these technologies continue to become more pervasive in modern culture(s), what sort of power relations will manifest? Also, certain cultural fields widely considered savvy, such as media(s), will also have a prominent voice in how these technologies develop and move forward. Those within these fields, or those who interact with them on a semi-regular basis, will be more equipped to adapt, to use these technologies in tactical ways to further position the self advantageously. Additionally, mobile media practices will become further naturalised, masking their role in culturally producing and reproducing power. The technologies themselves come to be seen as part of a person's compositional makeup, rather than a tool embedded with power relations.

It is clear that these technologies have been widely embraced and incorporated into several aspects of daily life. Whether one is an active participant is inconsequential because, as Ling (2012) demonstrates, one must deal with a world that for the most part has accepted these technologies into the everyday social ecology. Gene explained that those who are willing to evolve with the technology will become more comfortable with

the 'software shell' and speculated that the next great device will drop the phone label and become regarded as a personal device. The device will be something wearable and will no longer require pulling it out and powering it up (we have now already witnessed the first phase of this with the release of Apple's iWatch in 2015). It will appear as though we interact less with it because its features will be far more seamless. Plus, the device will be one that can filter information for the user. He proposed that, 'at the moment, there's so much information out there and it's nearly impossible to wade through it. Our devices are learning our habits, whether it's advertising or consumption, they'll be able to filter through all this world of information and give us exactly what suits us, what will put us in a position to succeed' (Gene, personal communication). While this might seem exciting to those already possessing the capacities to maximise their chosen technology, it is simultaneously concerning because those who are currently proficient possess greater opportunity to become more adept and more capable to exploit these technologies, while those who lack the means to participate will, most likely, become further entrenched in their position.

In closing, despite the perceived benefits being brought to these users, each exhibited varying levels of hesitancy with regards to involvement. While each participant demonstrates an awareness of how invaluable their mobile technology is for the work on one's self, they also expressed trepidation regarding its intrusive nature. Gene states that he simply *has* to use his phone and its connections to social media in order to be successful in the television industry; embrace the technology and the lifestyle or you will fail; no other option exists. Michael, additionally, expressed that:

> It's almost like a necessity in our day and age. You need to have it, people expect you to be contactable 24/7. I really don't like that. Actually, I feel like I have this thing with me at all times as an obligation to other people. All the things I really enjoy about it, the camera, the notepad, it all stems from this obligation to others. I have this thing and I love gadgets, but I have it mainly so someone can contact me and I don't love that, I just know it's expected of all of us. If I could get away with not having this thing, I would. On days when I forget my phone, at first I'm like, 'oh shit, someone may need to call me', but I'm not worried about calling anyone else though. It's a device I keep out of an obligation to others. Any of the benefits that come from it I could probably replicate on my iPad and be less connected. Really, I worry about people relying on forms of phone-based communication to augment their experience. (Michael, personal communication)

Furthermore, Claudia articulated concerns as well. Claudia asserted that while she loves that she can work from anywhere at any time, she is not

convinced that the level of focus is the same when utilising this particular instrument. She proposed that it might not necessarily make us better at our jobs and that sometimes mental health and personal relationships do suffer because of how it functions as both a convenience and a curse (Claudia, personal communication).

Despite this hesitancy, people are still using these technologies and further incorporating them into their lives. They have accepted that most societies have moved in a direction where these technologies are necessary for daily living. However, I question this proposition. It is not that these technologies are imperative devices to get on with life. Obviously there are modes of being that can exclude various technologies. However, to be valuable in life, in specific cultural contexts, these technologies are instrumental. More so than any piece of technology we regularly encounter in the modern world, mobile media technologies perhaps above all speak to what Bourdieu referred to as the power of capital 'to persist in its being' (Bourdieu 1986: 241).

REFERENCES

Battin, J. 2015a. 'Mobile Media Technologies and Unconcealment: A Phenomenological Ethnographic Investigation', Ph.D. dissertation. University of Sunderland.

——. 2015b. 'Practical Uses and the Unconcealment of Worldly Investment: A Heideggerian Inspired Investigation into the Embodies Uses of Mobile Media Technologies', in C. Bassett, R. Burns, R. Glasson and K. O'Riordan (eds), *The Tablet Book*. Falmer: REFRAME Books [PDF Version].

Bourdieu, P. 1977 [1972]. *Outline of a Theory of Practice*. Cambridge: Cambridge University Press.

——. 1986. 'The Forms of Capital' in J. Richardson (ed.), *Handbook of Theory and Research for the Sociology of Education*. Westport, CT: Greenwood, pp. 241–58.

——. 1990 [1980]. *The Logic of Practice*. Palo Alto, CA: Stanford University Press.

——. 2000. *Pascalian Meditations*. Stanford, CA: Stanford University Press.

Goffman, E. 1959. *The Presentation of Self in Everyday Life*. London: Penguin Books.

Harker, R., C. Mahar and C. Wilkes. 1990. *An Introduction to the Work of Pierre Bourdieu*. London: Macmillan.

Kozinets, R. 2010. *Netnography: Doing Ethnographic Research Online*. London: Sage.

Ling, R. 2012. *Taken-For-Grantedness: The Embedding of Mobile Communication into Society*. Cambridge, MA: MIT Press.

Merleau-Ponty, M. 2004. *The World of Perception*. Abingdon: Routledge.

Mobile Network Statistics 2015. Retrieved 24 January 2016 from: https://mobiforge.com/research-analysis/mobile-networks-statistics-2015-0.

Moran, D. 2000. *Introduction to Phenomenology*. London: Routledge.

Seamon, D. 1979. *A Geography of the Lifeworld: Movement, Rest, and Encounter*. New York: St. Martin's.

Thrift, N. 2007. *Non-Representational Theory: Space, Politics, Affect*. Abingdon: Routledge.

Webb, J., T. Schirato and G. Danaher. 2002. *Understanding Bourdieu*. Crows Nest, Australia: Allen & Unwin.

Wetherell, M. 2012. *Affect and Emotion: A New Social Science Understanding*. London: Sage.

Justin Battin is an invited associate professor at the University of Bogotá – Jorge Tadeo Lozano in Colombia. His research interests are primarily geared towards how mobile media technologies intersect with phenomenological interpretations of dwelling, embodiment and inhabitation. Justin's recent research output includes acting as co-editor in a yet to be titled collection that merges media-centric concepts with the philosophy of Martin Heidegger (co-edited with German Duarte, forthcoming, 2016) and a chapter in *The Tablet Book* (REFRAME, 2015).

Chapter 8

Weak (Cultural) Field

A Bourdieuian Approach to Social Media

Antonio Di Stefano

INTRODUCTION: BOURDIEU AT STAKE IN THE ERA OF SOCIAL MEDIA

The objective of this chapter is to discuss the potential of Pierre Bourdieu's microtheory of power (Moi 1991; Di Stefano 2013) and cultural field theory in investigating both the social media environment and Internet power. The chapter seeks to promote an approach to specific properties of Bourdieu's work that take them as a point of departure, and as a means for generating new questions about (new) social media context. Relatively little attention has been paid by new media researchers to Bourdieu's own theoretical work on the cultural field. In some cases, appropriation has been overly selective and has led to an underestimation or a misunderstanding of his work. Although the French sociologist has been one of the most quoted scientists in the field of cultural sociology (Santoro 2011: 5), capable of equalling and outweighing in the number of citations important social scholars like Goffman, Giddens, Bauman, and Elias, and his work has successfully been applied to the analysis of many social domains (Lamont 2012: 229), there appears to be no (manifest) applicability of Bourdieu to better understand the character of digital interaction patterns. More specifically, even though his categories of cultural and social capital (Ellison, Steinfield and Lampe 2007), distinction (Boyd 2008; Liu 2008) and habitus (Papacharissi and Easton 2013) have been adopted to explain and analyse structural and technological factors impacting the behaviour that users exhibit in online

communities, cultural field has been a marginal concept in sociological investigations of social media. In fact, only a small number of communication scholars (Benson 1999; Couldry 2003; Hallin and Mancini 2004) have embraced his relational thinking by developing a new paradigm for media studies and depicting the functioning of media systems (e.g., the journalistic field). This is because Bourdieu failed to incorporate the media into his theory of culture, while his study on television (1998) appeared to be excessively polemical (Hesmondhalgh 2006: 211).

Accordingly, in order to carry out a deeper investigation of the aforementioned aspects, I have three main objectives: first, to explain the most common causes of such difficulty, by focusing on the relationship between intrinsic properties of social media environments and the most frequent patterns of their sociological representation.[1] Second, I will underline the potential application of the Bourdieuian analytical category of the cultural field, with the aim of disclosing the structure behind online social networks and, mainly, the objections against Bourdieu's idea. In fact, the cultural field has been charged with being a metaphor rather than a simple descriptive term, turning people acting inside its own borders into caricatures (Becker and Pessin 2006: 276–77), and providing an inappropriate outline of interactions taking place within it, as they appear to be exclusively relations of domination (de Nooy 2003: 323). Third, I will develop a hybrid term – weak field – that is capable of recovering both the relational/positioning logic of the cultural field and the networking property of social media environments. In the following pages I discuss ways in which weak field can be adopted as a tool for investigating social media contexts.[2] Therefore the following chapter involves assuming an intellectual position towards Bourdieu's work that can be summarised as being both a selective appropriation and a constructive criticism of the French sociologist's project (Santoro 2011: 16).

BOURDIEU AND SOCIAL MEDIA: A FAILED ENCOUNTER?

Before analysing the ways in which Bourdieu's theories have been employed by Internet researchers to explain and describe social worlds that he himself did not include in his contribution to field theory, the spread and growth of his own work among scholars dealing with social media and online practices merits some attention, because research on actual dissemination of Bourdieuian categories in this domain is still lacking.

Some empirical investigations have shown Bourdieu's impact on several sociological contexts. In retracing the reception of his work among social scientists in the United States between 1980 and 2004, Sallaz and

Zavisca (2007) found in their analysis of references to Bourdieu in four important sociology journals that the forms of capital (especially cultural and social capital) have been dominant concepts in comparison with other Bourdieuian analytical categories such as field and habitus, and that a steady increase in the influence of Bourdieu's work on American sociology took place over this time period. Moreover, in 2008, *Sociologica*, an Italian journal of sociology, published a symposium dealing with the international circulation of Bourdieu's theory, with contributions addressing the diffusion of Bourdieuian work across different sociological contexts (see, e.g., Sapiro and Bustamante 2009; Robbins 2008).

None of these investigations, however, is concerned with the reception of Bourdieu among those scholars primarily studying the Internet and online environments. In order to bridge this gap, we will illustrate the ways in which Bourdieu's analytical concepts have been quoted and adopted in articles published by two influential Internet-oriented journals since 2005.[3] Although this is not a thorough examination of the spread of Bourdieuian categories across this field of study, it is able to provide an initial mapping of the propagation of sociological concepts such as capital, habitus and field within a (social) media research domain, by deploying methods both quantitative (an empirical investigation of citation patterns) and qualitative (a deepened analysis of specific articles).

Four indicators of the spread of such concepts were considered: the number of articles citing Bourdieu, the number of citations per article, the level of variety of Bourdieuian categories that are mentioned in the articles, and the level of analytical depth of citations quoting Bourdieu's work. We compiled a database of all articles published in two communication journals between 2005 and 2014, namely *New Media & Society* and *Journal of Computer-Mediated Communication*. The reasons for this choice are as follows: firstly, these journals are characterised by a high influence in the field, according to their impact factor and the Communication Index; secondly, their different editorial positions (NM&S is a more generalist journal, while JCMC is more specialist) are expected to provide an overview of the most frequent patterns of reception of Bourdieu's concepts.

The aforementioned database was comprised of 1,193 articles (NM&S: 774; JCMC: 419) from which we extracted all that cited the French scholar at least once, generating a total of 92 articles (NM&S: 68; JCMC: 24) – that is, 7.7 per cent of all articles published from 2005 to 2014. This is a noteworthy and surprising result only if compared with the outcome (5.8 %) that Sallaz and Zavisca (2007: 26) observed – as we have seen above – by analysing Bourdieu's reception in a particular sociological field, and if the popularity of the French sociologist underwent a direct comparison with other

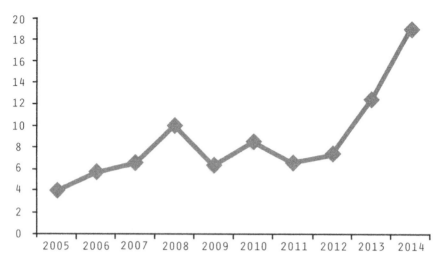

Figure 8.1 Percentage of all articles (NM&S, JCMC) citing Bourdieu's work per year

* It should be noted that the percentage of articles citing Bourdieu at least once is proportional to the total number of articles published until April 2014.

important social scholars over this time period. In this regard, the diffusion of Bourdieuian work, at least as far as it can be measured comparatively by looking for the number of citations of a sample of influent contemporary authors, confirmed that his own reception is influential with other sociologists' performance. In fact, contrary to what could be expected, Bourdieu is an established reference in NM&S and JCMC – that is, a 'quantitative presence', which is similar to that of important sociologists such as Goffman (104) and Habermas (93), while it exceeds Giddens' reception (65).

At first sight, Figure 8.1 appears to suggest, in keeping with Sallaz and Zavisca's findings about Bourdieu's spread in the American sociological context, that his presence in the field of Internet studies is surprisingly steady. Our data seem to demonstrate an increasing trend in the impact of the French sociologist since at least 2005.

For these data to be more meaningful, however, further investigations are needed. In fact, the citation patterns that are most frequently employed by Internet researchers outlined a critical and complex reception process. It is enough to look at Table 8.1, which provides interesting insights into the 'quality' of scientific adoption of Bourdieu's theoretical framework. Most articles (55.7 %) mentioning his writings are characterised by a low level of engagement with his concepts that, as a result, are not used to design new empirical research or to develop debates in this field of study. For these

Table 8.1 Different citation patterns regarding reception of Bourdieu's categories

	Low	Middle			High	Total*
	1**	2–3	4–5	6–7	7>	
Journal						
JCMC	62.5%	25%	0%	0%	12.5%	24
NM&S	55.9%	26.5%	7.3%	1.5%	8.8%	68
Total	57.6%	26.1%	5.4%	1.1%	9.8%	92

* 'Total' refers to amount of articles citing Bourdieu per journal.
** The numbers indicate the amount of Bourdieu citations per article (list of references excluded).

Table 8.2 The reception of Bourdieu's key concepts

	Capital	Habitus	Field	Other	Total
Journal					
JCMC	60%	11.4%	2.9%	25.7%	35*
NM&S	38%	5.1%	16.4%	40.5%	79*
Total**	55.4%	8.7%	15.2%	44.6%	92

* In this case, 'total' does not refer to all articles citing Bourdieu at least once, rather it shows the total number of times all Bourdieuian categories have been cited.
** It must be remembered that a single article may cite more than one concept.

reasons we argue for a deeper analysis of the correlation between citation patterns and the scientific profile of the author writing an article. In addition, a comparative investigation into other sociologists' reception would be useful to make the hidden causes of this difficult adoption of Bourdieu easier to understand.

Although these are 'only' quantitative data, they would appear to imply that Bourdieu's work has been introduced unreflexively into the field of study devoted to the Internet, by treating it as a traditional research programme. In other words, Bourdieu's concepts encountered many obstacles before being applied to new empirical domains. It was expected that capital would be the most quoted Bourdieuian analytical term (Table 8.2) in that it constitutes, mainly in comparison with the concepts of field and habitus, a mainstream category or, more precisely, a 'bridge-category'– that is, a sociological concept capable of establishing a scientific dialogue with the vocabulary of social media literature, which is full of terms such as 'connection', 'relation', 'social network', 'resources' and so on.

Table 8.3 The reception of Bourdieu's capital

	Cultural	Social	Economic	Symbolic	Total
Journal					
JCMC	25%	50%	15%	10%	20*
NM&S	40%	50%	6.7%	3.3%	30*
Total	18.5%	27.2%	5.4%	3.3%	92

* Indicates total number of times (one per each form of capital per article) Bourdieu's forms of capital have been quoted.

Not surprisingly, more than 1 out of 4 articles quoted social capital as Bourdieu's key term (Table 8.3).[4] This result appears to be influenced by a common representation of online networking spread among media researchers (with a shared disposition to mainly depict and outline users' practice as a networked performance), and seems also to reflect the increasing interest in social capital across different sociological subfields (Sallaz and Zavisca 2007: 29).[5]

What emerges from these analytical uses of the Bourdieuian theoretical project is a problematic and 'unsatisfying' pattern of reception. In fact, firstly, the relational approach in adopting his categories, suggested and proposed by Bourdieu himself, appears to be marginal or peripheral in the articles citing his concepts. Secondly, Internet researchers, in mentioning such categories, are likely to adopt mainly his mainstream works such as *Distinction* and *The Forms of Capital*, by forgetting or disregarding other important texts; for example, those devoted to cultural reproduction or education, in which Bourdieu began to address and develop the larger and complex topic of capital. However, another factor that is worth discussing is that the reception of Bourdieuian categories assumes a long tail structure (Figure 8.2). The mainstream concepts of Bourdieu's framework (capital, habitus, and field) have been quoted in 79.3 per cent of all articles, whereas the whole number of other terms that, of course, should not be considered as second-class categories (e.g., practice, symbolic power) have been cited in 44.6 per cent of cases. This kind of dispersion would seem to reflect the overall complexity of Bourdieuian theory, which encompasses several meaningful concepts while following one paradigmatic proposal (the structuralist one).[6]

As we have underlined above, further investigations are needed, and particularly it would be advisable to analyse in some depth both the scientific profile of scholars engaging with Bourdieu's ideas, with the aim to determine whether a possible relationship exists between interdisciplinary

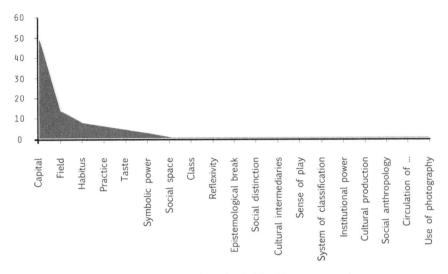

Figure 8.2 Bourdieu's long tail within the field of Internet studies

membership and uses/misuses of specific theoretical frameworks, and the structure of the field of study. Thus, attempting to answer the question raised at the beginning of the chapter, one is tempted to say that in social media literature Bourdieu's work has been adopted with some contradictions, which is not a negative aspect in itself. In fact, it would have been a more critical reception if he had not been quoted at all. All the same, specific research areas within Internet studies have shown themselves particularly refractory to Bourdieuian categories, which is confirmed by a prevailing attitude to ignore or disregard those fundamental concepts (habitus and field) comprising a large proportion of Bourdieu's sociological architecture. However, at this point of the research, suggestions and hypotheses exceed empirical responses. In fact, data at our disposal do not allow us to know if the authors of the aforementioned articles citing Bourdieu had been driven in their choice of references by a predetermined belief in the negative/positive value of the Bourdieuian paradigm, in comparison with other proposals, or by their objects of study.

WEAK CULTURAL FIELD, OR HOW BOURDIEUIAN RELATIONALITY MEETS THE SOCIAL MEDIA ENVIRONMENT

These results obviously do not offer a representative explanation and outline of Bourdieu's reception in the field of Internet studies as a whole.

However, they sketch out a preliminary, explanatory framework capable of identifying some common patterns of adoption of Bourdieuian work among those scholars dealing with new media. For the purposes of this chapter, the key point here is that the concept of field, as well as of habitus, has been underestimated in the two journals considered for the analysis. One may argue that, actually, few scholars have employed Bourdieu's relational process to investigate and describe social practices taking place in social media environments. But, as we have underlined above, this kind of result could have been foreseen to some extent. There are several explanations for the difficult reception of Bourdieu's theoretical framework within the boundaries of the field of media and Internet studies, although it should be noted that these scholarly domains have internalised Bourdieuian proposals in a different way that is neither necessarily comparable nor interpretable as a homogeneous process.

Given these premises and the aforementioned results, might one claim that Bourdieu is a minor scholar in the field of Internet studies? And that particularly cultural field is a secondary category in the literature focused on social media? In seeking to respond to these questions, one might develop a deeper knowledge of Bourdieu's actual influence on the communication field, and his potential application to explain the structures behind online social practices, by recovering what Moi (1991) stated about his general theories of the reproduction of cultural and social power. According to Moi, some aspects of Bourdieu's proposal are not radically innovative, in that his general theory of power does not outweigh in originality that of a Marx or a Foucault, and his explanation of the modes through which individual subjects come to internalise and identify with dominant social institutions appears in some ways similar to the Gramscian theory of hegemony. However, on the other hand, Bourdieu's originality can be found in his development of what one might call a microtheory of social power: 'where Gramsci will give us a general theory of the imposition of hegemony, Bourdieu will show exactly how one can analyse teachers' comments on student papers, rules for examinations and students' choices of different subjects in order to trace the specific and practical construction and implementation of a hegemonic ideology' (Moi 1991: 1019).

A microtheory of power allows us to focus our analysis both on the specific domains in which power is actualised, and on the specific practices and strategies of power taking place in these domains. 'Micro', in Bourdieu's work, refers to forms of empowering or disempowering that support or deny the individual provided with or lacking the right form of capital. In this regard, especially, but not only through the notion of cultural field, a microtheory of power could be effectively realised by evaluating the impact

of structural forces on the actualisation of subjective practices (also in a social media context). In more detail, Bourdieu's field theory provides the possibility of analysing the new media environment by linking online practices with macro features of fields ('relations to political and economic fields, and dominant internal logics or "rules of the game"' (Benson 2009: 403)) as well as internal field differentiation (the specific cultural logic of a social network site).

Bourdieu identified three main criteria needed to eventually determine a field – that is, (1) the possibility of pointing out differentiated agents positioned in relatively stable relations (of power) with each other; (2) the existence of a certain amount of autonomy; and (3) the possibility of demonstrating the existence of – or maybe, more precisely, demonstrate the effect of the existence of – a form of capital that is specific to the field (Bourdieu and Wacquant 1992; Bourdieu 1993). In sum, position, relative autonomy (from the dominant economic and political fields) and legitimate forms of capital are the fundamental categories through which a field can effectively take the form of a social relational system for a sociological gaze.

In his own theoretical framework, Bourdieu emphasised the role of objective relations, which he depicted as connections between the positions occupied in the distribution of resources: economic, cultural, social and symbolic capital. From a Bourdieuian perspective, the position occupied by an agent shows its significance in shaping cognitive attitudes and defining the connection among agents occupying similar positions on the basis of capital fractions. However, as de Nooy (2003) rightly observed, in Bourdieu's proposal the distinction between structure and interaction, namely between 'objective relations' structuring society and the social field and individual activities, represented a crucial point. In fact, an objective relation that is structured by capital's possession operates on the subject as a force capable of aiming individual intentions at a particular action. This way, according to Bourdieu, intersubjective relations cannot exist or be thought of as outside an objective relation, instead the former are determined, consciously or unconsciously, by the latter. This kind of distinction is not superfluous for our purposes, but rather than following it with no objection, the approach we intend to propose (in keeping with intrinsic properties defining practices taking place in a social media environment) acknowledges 'that a field's structure does not merely reflect objective relations. Interaction or intersubjective relations, which have a dynamic of their own, at least mediate and transform the forces of objective relations' (de Nooy 2003: 321). A fortiori in an online social world, subjective interactions are likely to establish a steady dialogue with objective relations. In other words, individuals or users can be imagined as embodied subjects, who along with other individuals move

within 'social environments' they themselves help to create through their practices and discourses (see, e.g., Schatzki, Knorr Cetina and von Savigny 2001).

However, as I explain below, the point is not only that an egalitarian relationship between subjective and objective relations could exist. In fact, if the former are manifest elements, how to investigate what is directly unseen (that is, the latter)? And, extending the focus of our analysis, where is the social media field located in the field of cultural production? Finally, what techniques are more suitable to analyse these hybrid practices?

Probably we would remain disappointed by the outcome if the prerequisites allowing us to identify a field were fully applied to the social media environment, which only partly meets the aforementioned criteria. In fact, in contrast to an offline cultural field, a social media platform is likely to be characterised by an apparent yet significant network culture [7] that we may detect, for instance, as one user decides to make him/herself autonomous from the rules or the dominant attitude guiding a single online network. The pattern of an online action appears to be less constrained or bounded by competition rules and structural norms, as Becker indirectly stated by proposing his own interactionist category of 'world': 'Someone is monopolising the field you want to work in? Move somewhere else and start your own field. You don't even have to compete with the other people. You can criticise them to your followers, or ignore them, but they are not powerful enough and do not have enough of a monopoly to prevent you from doing anything' (Becker and Pessin 2006: 280). So, it is necessary to look at social media from a slightly different perspective capable of mixing objective and subjective relations into a single analytical frame. It should be remembered that in social media environments, position no longer works as Bourdieu primarily described it, or at least position works under different conditions in comparison with what he originally advocated. Furthermore, the social media field is not an institutionalised system and one might encounter many theoretical and empirical difficulties if production and consumption were totally divided in the course of analysis. Not surprisingly, notions like 'produsage' and 'prosumer' that emphasised the mixed nature of online practices through which a user is at same time producer and consumer, writer and reader, emerged in recent debates on this topic (see, e.g., Bruns 2008; Ritzer and Jurgenson 2010).

Thus, we may not totally support the Bourdieuian theoretical project, unless combining it with other theoretical perspectives focused, for instance, on the role played by social interactions (networks and interactions) (Bottero and Crossley 2011) and technological aspects (site infrastructure, algorithm and so on) (see, e.g., Terranova 2014) in online environments. Bourdieu's

contribution lies in his reflection on the structural effects produced by the field, or to put it differently, starting from a Bourdieuian theoretical horizon, net power is framed in a more specific manner and observed in a more systematic way because it allows us to analyse how online boundaries function, how relations are actualised and become structured, and how design of social media invokes the very notion of relationship itself. Therefore, following Bourdieu's proposal, although integrated into other theoretical approaches that are more inclined to emphasise how interactions take place and develop (rather than overestimating the function of objective relations), the choice of integrating multiple correspondence analysis, social network analysis and qualitative research techniques such as participant observation and in-depth interviews might allow us both to measure how structural factors work and to investigate the actors' different capability of embodying and actualising these structural dimensions.

Moreover, might one argue that the social media sites are a cultural field? And that Facebook is a cultural subfield? According to Couldry (2004: 169), 'as a sphere of cultural production, the media can be analysed as a single field, or a collection of fields, (each) with a distinctive pattern of prestige and status and its own values'. If we assume social media to be the whole of social networking sites, blogs, wikis and user-generated content sites in which users create their (private and public) networks and list of contacts, share and upload photos and videos, and write messages and comments within spaces seemingly endless but effectively delimited, and where different norms and rules exist regulating online interactions, then it implies that they reproduce, at least partly, some features of cultural fields. Following what Champagne (1995) states about the journalistic field's position, we may feel that, in a similar way, social media occupies an 'ambiguous position' in the field of power due to the fact they are powerful in their effects, but, for this same reason, dominated by the economic and political fields. This topic merits more room to be sufficiently investigated, but for our purposes it is enough to say that the literature in media studies has widely analysed how the role played by politics on the Internet and within its multiple constellations of social relations has become more and more manifest (Morozov 2011), and how the emergence of Web 2.0 made evident that digital labour was a different type of exploitation of individual involvement in social and cultural activities (Terranova 2000; Fuchs 2010; Baym 2015).

Social media sites would appear to configure themselves as an intertwined set of fields partly dominated by what Papacharissi and Easton (2013) conceptualised as habitus of the new, which indicates how a state of permanent novelty affects the dispositions taking place within these online

environments. Therefore, in order to specify the actual functioning of a social network site in terms of field, we need to introduce the notion of weak field, which allows the description and examination of the inherent activity of networked environments, actors and new technologies by focusing on the connection between site infrastructure and user, user and user, and online networks and user. The category of weak field underlines the blurred nature of an online world in which: interactions among users are characterised by loose forms of contact; 'space' is to be understood as an open structure (a configuration that contrasts with the idea of 'zero-sum game') (Lamont 1992); network style manages to mediate the field's effects;[8] and the flow of content and discussion redefines the ways in which users share, consume and produce their identity. Therefore, the social media environments profile themselves as weak field because of their internal structure. More specifically, they emerge as complex sets of intertwined spheres, at the same time inclusive and exclusive. In attempting to operationalise such a concept, several aspects could be put under investigation, such as the form of capital that is likely to be legitimated in a particular social network site; if the boundaries of an online field are demarcated by where its effects end; the relationship between position and flow; and the role played by a single network in mediating the impact of the field's effect. These elements do not exhaust all the research possibilities, instead they point out some potential key points that could be studied.

Since the aforementioned properties cannot be discussed here at length for reasons of space, particularly the notion of capital is analysed below because it represents, in all probability, the key term to better assess what contribution Bourdieu's field theory could make to the examination of social media functioning. Any social network site may be a constantly changing result of the strict relationship among various human, social and technological actors, infrastructure, network and user, the combination of which is sparked by, and simultaneously results in, the mobilisation of four principal types of capital: infrastructural, network, navigational and environmental.

Each online environment actively contributes to the overall composition of social media context, both in a distinctive as well as integrated manner. It is distinctive because any online subfield reflects a set of intrinsic properties, such as technological configurations and relational patterns. For example, by comparing Instagram and Twitter, it is very clear that the first one, particularly, emphasises the iconic element, as reflected in the intensive process of bodily self-aestheticisation, whereas the second one, while providing the requisite mechanisms for users to upload images and to stream live video (in this regard, one might mention Periscope, whose services were purchased by Twitter in 2015), was built around the structuring

function played by text and word. At the same time, such environments are based on a similar network organisation (integrated characterisation); to put it another way, they give life to a technologically embedded social structure relying on seemingly horizontal relationships between strong and weak actors, as for example with celebrities (or micro celebrities) (Senft 2013) and their followers (Marwick and Boyd 2011a). It should be noted that, even though these relational structures seem to bring closer together individuals traditionally separated, the reality of the situation reveals that power differentials are still intrinsic to the relationship (Marwick and Boyd 2011b).

Infrastructural capital, therefore, refers to the overall, technical configuration of the environment, in other words the implementing potentialities that it provides in terms of profile-building, mediated self-arrangement and connection to own followers and friends. Such a capital is strictly related to the engineering work as well as the philosophy that lies behind the design of the device, although, as briefly underlined above, any online context emerges out of a constant negotiation with users' demands.

The social network's infrastructure is crucial in shaping the horizon of aggregative online strategies available to the user. The aesthetic and structure of the social network site's architecture can stratify the user's degree of participation, by determining relationships and social exchange mechanisms (Donath 2008). This way, for instance, Facebook or Twitter are thought of as defined reality with their internal functioning, delimited by specific technological and social boundaries. In fact, in an interesting study conducted on three different SNSs – Facebook, ASmallWorld, and LinkedIn – Papacharissi (2009) showed how their technological and cultural shape, articulated in structure, design and organisation, helped to define the meaning of individual practice. More specifically, this research focused on how the membership process creates structural boundaries in organising network composition; the architectural dimension affects the access pattern, and the website allows users to control their privacy. In this regard, Facebook reproduces architecturally the structure of a glass house in that its publicly open domain can be relatively transformed or modified by users with the aim to generate and navigate through restricted (private) spaces. LinkedIn in turn, a business-oriented social networking site, adopts a gated-access approach, implying that any kind of connection demands an existing form of relationship among users for it to take place. In comparison with Facebook, which appears to be more oriented to stimulate users to widen their list of contacts (bridging social capital), LinkedIn instead attempts to encourage, directly or indirectly, users to create networks based on trust among members (bonding social capital)

(see Putnam 2000). Another interesting example of an online social network site described by Papacharissi (2009) is ASmallWorld. While sharing several properties of other social networking sites, it takes the form of a private community – that is, in order to become a member, an external user has to be invited by internal members, whose privileges are relative to the number of network contacts, time of membership and social activity. In this case, the level of symbolic capital (mainly determined by media and economic capital) a user is able to acquire in his/her offline life becomes crucial to allow him/her to deploy properties and features dependent on the possession of social capital.

These reflections suggest that each social network site foresees in its structure that particular dispositions, conditions, attitudes (doxa) and forms of capital could take place depending on different circumstances and events. Focusing, for instance, on YouTube, Twitter or Wikipedia means analysing and examining specific and different patterns of conduct. On YouTube, the users are likely to share and upload videos in which irony, fun, and derision prevail over other sentiments, and where politics and information are secondary or peripheral topics. Twitter in turn seems to show both a close connection with the world of journalism and political issues, and a tendency, among users, towards teasing and self-presentation (see, e.g., Lindgren and Lundström 2011). Wikipedia, instead, is guided by a generally serious approach towards reality, since it increases its reputation through improving the accuracy of its information. These examples show the intrinsic features of subfields that, together, comprise a large proportion of the social media field. Moreover they introduce in the analysis a further aspect that needs to be studied, namely the relationship between a field's effect and a user's perception of it.

Field effects are actualised under different conditions and circumstances, because of the role played by networks in mediating them and the practical strategy the users are able to undertake. Infrastructural capital, therefore, is inseparable from network capital – that is, a type of resource and property whose structure and volume does not simply follow from the sum of micro relations involving the user and his/her own network, but rather from the intertwined, overall set of defined relations that profile themselves as both infrastructurally and socially determined. In order to elucidate that point, it is worth mentioning, again, Twitter and its 'linguistic fields' (Lindgren and Lundström 2011), whose temporary, constantly changing shape manages to find an apparent coherence (or identity) through the structuring role of hashtags. Papacharissi (2015) comes to describe such aggregations as a structure of feeling, by borrowing the term from Raymond Williams, who made use of it in the *Long Revolution* (1961) with the aim to

label those social experiences that are characterised by a certain degree of volatility. In the same way, Papacharissi revealed that, for example, a tag like #Jesuischarlie might be conceptualised as a structure of feeling because of its capacity to bring people together or to keep them apart, a structure of feeling 'open enough to permit differentiated classes of people to locate meaning in it and further infuse it with meaning. It is loosely demonstrative of the mood of the time, or *kairos,* and as such, is *socially solvent*' (Papacharissi 2015: 116, emphasis added). This example describes, however briefly, a macro network that can appear as quickly as it disappears, even though #Jesuischarlie is probably a powerful tag imbued with deeper meaning everyone may refer to, such as the freedom of speech or, at worst, the clash of civilizations. Such characterisation makes it more durable than other similar digital aggregations. However, social media environments also include the presence of more established micro networks that rely on seemingly strong ties (Granovetter 1973) such as those relations the user is likely to establish with his/her friends and close associates with whom he/she shares or may share every moment of his/her existence on a social network site. In this regard, such a network is organised largely around a more patient and structuring type of capital in comparison with the aforementioned form that is likely to characterise online macro networks.

Therefore, the strict relationship between the infrastructural properties of digital environments and the intrinsic features of a social network (in terms of macro vs. micro, impatient vs. patient capital, weak vs. strong ties, inclusivity vs. exclusivity, etc.) gives rise to a particular form of subcultural capital (cf. Thornton 1995). In other words, a capital emerges that is able to nourish itself with continuous connections between widespread digital culture (that culture involving the social network site as a whole: for example, LinkedIn tends to be mainly structured by a professional capital) and restricted digital culture (that culture whose extent is socially limited in terms of contacts and nodes).

The user, in turn, may deploy two intertwined forms of capital: navigational and environmental. Both infrastructure and network require him/her to be able to become a resident of a digitally structured reality and, at the same time, to develop a correct awareness of the various internal maps. In other words, environmental capital implies the knowledge of doxa structuring the social as well as the technical functioning of a social network site. Such a capital entails, therefore, different capabilities, ranging from the capacity to set up a more effective personal profile to an awareness of cultural norms related to the process of self-branding; from the capacity to use properly any tools the digital environment makes available to its users to the correct knowledge of privacy norms. Accordingly, environmental capital is

paradoxically both politically and commercially oriented, and such a difference that organises the relationship between public and private space results also from what value the user places on his/her own participation in social media. On the other hand, navigational capital suggests that the social media environments are evolving contexts, needing to be repeatedly crossed. However, the capacity to navigate does not refer exclusively to a technical mobility (for instance, the aspect of access), but rather to a cultural mobility (Appadurai 2004) involving the possibility to catch the intrinsic properties of social media to explore the social world more deeply and to 'exploit' its remarkable potentialities in terms of cognitive and affective surplus (Shirky 2010).

CONCLUSION

Although we are aware of the fact that field theory has to be empirically investigated for an analytical revision of it to be realised, we believe the notion of weak field occupying an intermediate position between Bourdieu's idea of field and Becker's theory of world could be a useful theoretical category for sociological literature concerning both field theory and social media. In fact, it is capable of better understanding the role played by the technological and social structures behind the manifest system of interactions, and of examining the process of perception that users and their networks can actualise. While this study is just a preliminary analysis, what is interesting here is, firstly, that Bourdieu remains somehow a fundamental, critical, point of reference in a relatively novel scholarly domain, and, secondly, that social media gave birth to a new form of field, neither totally institutionalised nor fully imbued with an informal spirit.

This field is redefining the 'sense of social play' of individual actors and especially of institutional subjects, affecting and being affected by political and economic strategies. Autonomy, again, is the stake of a symbolic struggle, whose boundaries, objectives and players appear, however, more and more blurred. In that case, the notion of weak field suggests that these environments are second-order realities because of their technologically mediated nature, but more importantly, they profile themselves as both evolving and inertial worlds: evolving because they are asked from the inside and the outside to repeatedly innovate their overall shape by changing intrinsic norms and technical features; inertial because these realities are triggered by a dynamic, unequal relationship among structures endowed with different levels of power and strength (one might mention the role of politics in monitoring users' traffic, the part played by corporations that exploit users'

online activities, and so on). For these reasons also, the concept of field, obviously revised, may help examine social media as entities where different forces and struggles continuously converge.

NOTES

1. In this regard, further investigation on University programmes offering gradu-ate and doctoral degrees in media studies would be advisable in order to verify whether Bourdieuian sociology represents an orthodox or a heterodox perspec-tive in this scientific domain.

2. In that case, the approach guiding the writing of this chapter and the pursuing of the third objective reflects the sociological 'mood' we can read between the lines in the following quotation by Lizardo (2008: 13): 'Bourdieu's concepts should be appropriated, dismembered and used and modified as the analyst sees fit, rejecting what they do not need, or find to be in contradiction to evidence. I think his work should be mined without any 'contamination' worries. Scholars should pick what is useful to them and the analytical problem at hand as they deem appropriate ... Bourdieu's works are full of useful sensitising concepts, empirically-testable hypotheses and suggestions for research'.

3. The choice to select this particular year is linked to the fact that 2005 marked a watershed in the history of social media's history: YouTube was created in 2005 and Twitter in 2006.

4. At the same time, it should be noted that Bourdieu's category of social capital is not always located at the core of mainstream reflection with regards to the study of social media environments. In fact, one can take into account one of the most influential works devoted to this topic (Wellman et al. 2001), which was aimed at analysing the relationship between Internet and social interactions, online and offline. In the paper, the authors discussed whether the Internet increased inter-personal contacts and social participation (visitors to the National Geographic Society website). The scholars revisited Putnam's proposal encompassing two forms of social capital, which Wellman et al. called network capital and par-ticipatory capital. However, Bourdieu's contribution in the article is completely lacking. As Portes (1998: 3) points out, Bourdieu's formulation of social capital has suffered a lack of visibility in the English-speaking world, due to the fact that his analysis of the concept was originally published in French (in the *Actes de la Recherche en Sciences Sociales*), and then in a text on the sociology of education, precisely *The Forms of Capital* (1986).

5. Hugo Liu's article (2008) was one of the first influential analyses to take Bourdieu's work (and Goffman's description of everyday performance) as a point of departure to investigate the relationship between cultural capital and taste in a social media context. More specifically, Liu's analysis of the presenta-tion of the self as an expression of personal taste on MySpace has shed light on the distinctive spirit guiding the purpose of individual discourses (Donath and

Boyd 2004; Donath 2008). Bourdieu's work (*Distinction*) (1979) has been quoted and discussed by Liu to verify whether 'variation in the taste norms of various demographic groups on MySpace can be accounted for by the socioeconomic capital associated with each group' (Liu 2008: 256). Surprising outcomes from the research have revealed users are likely to show different tastes in comparison with their friends. Yet, as Boyd points out (2008: 135), this performative differentiation depends upon the fact that the 'public frame' of online connections pushes people to pursue differentiation strategy in listing tastes.

6. At the same time, this could also suggest that the higher the level of dispersion (more than 50% may be hypothesised), the greater the engagement with an author's framework is likely to be. In that case, we are referring to the scientific production spread through journals.

7. Terranova (2004), reflecting on the Internet before social media began to emerge, depicted a network culture in terms of the convergence of physical and political processes. This proposal has the advantage of catching the intrinsically dual nature of online social life, at once fluid and inertial, liquid and material, aggregating and disaggregating, and to integrate these contrasting dimensions in a single meaningful category.

8. See the idea of 'culture in interaction' developed by Eliasoph and Lichterman (2003), whose study on group style revealed how implicit, culturally patterned styles of membership filter collective representations. In my chapter, I replace 'group style' with network style and 'collective representations' with field's effect.

REFERENCES

Appadurai, A. 2004. 'The Capacity to Aspire: Culture and the Terms of Recognition', in V. Rao and M. Walton (eds), *Culture and Public Action*. Redwood: Stanford University Press.

Baym, N. 2015. 'Social Media and the Struggle for Society', *Social Media + Society* 1: 1–2.

Becker, H.S. and A. Pessin. 2006. 'A Dialogue on the Ideas of "World" and "Field"', *Sociological Forum* 21(2): 275–86.

Benson, R. 1999. 'Field Theory in Comparative Context: A New Paradigm for Media Studies', *Theory and Society* 28(3): 463–98.

———. 2009. 'What Makes News More Multiperspectival? A Field Analysis', *Poetics* 37(5–6): 402–18.

Bottero, W. and N. Crossley. 2011. 'Worlds, Fields and Networks: Becker, Bourdieu and the Structures of Social Relations', *Cultural Sociology* 5(1): 99–119.

Bourdieu P. 1979. *Distinction. A Social Critique of the Judgement of Taste*. Cambridge, MA: Harvard University Press.

———. 1986. 'The Forms of Capital', in J.C. Richardson (ed.), *Handbook of Theory and Research for the Sociology of Education*. Westport: Greenwood Press, pp. 47–58.

——. 1993. *The Field of Cultural Production: Essays on Art and Literature.* New York: Columbia University Press.

——. 1998. *On Television and Journalism.* London: Pluto.

Bourdieu, P. and L. Wacquant. 1992. *An Invitation to Reflexive Sociology.* Chicago: The University of Chicago Press.

Boyd, D. 2008. 'Taken Out of Context: American Teen Sociality in Networked Publics', Ph.D. dissertation. Berkeley: University of California.

Bruns, A. 2008. *Blogs, Wikipedia, Second Life, and Beyond. From Production to Produsage.* New York: Peter Lang.

Champagne, P. 1995. 'La double dependence. Quelques remarques sur les rapports entre les champs politique, economique et journalistique', *Hermes* 17–18: 215–29.

Couldry D., 'Media meta-capital: Extending the Range of Bourdieu's Field Theory', in D.L. Swartz, V.L. Zolberg (eds), *After Bourdieu. Influence, Critique, Elaboration.* Boston: Kluwer, 2004.

de Nooy, W. 2003. 'Fields and Network Analysis: Correspondence Analysis and Social Network Analysis in the Framework of Field Theory', *Poetics* 31: 305–27.

Di Stefano, A. 2013. *Una micro-teoria del potere. Pierre Bourdieu tra etnografia, cultura e relazionalità.* Rubbettino: Soveria Mannelli.

Donath, J. 2008. 'Signals in Social Supernets', *Journal of Computer-Mediated Communication* 13(1): 231–51.

Donath, J. and D. Boyd. 2004. 'Public Displays of Connection', *BT Technology Journal* 22(4): 71–82.

Eliasoph, N. and P. Lichterman. 2003. 'Culture in Interaction', *American Journal of Sociology* 4: 735–94.

Ellison, N., C. Steinfield and C. Lampe. 2007. 'The Benefits of Facebook "Friends": Social Capital and College Students' Use of Online Social Network Sites', *Journal of Computer-Mediated Communication* 12: 1143–68.

Fuchs, C. 2010. 'Labor in Informational Capitalism and on the Internet', *The Information Society* 26: 179–96.

Granovetter, M.S. 1973. 'The Strength of Weak Ties', *American Journal of Sociology* 78(6): 1360–380.

Hallin, D.C. and P. Mancini. 2004. *Comparing Media Systems. Three Models of Media and Politics.* Cambridge: Cambridge University Press.

Hesmondhalgh, D. 2006. 'Bourdieu, the Media and Cultural Production', *Media, Culture & Society* 28(2): 211–31.

Lamont, M. 1992. *Money, Morals & Manners.* Chicago: The University of Chicago Press.

——. 2012. 'How Has Bourdieu Been Good to Think With? The Case of the United States', *Sociological Forum* 27(1): 228–37.

Lindgren, S. and R. Lundström. 2011. 'Pirate Culture and Hacktivist Mobilization: The Cultural and Social Protocols of #WikiLeaks on Twitter', *New Media & Society* 13(6): 998–1018.

Liu, H. 2008. 'Social Network Profiles as Taste Performances', *Journal of Computer-Mediated Communication* 13(1): 252–75.

Lizardo, O. 2008. 'Comment on John Goldthorpe: Three Cheers for Unoriginality', *Sociologica* II, 1, doi: 10.2383/26580

Marwick, A.E. and D. Boyd. 2011a. 'I Tweet Honestly, I Tweet Passionately: Twitter Users, Context Collapse, and the Imagined Audience', *New Media & Society* 13(1): 114–33.

———. 2011b. 'To See and Be Seen: Celebrity Practice on Twitter', *Convergence: The International Journal of Research into New Media Technologies* 17(2): 139–58.

Moi, T. 1991. 'Appropriating Bourdieu: Feminist Theory and Pierre Bourdieu's Sociology of Culture', *New Literary History* 22: 1017–49.

Morozov, E. 2011. *The Net Delusion: The Dark Side of Internet Freedom*. New York: PublicAffairs.

Papacharissi, Z. 2009. 'The Virtual Geographies of Social Networks: A Comparative Analysis of Facebook, LinkedIn and ASmallWorld', *New Media & Society* 11(1 and 2): 199–220.

———. 2015. *Affective Publics: Sentiment, Technology, and Politics*. Oxford University Press.

Papacharissi, Z. and E. Easton. 2013. 'In the Habitus of the New: Structure, Agency, and the Social Media Habitus', in J. Hartley, J. Burgess and A. Bruns (eds), *A Companion to New Media Dynamics*. Oxford: Blackwell.

Portes, A. 1998. 'Social Capital: Its Origins and Applications in Modern Sociology', *Annual Review of Sociology* 24: 1–24.

Putnam, R. 2000. *Bowling Alone: The Collapse and Revival of American Community*. New York: Simon & Schuster.

Ritzer, G. and N. Jurgenson. 2010. 'Production, Consumption, Prosumption: The Nature of Capitalism in the Age of the Digital "Prosumer"', *Journal of Consumer Culture* 10(1): 2010: 13–36.

Robbins, D. 2008. 'French Production and English Reception: The International Transfer of the Work of Pierre Bourdieu', *Sociologica* 2: 1–32, doi: 10.2383/27720

Sallaz, J. and J. Zavisca. 2007. 'Pierre Bourdieu in American Sociology, 1980–2005', *Annual Review of Sociology* 33: 21–41.

Santoro, M. 2011. 'From Bourdieu to Cultural Sociology', *Cultural Sociology* 5(1): 3–23.

Sapiro, G. and M. Bustamante. 2009. 'Translation as a Measure of International Consecration: Mapping the World Distribution of Bourdieu's Books in Translation', *Sociologica* 2–3: 1–45 doi: 10.2383/31374

Schatzki, T.R., K. Knorr Cetina and E. von Savigny (eds). 2001. *The Practice Turn in Contemporary Theory*. London: Routledge.

Senft, T.M. 2013. 'Microcelebrity and the Branded Self', in J. Hartley, J. Burgess and A. Bruns (eds), *A Companion to New Media Dynamics*. Oxford: Wiley-Blackwell.

Shirky, C. 2010. *Cognitive Surplus: How Technology Makes Consumers into Collaborators*. New York: The Penguin Press.

Terranova, T. 2000. 'Free Labor: Producing Culture for the Digital Economy', *Social Text,* 63 18(2): 33–58.

——. 2004. *Network Culture.* London: Pluto.

——. 2014. 'Red Stack Attack! Algorithms, Capital and the Automation of the Common', in R. MacKay and A. Avanessian (eds), *# Accelerate: The Accelerationist Reader.* Falmouth: Urbanomic.

Thornton, S. 1995. *Club Cultures: Music, Media and Subcultural Capital.* Cambridge: Polity.

Wellman B., A.Q. Haase, J. Witte, and K. Hampton. 2001. 'Does the Internet Increase, Decrease, or Supplement Social Capital? Social Networks, Participation, and Community Commitment', *New Media and Society* 45(3): 436–55.

Antonio Di Stefano is a postdoctoral fellow at the Department of Communication and Social Research, Sapienza University of Rome and is a contract professor at Libera Università di Bolzano. He has published several books and articles on different topics ranging from the relationship between Bourdieu's relational architecture and the social media environments to the affective imaginary of media corporations.

Index

Abel, Richard 4–5
actor-network theory (ANT) 108, 110
aesthetic ruptures 17
aesthetic sphere 72
Affect and Emotion: A New Social Science Understanding (Wetherell, M.) 55
The African Queen (John Huston film) 27–8
Algeria, French occupation of 6
Algeria 1960 (Bourdieu, P.) 52, 59
Algerian women's emotional habitus, images of 51–66
 Barakat! (Djamila Sahraoui film) 53, 62–3, 64
 biologicization of the social 55
 Bourdieu's link with Algeria, strength of 51–2
 Chéliff Valley, near Algiers, Bourdieu as soldier in 52
 dispositions of the body 54
 domination, relationship of 54
 embodied thoughts, Rosaldo's notion of 57
 emotions, betrayal of 56
 female body, issues of permanence and change and the 55–6
 female characters as emotional beings 66
 feminist explorations of relation between habitus and embodied subjectivity 54–5
 feminist perspective on ideas of Bourdieu 53
 FIS (Front islamique du salut) 53
 gendered cosmology 54

GIA (Groupe islamique armé) 53
habitus
 dispositional and perceptual bodies and 56
 as dissonance between permanence and change 61–2
 and embodied subjectivity, feminist explorations of relation between 54–5
 and emotion, illustrations of 58–62
 and emotion, masculine domination and 53–8
 as generative structure 61
 investigation and uncovering of 59
 theoretical formulation of 57
illustrations of habitus and emotion 58–62
images of Algerian women's emotional habitus 62–5
individual being and emotional experience within social world 65–6
El Manara (Belkacem Hadjaj film) 53, 62–3, 64–5
Masculine Domination (Bourdieu, P.) 52–3, 53–8, 60, 62
patriarchy, naturalisation of 55
peasant resettlement, effects of 57
photographs of Algerian women 54, 58–61, 62–5
political commitment and personal engagement of Bourdieu with Algeria 52
Rachida (Yamina Bachir-Chouikh film) 53, 60, 62–3, 64

Algerian women's emotional habitus,
 images of (*cont.*)
 rural origins in France and Bourdieu's
 empathy with social suffering
 52–3
 sexual division of labour in Kabylia 54
 sexual order
 idea of destabilisation of 54–5
 permanence of 65
 social upheaval, visual documentation
 of 59
 symbolic violence
 effects of 55–6
 notion of 65
All The Real Girls (David Gordon Green
 film) 97
Android 125, 137
'art-house' cinema, emergence of 20–21,
 27
artistic fields, formation of 9
artistic value, generation of hierarchies
 of 72
autonomy 16
 artistic autonomy, importance for
 interrogation of power 30
 autonomous fields, production of 18
 problems resulting from building
 autonomous fields 28–9
 social media, Bourdieuian approach
 to 156
avant-garde field 17

Baudelaire, Charles 16, 18
Bauman, Zygmunt 141
The Beatles 7
Bicycle Thieves (Vittorio de Sica film) 22
biographical illusion 16
biologicization of the social 55
Bonny and Clyde (Arthur Penn film) 27
Bourdieu, Pierre
 citation patterns of articles in Internet-
 oriented journals 145
 communication field, influence on
 148
 complexity and phases of thought of
 9–10
 complexity of thought 9–10
 consecration and auteur perception in
 cinema 4–5, 15, 35, 44, 71
 cultural capital, concept of 2–3

cultural production, relationality and
 4, 5–6
 digital technologies, engagement with
 5
 field theory 5, 37, 40, 47, 101, 108–10,
 141, 142, 149, 152, 156
 film studies, incorporation into 3
 link with Algeria, strength of 51–2
 new media, scepticism about powers
 of 10–11
 phases of thought and insights 9–10
 relationality, social media environment
 and 147–56
 rural origins in France and empathy
 with social suffering 52–3
 scholasticism, opposition to 70–71
 social media era and 141–2
 social theorization of, power of 1
 subcultures, work on 2
 time periods, perceptions and 4–5
*Bourdieu in Algeria: Colonial Politics,
 Ethnographic Practices, Theoretical
 Developments* (Goodman, J. and
 Silverstein, P.) 51

Cahiers du Cinéma 8, 20–21, 24
camera, exploratory uses of 15
Canudo, Ricciotto 5
capital 124–5, 128, 129
 acquisition of 124–5, 128, 136–7
 ownership of, inequalities generated
 by 29–30
 usage of term 136
Capturing the Friedmans (Andrew Jarecki
 film) 42
Chabrol, Claude 7, 8, 20, 24
Chaplin, Charlie 23–4, 28, 30
chic radicalism 16
cinema
 art and commerce in, polarity between
 7–8
 cinematographic language games 8–9
 genesis of autonomous restricted field
 20–22
 photography and, Bourdieu's
 perspective on 14–15
 place of, cultural production and
 16–18
citizen journalism, phenomenon of 74
Citizen Kane (Orson Welles film) 24–5

coding, practices of 3
collective memory 15, 19, 28
Collège de France 6
Communication Index 143–4
communications technology, social life and 111
The Conquest of Cool (Frank, T.) 95
consumer/producer divide in, looking beyond
film studies 47
consumption 3, 44, 70, 75, 95, 103, 138, 150
film and media consumption 35–6, 37, 71, 74, 131
globalised consumption 28
mass consumption 8
Contre-feux and Contre-feux 2 (Bourdieu, P.) 7–8, 9
CPH:DOX in Copenhagen 43
'creative class,' concept of 95–6
The Cult of the Amateur: How Today's Internet is Killing Our Culture (Keen, A.) 73
cultural capital 128, 129, 136
acquisition of 128–9
forms of 129
social media, Bourdieuian approach to 141
sociology-of-taste agenda and 35–7
taste and distinction, notions of 36
cultural production
genesis of 14
independence of 9
power and 94
reception and, criticism as intermediary between 72
cultural production, cinema and 4–5, 13–30
aesthetic ruptures 17
American worker, golden age of 26
'art-house' cinema, emergence of 20–21, 27
autonomy 16
artistic autonomy, importance for interrogation of power 30
autonomous fields, production of 18
problems resulting from building autonomous fields 28–9
avant-garde field 17
biographical illusion 16
Cahiers du Cinéma 20–21, 24

camera, exploratory uses of 15
capital ownership, inequalities generated by 29–30
chic radicalism 16
cinema, genesis of autonomous restricted field 20–22
cinema, place of 16–18
cinema and photography, Bourdieu's perspective on 14–15
collective memory 15
critical 'heterodoxies,' analysis of 16
critique 18–20
cult aspects of Hollywood films 27
cultural production, genesis of 14
defamiliarisation 15
dominant classes in capitalist societies, arts as symbolic armour against 13–14
domination, Bourdieu's analysis of social reproduction of 29–30
education, cultural capital and 30
ethic of suspicion 16
fetishised sacralisation of secular culture 13–14
formalist realism 17, 23
Grandes Ecoles film schools 21
group ethos 17
habitus, actors' modes of perception and 14
Hollywood films 23–8
improvisational flair 16
independent Hollywood directors, rise of 28
intellectuals, corporation of 16
Italian cinema (1940s) 22–3
Jansenist world vision 24
legitimacy, relationships of 17–18
legitimisable arts 14–15
McCarthyism 24–5, 27
material needs of artists 18–19
modernity, professional existence in 16
narcissistic relativism 16
neorealism in Italian cinema (1950s) 22–3
New Deal, Popular Front culture of 24, 26
New Wave (Nouvelle Vague) 20–21
perception frames, photography and 15

photography, recognition as major art
15
photography and cinema 14–15
popular art
Bourdieu's disavowal of 19–20
as illusion 30
power or powerlessness, positions of 14
practice, logic of theory of 13
reason, corporation of 16
social reality, discovery of 'mechanisms'
governing 14
studio-system in Hollywood 26–7
suspicion, ethic of 16
symbolic power, Bourdieu on 29
cultural sociology 141–2
culture
convergence culture 91
digital culture, collaborative and
audience-driven modes of
production and 73
fetishised sacralisation of secular
culture 13–14
Indie (or alternative) culture 95
multidimensional arena of 71
news media and culture industries 92
subcultures, Bourdieu's work on 2
taste cultures 90–91, 92, 95, 103
white elite cosmopolitan culture 91
see also cultural capital; cultural
production

The Daily Show (Comedy Central TV) 93
Daughter from Danang (Gail Dolgin and
Vicente Franco film) 40–41, 42
Demy, Jacques 20
Deschanel, Zooey 97–101
Distinction (Bourdieu, P.) 3, 158
cultural production, cinema and 13, 15
film studies 35, 36, 47
protest and social turbulence,
Millennial generation and 91
social media, Bourdieuian approach
to 146
DocLisboa 43
DocPoint (Helsinki) 43
documentary ethics 37
field enforcement and 40–42
journalistic ethics and 41
DOK Leipzig 43, 44
Doniol-Valcroze, Jacques 20

Elias, Norbert 141
epoche, Husserl's notion of 137
Evernote 132

Facebook
Internet studies, Bourdieuian approach
to 116, 117
mobile media technologies, distinction,
capital and 125, 131, 135, 136
social media, Bourdieuian approach to
151, 153
Failure to Launch (Tom Dey film) 98
*Feminism After Bourdieu: International
Perspectives* (Adkins, L. and Skeggs,
B.) 56
feminist explorations of relation between
habitus and embodied subjectivity
Algerian women's emotional habitus,
images of 54–5
*The Field of Cultural Production: Essays on Art
and Literature* (Bourdieu, P.) 4, 10,
13–31, 36
The Field of Cultural Production (Bourdieu,
P.) 36
fields
autonomous fields, Bourdieu's call
for 6
capital and habitus, operationalising in
Internet studies 114–20
communication field, Bourdieuian
influence on 148
concept of, Bourdieu's definition of 3
determination of, Bourdieuian criteria
for 149, 150
dynamic nature of 41–2
field effects, actualisation of 154–5
field theory, critics characterisation of
limits of 108
hierarchical nature of 113
importance as tool for revealing
symbolic order and capitals
116–18
quasifields 3
relationality and 5–6
relations and 110–11
tentative fields 3
underestimation of concept of 148
Fifty Dead Men Walking (Kari Skogland
film) 81–2
Film Comment 80

film studies 35–47
 Bourdieu's incorporation into 3
 consecration and auteur perception in
 cinema, Bourdieu's emphasis on
 4–5, 15, 35, 44, 71
 consumer/producer divide in, looking
 beyond 47
 cultural capital
 sociology-of-taste agenda and 35–7
 taste and distinction, notions of 36
 Daughter from Danang (Gail Dolgin and
 Vicente Franco film) 40–41, 42
 documentary ethics 37
 field enforcement and 40–42
 journalistic ethics and 41
 fields, dynamic nature of 41–2
 film festival circuit as field effect 42–6
 film festival studies, social field and
 37, 43
 film scholars' reception of work of
 Bourdieu 35–6
 Hollywood production culture 38–40
 media consumers, diverse stakes of
 39–40
 middlebrow production culture 38–40
 misunderstanding (selective) of
 Bourdieu in American academy
 47
 paracinema 36
 poetic documentary screening 45
 populist desire to resist bourgeois taste
 36
 Presenting Lily Mars (Norman Taurog
 film) 38–40
 social field
 areas of inquiry and debate and 36–7
 Bourdieu's definition of 37
 film festival studies and 37, 43
 reframing debates within film studies
 36–7
 social movement and 41–2
 sociological method, the interpretive
 methods and 35
 sociology-of-taste agenda 35–7
FIS (Front islamique du salut) 53
The Flat White Economy (McWilliams, D.) 96
Flaubert, Gustave
 cultural production, cinema and 16,
 17, 18, 35
 film studies 35

Fonda, Jane 7
formalist realism 17, 23
'The Forms of Capital' (Bourdieu, P.)
 146
Friends (NBC TV comedy series) 101

Galbraith, James K. 93
gendered cosmology 54
Generation X 91
Gentleman's Agreement (Elia Kazan film) 25
Germinal (Claude Berri film) 21–2
GIA (Groupe islamique armé) 53
Giddens, Anthony 141
Ginsberg, Allen 7
Girls (HBO comedy-drama series) 97–101
Godard, Jean-Luc 6–7
 cultural production, cinema and 20,
 21, 24
Goffman, Erving 141, 144
Google+ 125, 131
Grandes Ecoles film schools 21
Grapes of Wrath (John Ford film) 25
The Great Dictator (Charlie Chaplin film)
 23–4
Il Grido (Michelangelo Antonioni film) 22
Guillory, John 47

Habermas, Jürgen 144
habitus 4, 14, 15, 16, 30, 71, 85
 actors' modes of perception and 14
 bohemian habitus 95
 definitions of 90, 127
 digital social practice and 119
 dispositional and perceptual bodies
 and 56
 as dissonance between permanence and
 change 61–2
 and embodied subjectivity, feminist
 explorations of relation between
 54–5
 and emotion
 illustrations of 58–62
 masculine domination and 53–8
 film studies, Bourdieu and 39, 40, 41
 as generative structure 61
 indispensability of 128
 Internet studies, rethinking digital
 practice 108–9, 110, 114–20,
 120–21
 investigation and uncovering of 59

habitus (*cont.*)
 mobile media technologies,
 deployment of 124, 127–9
 modification of, possibility of 128
 neo-liberal capitalism and potential for
 homologies 89–90
 protest, counterculture and recession-
 era populism 89–91, 92, 94, 95,
 97, 101–2
 social media, Bourdieuian approach to
 141–2, 143, 145, 146, 147–8,
 151–2
 study framing and 126–9
 tacit and embodied dimension to 119
 theoretical formulation of 57
 unconscious influences on practice and
 119–20
 underestimation of concept of 148
Hall, Stuart 3
hegemony, Gramscian theory of 148
Hitchcock, Alfred 24, 28, 30
Hollywood
 films of 23–8
 production culture of 38–40
Hollywood Antitrust Law (1948) 25–6
homologies
 habitus, neo-liberal capitalism and
 potential for 89–90
 potential for (and blocking of) 90, 91,
 92, 97, 102
Hunger (Steve McQueen film) 3, 71, 74,
 75–6, 77–9, 80, 81–2, 83, 84
 cinefile reviews of 79–80
 critical reception for 77–9
 film fan reviews of 79–80
 genre fan reviews of 82–3
 IMDb reviews of 79–83, 84–5
 politically invested reviews of 81–2
 pragmatic advisors, reviews of 83
 thematic sections within 76–7

In the Name of the Father (Jim Sheridan
 film) 83
Indie (or alternative) culture 95
Information society 111
Instagram
 mobile media technologies, distinction,
 capital and 125
 social media, Bourdieuian approach
 to 152

International Documentary Festival
 Amsterdam (IDFA) 43–4
Internet Movie Database (IMDb) 71, 73,
 74, 84–5
Internet studies, Bourdieuian approach
 to 107–21
 actor-network theory (ANT) 108, 110
 classification, schemes of 116
 communications technology, social life
 and 111
 comparativism of the essential,
 Bourdieu's call for 108
 connections and actors 110–11
 digital divide 114
 digital inequality, reconceptualisation
 of 115–16
 digital practice, Bourdieu's approach
 and research of 108–9
 digital sociality, technological fetishism
 and 117
 Facebook 116, 117
 field
 capital and habitus, operationalising
 in Internet studies 114–20
 field theory, critics characterisation
 of limits of 108
 hierarchical nature of 113
 importance as tool for revealing
 symbolic order and capitals
 116–18
 relations and 110–11
 habitus
 digital social practice and 119
 tacit and embodied dimension to
 119
 unconscious influences on practice
 and 119–20
 institutional cultural capital, agents
 investing in 111
 interactive ties in network theories,
 concern with 111
 Internet, 'newness' as medium 107–8,
 120
 Internet research, conceptual
 development of 107–8
 Internet studies, need for Bourdieuian
 approach to 109–14
 multiscalar network structures 109
 network theory, human agency and 110
 networked individualism 108, 109–10

objective relations 110–11
online groups, description as 'communities' 112
online social space, public sphere, field and 112–13
operationalising field, capital and habitus in Internet studies 114–20, 120–21
postmodern theories 108
power
 Bourdieuian interpretation of 110–11, 112, 113, 114–15, 115–16, 120–21
 networks of 109
power relationships, challenges to 109, 120
practice, technologically determinist refashioning of 114
public sphere
 Habermas' concept of 107–8
 ideal of 112–13
reputation systems 117–18
social and antisocial uses, dichotomy between 112
social capital 111, 114–15
social glue 113
social network analysis 111–12
struggle, identification of arenas of 115–16
system world 112–13
virtual reality 108
'vision and division,' agents' schemes of 116
iPhone 125–6, 127, 129, 132–3, 135, 136, 137
Italian cinema (1940s) 22–3

James, C.L.R. 24
Jilhava Documentary Film Festival 43
Journal of Computer-Mediated Communication 143–6

Karlovy Vary International Film Festival (KIFF) 44

Landscape. The Autobiography of Nicolae Ceausescu (Andrei Ujică film) 46
Landscape (Sergei Loznitsa film) 45–6
legitimacy, relationships of 17–18
legitimisable arts 14–15

life-world, investment with 127–8, 129
LinkedIn 153, 155
Locating Bourdieu (Reed-Danahay, D.) 55, 56
Long Revolution (Williams, R.) 154–5
Lost Boundaries (Alfred L. Werker film) 27

McCarthyism 24–5, 27
MacDonald, Ian 7
McQueen, Steve 3, 71, 74, 75–6, 77–9, 80, 81–2, 83, 84
Manchester school of Anthropology 109
Manifesto of the Seventh Art (Canudo, R.) 5
Marker, Chris 20
Marseille FID 43
Masculine Domination (Bourdieu, P.) 52–3, 53–8, 60, 62
Midnight Cowboy (John Schlesinger film) 27
Millennials Rising: The Next Great Generation (Howe, N. and Strauss, W.) 91
Miramax 28
mobile media technologies, distinction, capital and 124–39
 capital 124–5, 128, 129
 acquisition of 124–5, 128, 136–7
 usage of term 136
 computer-mediated social interaction, types of 125
 cultural capital 128, 129, 136
 acquisition of 128–9
 forms of 129
 day-to-day activities, management with iPhone 133–4
 differentiation of self 129
 everyday social ecology, mobile technologies and 137–8
 Facebook 125, 131, 135, 136
 film locations, scouting for 132–3
 generational aspect of social media usage 135
 Google+ 125, 131
 habitus
 definition of 127
 indispensability of 128
 modification of, possibility of 128
 study framing and 126–9
 hesitancy on involvement with technologies 138–9
 value in use despite this 139

mobile media technologies, distinction,
capital and (*cont.*)
human body, co-evolution with things
by 127
identity projection, iPhone use and
135–6
improvisational modes of pre-
production 132–3
individual agency, recognition of 127
information, access to 132
Instagram 125
iPhone 125–6, 127, 129, 132–3, 135,
136, 137
life-world, investment with 127–8, 129
media entertainment, daily life and 131
mobile media technologies,
incorporation into day-to-day
activities 126–7
netnography 125
Nietzsche's 'will to power' 129
note-taking with iPhones 133
office, reconception of notion of 131–2
organisational addiction 133
participants in study 125–6, 128
choice of, criteria for 126
positive associations, forming of 137
power relations, use of mobile
technologies and 137
reflexivity, Bourdieu's insistence on
137
relationship with things, Merleau-
Ponty's perspective on 127
self as brand 134–6
self-interest 128–9
social capital 136
social networking 125–6, 134, 135, 136,
137
social networking persona, brand
image and 133–4
social world, accumulation of history
and 137
'software shell,' comfort with 137–8
South By Southwest (SXSW) 126,
133–4
Sprint Evo LTE smartphone 125, 132,
134, 135
study methodology 125
tablets 127, 137
tactical application 130–34
value building 134–6

Modern Times (Charlie Chaplin film) 23–4
Montand, Yves 7
My Own Private Idaho (Gus Van Sant film)
101

narcissistic relativism 16
navigational capital, deployment of
155–6
neorealism in Italian cinema (1950s)
22–3
New Deal, Popular Front culture of 24, 26
New Girl (Fox TV comedy) 98
New Media & Society 143–6
New Wave (Nouvelle Vague) 7, 8, 20–21
New York Post 93
New Yorker
cultural production, cinema and 27
protest and social turbulence,
Millennial generation and 95
Newcastle University Research Centre in
Film and Digital Media 1, 12
Nietzsche's 'will to power' 129
Northern Ireland Peace Process 77

Occasione (Luchino Visconti film) 22
Occupy Wall Street 89, 90, 92–3, 102,
102n1
aim of 92
hypocrisy of participants, perception of
94–5, 96–7
privileged nature of the participants,
media attention on 92–3
On the Waterfront (Elia Kazan film) 25
online film reviews, taste distinctions in
70–85
aesthetic sphere 72
art films and cultural reception 74–6
artistic value, generation of hierarchies
of 72
citizen journalism, phenomenon of 74
competing perspectives, online
accumulation of 71
cultural legitimisation, process of 72
cultural production and reception,
criticism as intermediary between
72
culture, multidimensional arena of 71
digital culture, collaborative and
audience-driven modes of
production and 73

film viewing, sites of 70
Hunger (Steve McQueen film) 74, 75,
 76–7
 cinefile reviews of 79–80
 critical reception for 77–9
 film fan reviews of 79–80
 genre fan reviews of 82–3
 IMDb reviews of 79–83, 84–5
 politically invested reviews of 81–2
 pragmatic advisors, reviews of 83
 thematic sections within 76–7
informal communication networks,
 political salience of 74
Internet Movie Database (IMDb) 71,
 73, 74, 84–5
new cultural intermediaries 71–4
Northern Ireland Peace Process 77
online user reviews, phenomenon of
 71, 73–4
professional critics, writings of 73
reception studies, 'ancillary material'
 and 70
scholasticism, opposition to 70–71
structural constructivism 70–71
taste preferences, legitimisation of 71
Oullette, Laurie 94

Pascalian Meditations (Bourdieu, P.) 90,
 101–2
'A Question of Perception: Bourdieu, Art
 and the Postmodern' (Prior, N.)
 75
Periscope 152–3
Photography - A Middlebrow Art (Bourdieu,
 P., Boltanski, L. et al.) 14, 16
Picturing Algeria: Pierre Bourdieu
 (Schultheis, F. and Frisinghelli, C.)
 51, 52, 58–9
Pierre Bourdieu: Algerian Sketches (Yacine,
 T.) 51
Pinky (Elia Kazan film) 25
Pipeline (Vitaly Mansky film) 46
power
 Bourdieuian interpretation of 110–11,
 112, 113, 114–15, 115–16, 120–21
 microtheory of 141, 148–9
 networks of 109
 Nietzsche's 'will to power' 129
 power relationships, challenges to 109,
 120

 powerlessness or, positions of 14
 relations of, use of mobile technologies
 and 137
practice
 logic of theory of 13
 technologically determinist
 refashioning of 114
Presenting Lily Mars (Norman Taurog film)
 38–40
protest and social turbulence, Millennial
 generation and 89–102
 Apple customers 95–6
 Apple iPhone, 'Rainy Day'
 advertisement for 98
 bohemian habitus 95
 contemporary age, contradictions of 91
 convergence culture 91
 'creative class,' concept of 95–6
 cultural production, power and 94
 cultural texts 90
 Deschanel, Zooey 97–101
 economic inequality, voter turnout
 and 93
 entitlement, discourse of 94
 entitlement and hypocrisy, trope of
 98–9
 generational wealth gap 100
 habitus, definition of 90
 hipster youth, contradictions of 96
 hipsters and hipsterism 90–91
 homologies
 habitus, neo-liberal capitalism and
 potential for 89–90
 potential for (and blocking of) 90,
 91, 92, 97, 102
 hypersaturated consumer capitalism
 91
 Indie (or alternative) culture 95
 literary and artistic production in
 France, fields of 94
 media attention coding protester as
 hipster 91
 neoliberal ideology, collective solutions
 and 94
 nepotism, discourse of 97
 news media and culture industries 92
 Occupy Groups 92
 Occupy Wall Street 89, 90, 92–3, 102,
 102n1
 aim of 92

protest and social turbulence, Millennial
 generation and (*cont.*)
 Occupy Wall Street (*cont.*)
 hypocrisy of participants, perception
 of 94–5, 96–7
 privileged nature of the participants,
 media attention on 92–3
 opprobrium for hipsters 91
 personal responsibility, doctrine of 94
 recession-era populism 92–7
 ritual queuing for latest electronic
 devices 96
 slacker, recessionary figure of 100–101
 smartphone advertising, lifestyle
 assumptions and 96–7
 social reproduction, process of 90
 social structures, state of 90
 statistical truths about Millennial
 generation 99–100
 technological advances, fixation on
 95
 technological fetishism 96–7
 urban space, aggressive
 commercialisation of 96
 white elite cosmopolitan culture 91
 youth on film, Giroux's views on
 depiction of 101
public sphere
 Habermas' concept of 107–8
 ideal of 112–13

qualitative research techniques 151
quantitative presence of Bourdieu in
 Internet-oriented journals 144–5

Rachida (Yamina Bachir-Chouikh film)
 53, 60, 62–3, 64
reason, corporation of 16
reception and reception studies 3, 6, 30,
 35–7, 47, 70–72, 73–4, 78–9, 84–5,
 143–5, 147–8
Resnais, Alain 20
Rivette, Jacques 20
Rohmer, Eric 20, 24
Roma, città aperta (Roberto Rossellini film)
 22
Rossellini, Roberto 22, 28
The Rules of Art (Bourdieu, P.) 9, 36, 39,
 47
Rules of the Game (Jean Renoir film) 27

Sentimental Education (Flaubert, G.) 17
sexual order
 division of labour in Kabylia 54
 idea of destabilisation of 54–5
 permanence of 65
Shoeshine (Vittorio de Sica film) 22
Silva, Jennifer M. 94
The Snake-Pit (Anatole Litvak film) 25
Snow Crazy (Laila Pakalninia film) 45
social capital
 Internet studies, Bourdieuian approach
 to 111, 114–15
 mobile media technologies, distinction,
 capital and 136
 social media, Bourdieuian approach
 to 141
social field
 areas of inquiry and debate and 36–7
 Bourdieu's definition of 37
 film festival studies and 37, 43
 reframing debates within film studies
 36–7
 social movement and 41–2
social media, Bourdieuian approach to
 141–57
 autonomy 156
 Becker's theory of world 156
 Bourdieu at stake in era of social media
 141–2
 Bourdieuian relationality, social media
 environment and 147–56
 citation patterns of Bourdieu's articles
 in Internet-oriented journals 145
 communication field, Bourdieuian
 influence on 148
 cultural capital 141
 cultural field
 Bourdieu's theoretical work on 141
 potential for application of 142
 cultural sociology 141–2
 distinction, category of 141
 environmental capital, deployment of
 155–6
 feeling, aggregations of structure of
 154–5
 field
 field determination, Bourdieuian
 criteria for 149, 150
 underestimation of concept of 148
 field effects, actualisation of 154–5

habitus 141
underestimation of concept of 148
hegemony, Gramscian theory of 148
infrastructural capital 153
Internet-oriented journals, quotes of
Bourdieu's analytical concepts in
143–4, 145–6
Internet studies and engagement with
Bourdieu's ideas 146–7
intersubjective relations 149–50
journalistic field, position of 151
micro networks 155
navigational capital, deployment of
155–6
net power, framing of 151
objective relations, role of 149
online actions, patterns of 150
position in social media environments
150
power, microtheory of 141, 148–9
'produsage' and 'prosumer,' notions
of 150
qualitative research techniques 151
quantitative presence of Bourdieu in
Internet-oriented journals 144–5
social capital 141
social interactions, role of 150–51
social media
and ambiguous position of 151
Bourdieu and, failed encounter?
142–7
context, online environment and
152–4
environments, sociological
representation of 142
literature Bourdieu's work in 147
sites, configuration of 151–2
sociological investigations of 141–2
social network
analysis of 151
infrastructural properties of digital
environments and 155
social play, redefinition of sense of
156–7
social scientific reception of Bourdieu
in US 142–3
social solvency 155
subjective and objective relations,
egalitarian relationship between
150

weak field, hybrid capabilities of 142,
152, 156–7
'Social Space and Symbolic Power'
(Bourdieu, P.) 70–71
Sociologica 143
'Outline of a Sociological Theory of Art
Perception' (Bourdieu, P.) 3, 75
Sociologie du cinéma (Sorlin, P.) 22–3
The Sociology of Algeria (Bourdieu, P.) 52
sociology-of-taste agenda 35–7
Sofia's Last Ambulance (Ilian Metev film)
43–4
'software shell,' comfort with 137–8
South By Southwest (SXSW) 126, 133–4
Sprint Evo LTE smartphone 125, 132,
134, 135
Stiglitz, Joseph 98–9, 100
La Strada (Federico Fellini film) 22
structural constructivism 70–71
Student Room 116, 118
studio-system in Hollywood 26–7
'The Market of Symbolic Goods'
(Bourdieu, P.) 8
symbolic violence
effects of 55–6
notion of 65

tablets 127, 137
tactical application of mobile media
130–34
taste 3, 14, 43, 47, 112, 119, 124,
157–8n5
class dimension of 38–9
distinction and, notions of 36
hierarchies of 2
popular taste 20–21
populist desire to resist bourgeois taste
36
sociology-of-taste agenda and 35–7
taste classifications 38
taste cultures 90–91, 92, 95, 103
taste preferences, legitimisation of 71
see also online film reviews, taste
distinctions in
Tea Party movement 92
technicians, power in digital age of 9
technological advances, fixation on 95
technological fetishism 96–7
'La télévision, le journalisme et la
politique' (Bourdieu, P.) 10

On Television and Journalism (Bourdieu, P.)
　　1–2, 6, 10
　protest and social turbulence 101
An Outline of a Theory of Practice (Bourdieu,
　　P.) 52
Thessaloniki Documentary Festival 43
This is Not a Film (Jafar Panahi and
　　Mojtaba Mirtahmasb film) 18
Touch of Evil (Orson Welles film) 25
Tout va bien (Jean-Luc Godard film) 7, 8
Truffaut, François 7
　cultural production, cinema and 20,
　　24
Twitter
　Internet studies, Bourdieuian approach
　　to 116–17
　mobile media technologies, distinction,
　　capital and 125, 131, 135
　social media, Bourdieuian approach to
　　152–3, 154

The Uprooting (Bourdieu, P.) 52
urban space, aggressive
　　commercialisation of 96

value building 134–6
Varda, Agnès 20
Vermehren, Christian 5–6
Village Voice 27
virtual reality 108, 119

'vision and division,' agents' schemes of
　　116
Visions du Réel (Nyon) 43

Washington Post 93
weak field, hybrid capabilities of 142,
　　152, 156–7
The Weight of the World (Bourdieu, P.) 57
Welles, Orson 24–5, 28
*What Was the Hipster? A Sociological
　　Investigation* (Grief, M., Ross, K.
　　and Tortorici, D., eds.) 91
white elite cosmopolitan culture 91
Wikipedia 154
Woolf, Virginia 35
Work and Workers in Algeria (Bourdieu, P.)
　　52
Workers' Film and Photo clubs 20

youth on film, Giroux's views on
　　depiction of 101
YouTube
　Internet studies, Bourdieuian approach
　　to 120
　social media, Bourdieuian approach
　　to 154

ZagrebDox 43
Zucotti Park, Occupy Wall Street protest
　　in 89, 90, 92, 94, 96